FISHES, REPTILES and AMPHIBIANS
A PICTURE SOURCEBOOK
EDITED AND ARRANGED BY DON RICE

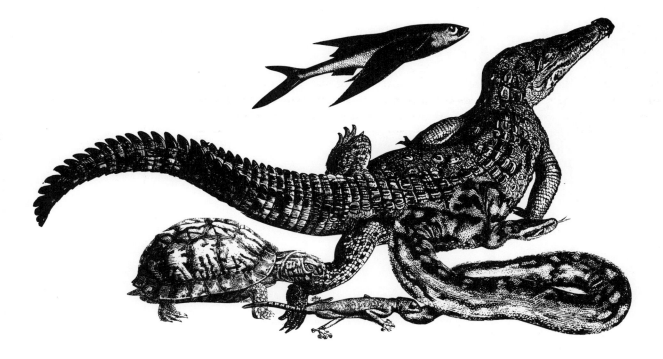

Over 500 copyright-free illustrations for direct copying and reference

 VAN NOSTRAND REINHOLD COMPANY
New York Cincinnati Toronto London Melbourne

Copyright © 1981 by Van Nostrand Reinhold Company
Library of Congress Catalog Card Number 81-185
ISBN 0-442-21196-1

All rights reserved. No part of this work covered by
the copyright hereon may be reproduced or used
in any form or by any means — graphic, electronic,
or mechanical, including photocopying, recording,
taping, or information storage and retrieval sys-
tems — without written permission of the publisher.
Printed in the United States of America.

Published by Van Nostrand Reinhold Company
135 W. 50th Street, New York, NY 10020

Van Nostrand Reinhold Limited
1410 Birchmount Road
Scarborough, Ontario M1P

Van Nostrand Reinhold Australia Pty. Ltd.
17 Queen Street
Mitcham, Victoria 3132, Australia

Van Nostrand Reinhold Company Limited
Molly Millars Lane
Wokingham, Berkshire, England

16 15 14 13 12 11 10 9 8 7 6 5 4 3 2 1

Library of Congress Cataloging in Publication Data

Rice, Don.
 Fishes, reptiles and amphibians.

 Includes index.
 1. Reptiles in art. 2. Fishes in art. 3. Amphibians
in art. 4. Art — Themes, motives. I. Title.
N7668.R46R52 760'.04432 81-185
ISBN 0-442-21196-1 AACR2

Introduction

The illustrations in this collection were drawn or engraved over a period of 100 years, from the early 1800s to the early 1900s, by innumerable artists demonstrating a wide variety of skills, styles, and knowledge about their subjects. Many are beautifully executed and very accurate. Some, such as the sawfish sawing its way through the bottom of a boat, are quite fanciful. All have useful applications for artists, students, and researchers. The collection is intended to serve as three books in one:

Clip Book

Up to 10 illustrations may be copied directly for each graphic arts project without obtaining further permission from the publisher. A credit line, though not necessary, would be appreciated.

Source Book

As a portable artist's "swipe file" it will provide a handy guide in the creation of original drawings and paintings of fishes, amphibians, and reptiles.

Reference Book

The creatures pictured are alphabetically categorized first by order (indicated by a solid black line), then by family (broken line), and then by species (with some lapses in alphabetizing to accommodate page layouts). It seemed unnecessary for the purposes of this book to divide the families into subfamilies and genera.

The animal kingdom was not systematically classified to any reasonable degree until Linnaeus published the 10th edition of his Systema Naturae in 1785. Since that time there have been radical changes in the approaches to scientific classification. One might suppose that by now the science of systematics would be an exhausted field, and that the classifications would be chiselled in stone. But this is far from being true. The approach to classification has broadened greatly in recent years, and revisions are constantly being made. The very names of established categorical sections cannot be agreed upon.

For example, one could examine three contemporary reference books in order to learn the name of the order to which sharks belong. In book A one would find the word *Pleurotremata*, in book B the word *Selachii*, and in book C the word *Squaliformes*. The latter is the designation that has been used in this book. It is highly possible that some readers will disagree with some of the choices that have been made in this regard. Readers may also find what they consider to be some out-and-out mistakes. They are encouraged to bring these to my attention by writing to the publisher.

Don Rice

Contents

FISHES

European Sturgeon

European Sturgeon

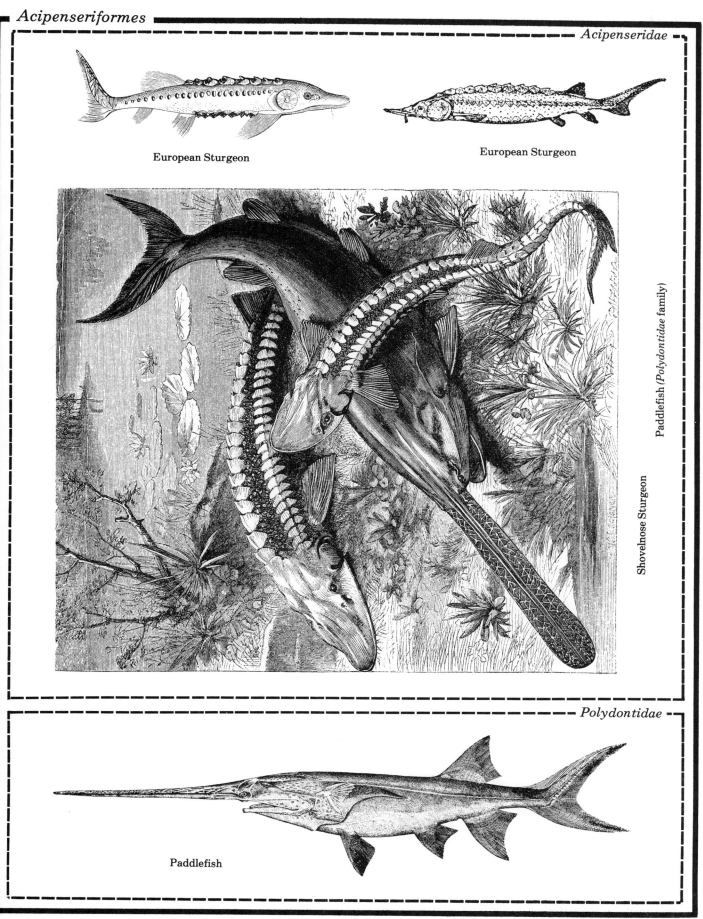

Paddlefish (*Polydontidae* family)

Shovelnose Sturgeon

Polydontidae

Paddlefish

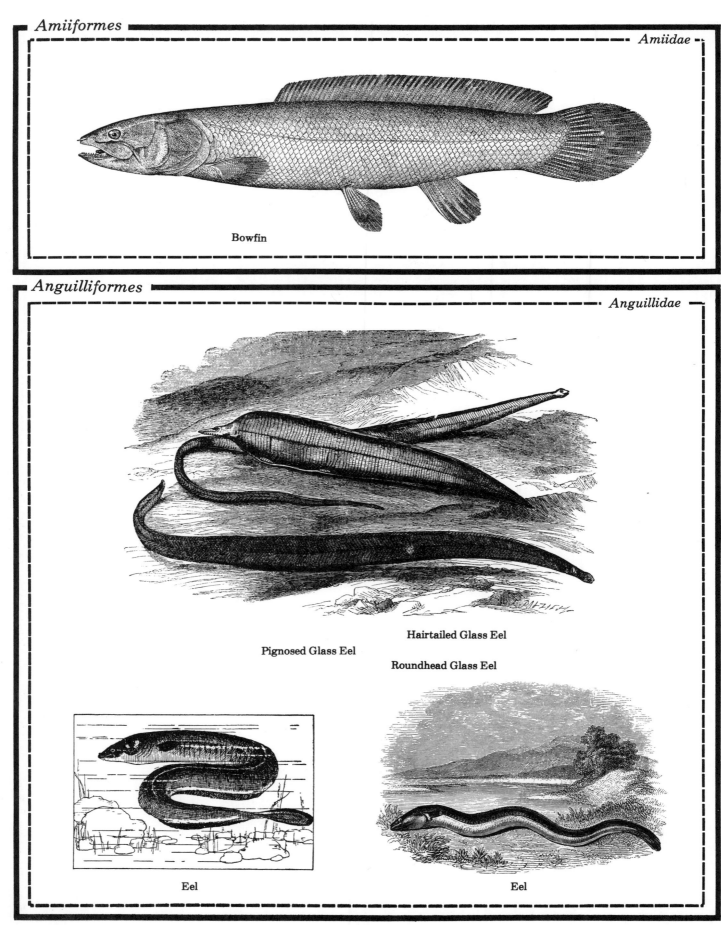

Bowfin

Hairtailed Glass Eel

Pignosed Glass Eel

Roundhead Glass Eel

Eel

Eel

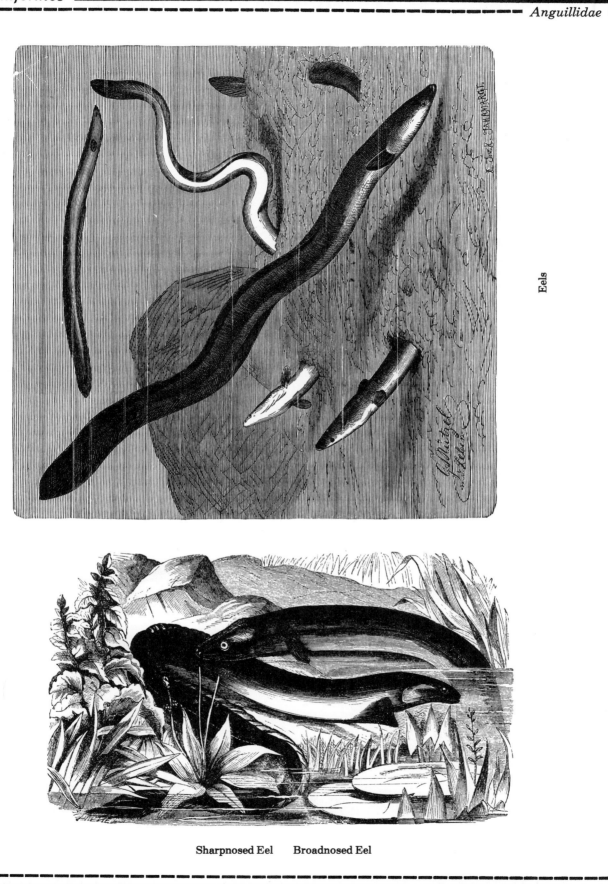

Eels

Sharpnosed Eel Broadnosed Eel

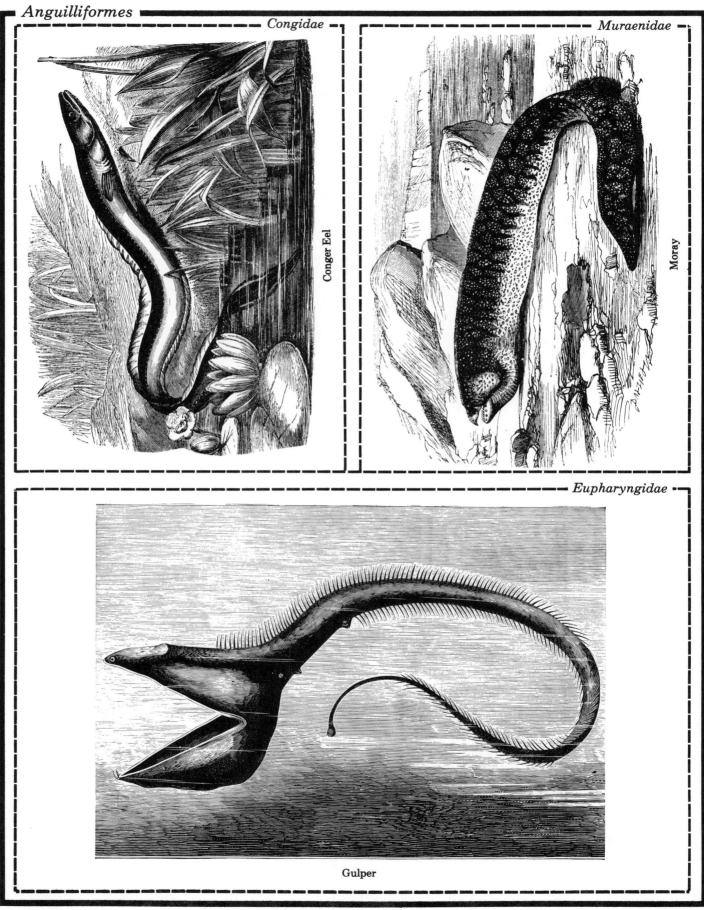

Anguilliformes

Congidae

Conger Eel

Muraenidae

Moray

Eupharyngidae

Gulper

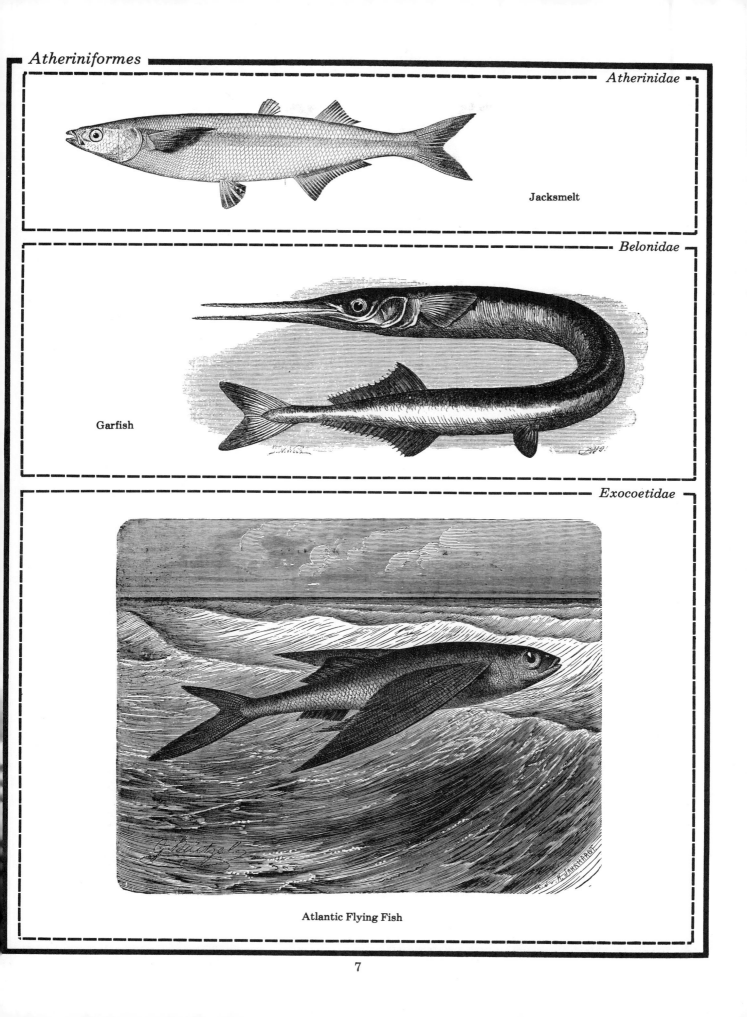

Atheriniformes

Atherinidae

Jacksmelt

Belonidae

Garfish

Exocoetidae

Atlantic Flying Fish

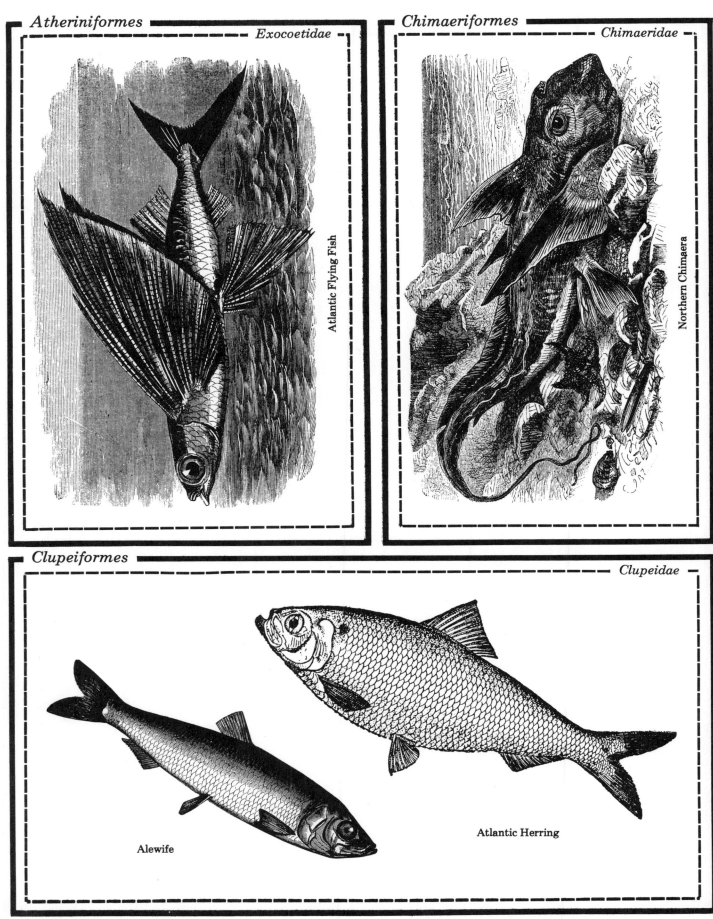

Atheriniformes — *Exocoetidae*

Atlantic Flying Fish

Chimaeriformes — *Chimaeridae*

Northern Chimaera

Clupeiformes — *Clupeidae*

Alewife

Atlantic Herring

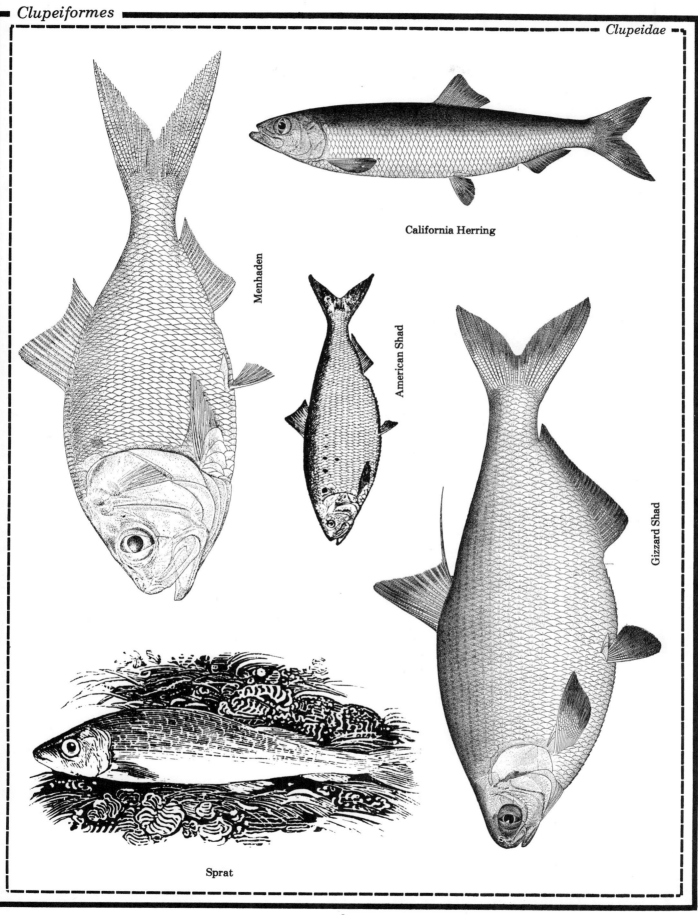

California Herring

Menhaden

American Shad

Gizzard Shad

Sprat

Clupeiformes

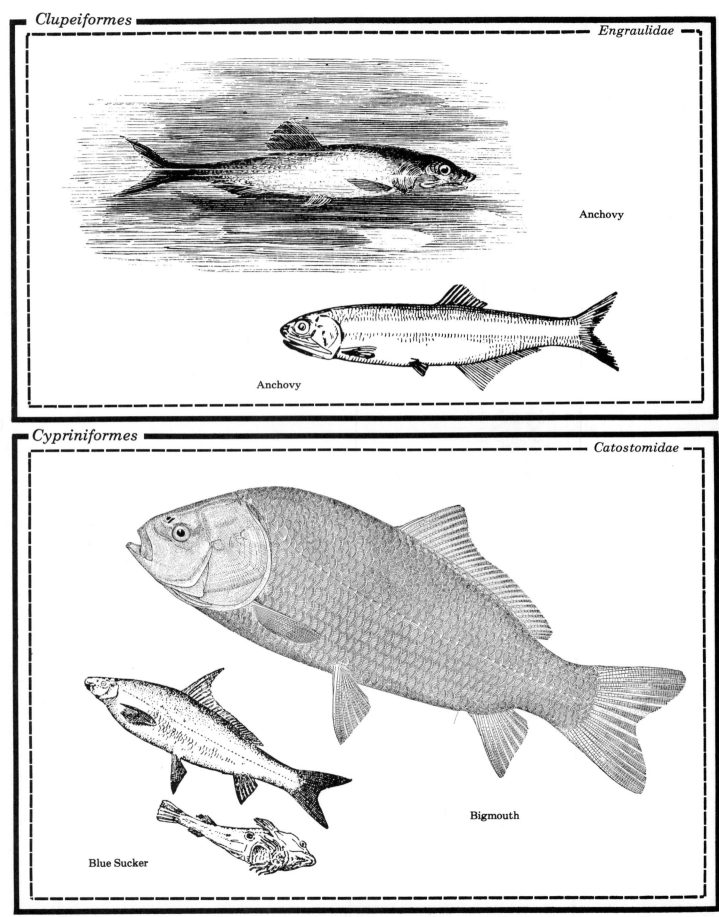

Anchovy

Anchovy

Cypriniformes

Bigmouth

Blue Sucker

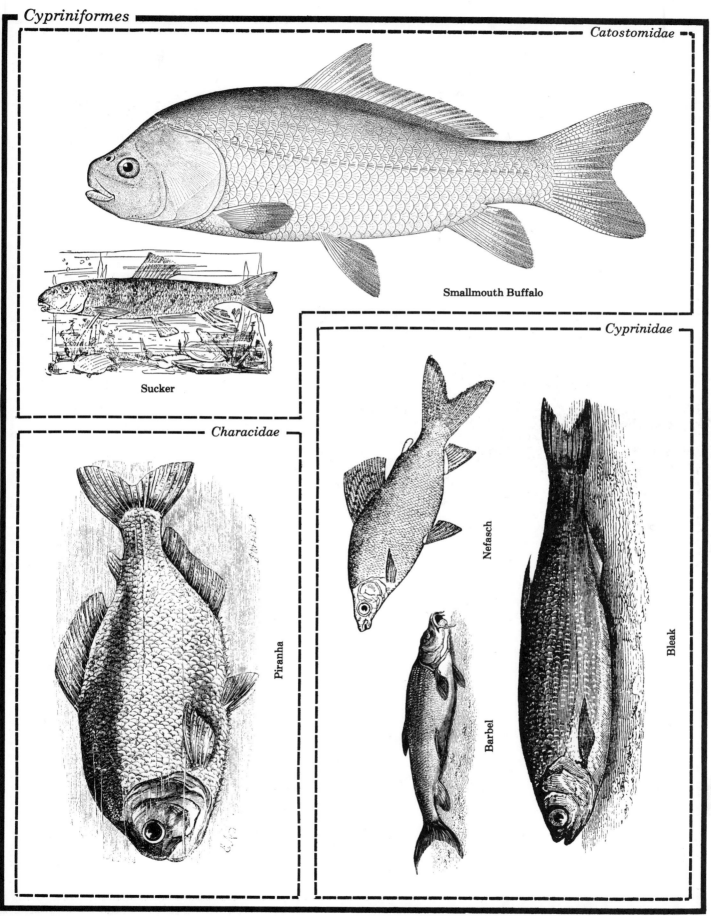

Cypriniformes

Catostomidae

Smallmouth Buffalo

Sucker

Cyprinidae

Nefasch

Bleak

Barbel

Characidae

Piranha

11

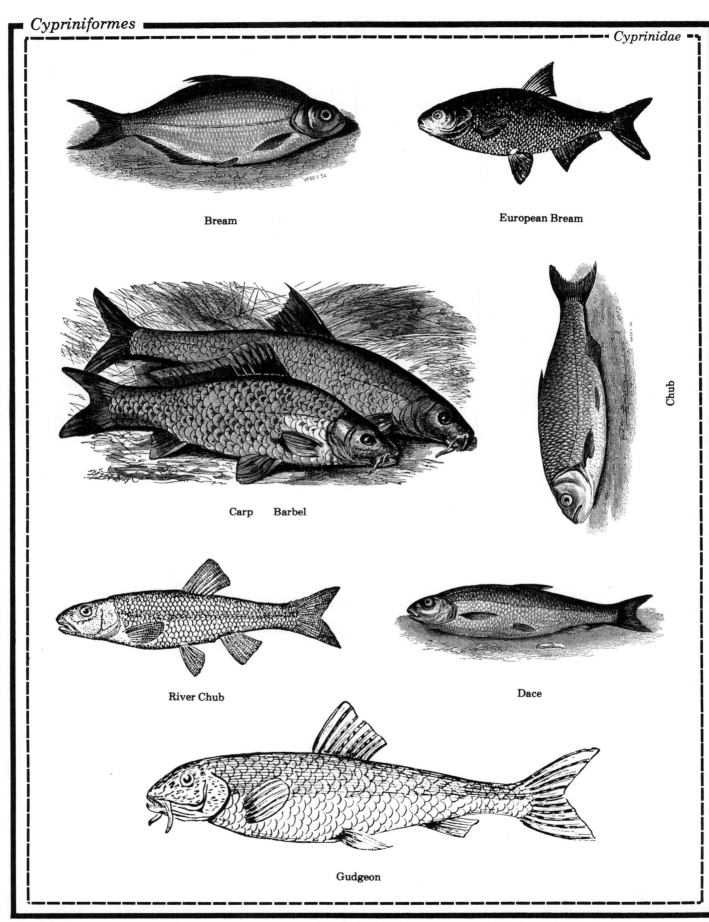

Bream

European Bream

Carp Barbel

Chub

River Chub

Dace

Gudgeon

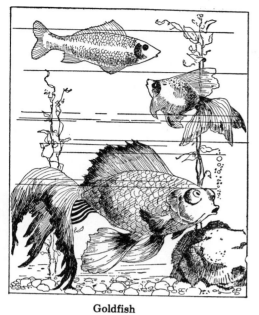

Goldfish

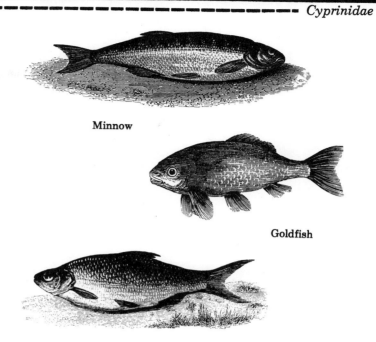

Minnow

Goldfish

Roach

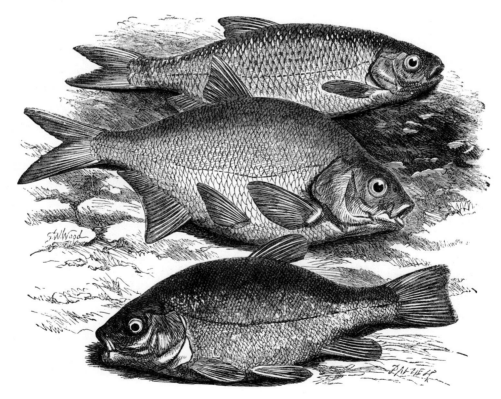

Roach

Bream

Tench

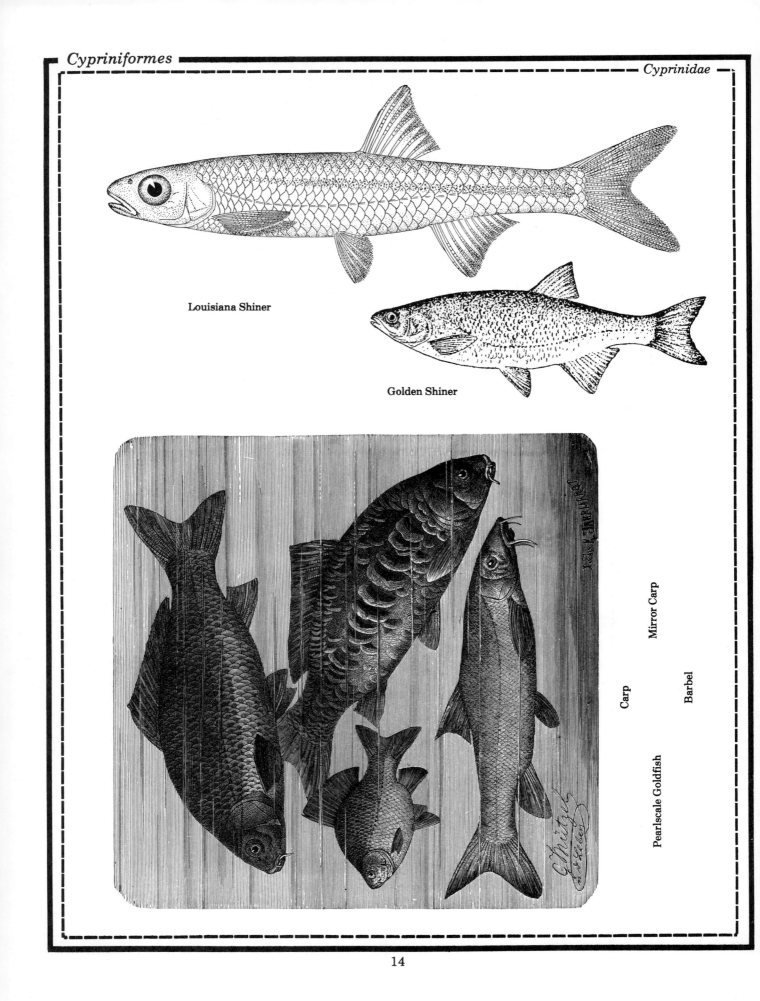

Louisiana Shiner

Golden Shiner

Pearlscale Goldfish

Carp

Mirror Carp

Barbel

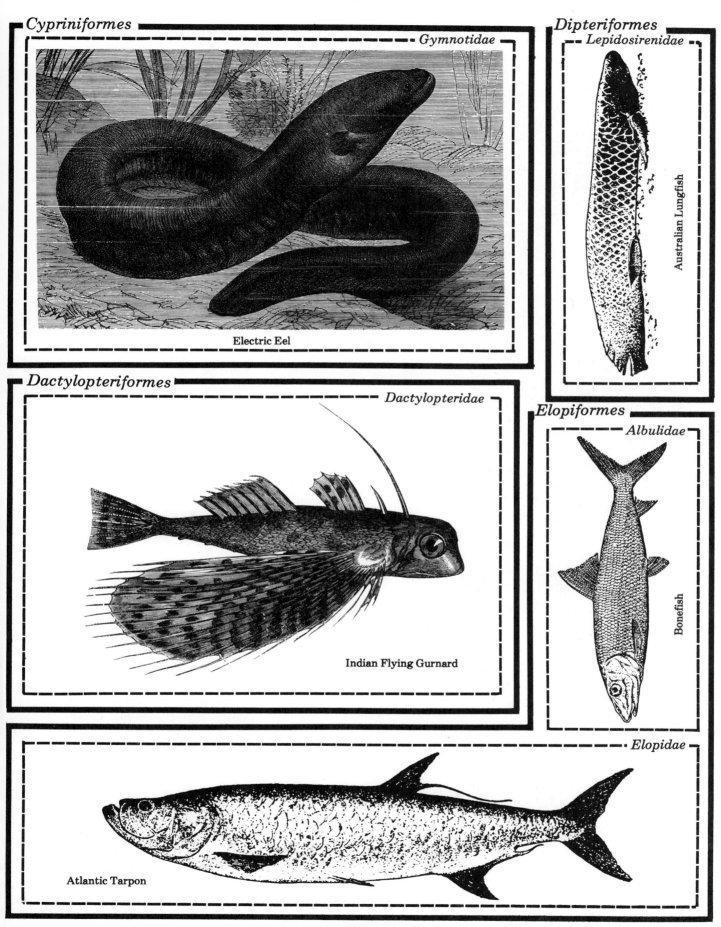

Cypriniformes

Gymnotidae

Electric Eel

Dipteriformes

Lepidosirenidae

Australian Lungfish

Dactylopteriformes

Dactylopteridae

Indian Flying Gurnard

Elopiformes

Albulidae

Bonefish

Elopidae

Atlantic Tarpon

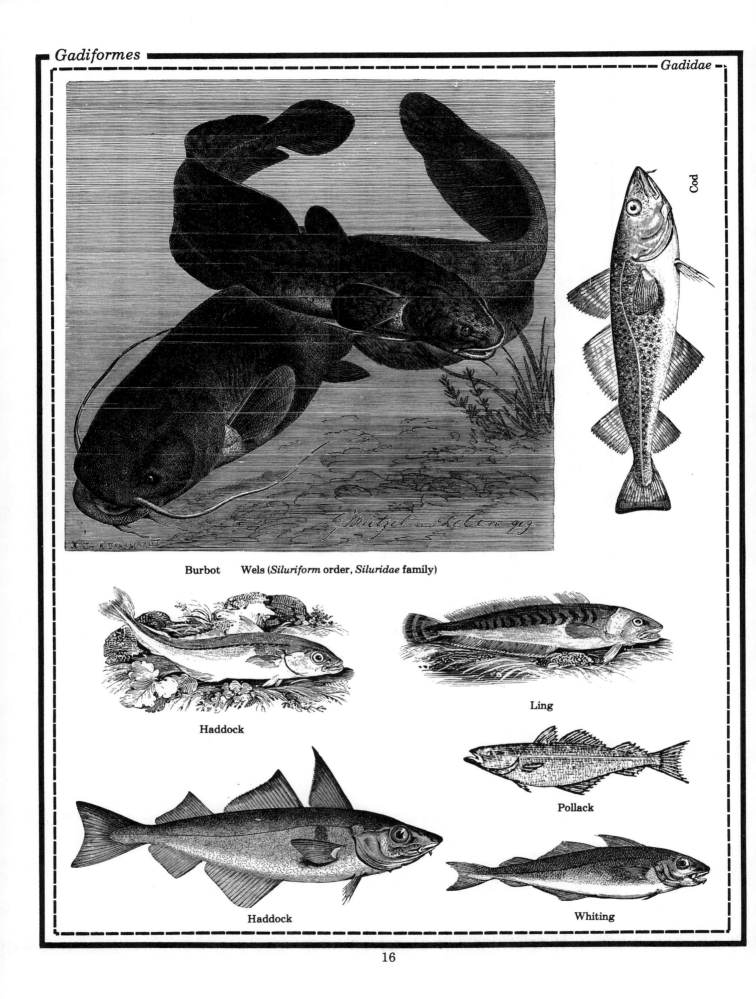

Cod

Burbot Wels (*Siluriform* order, *Siluridae* family)

Haddock

Ling

Pollack

Haddock

Whiting

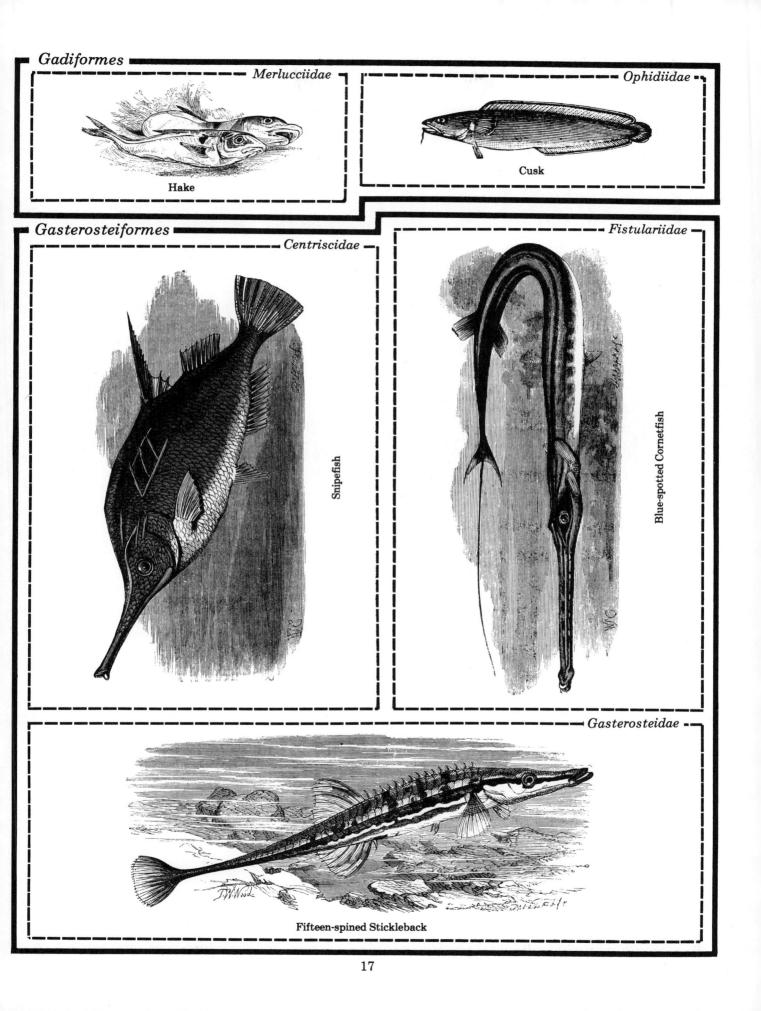

Gadiformes

Merlucciidae

Hake

Ophidiidae

Cusk

Gasterosteiformes

Centriscidae

Snipefish

Fistulariidae

Blue-spotted Cornetfish

Gasterosteidae

Fifteen-spined Stickleback

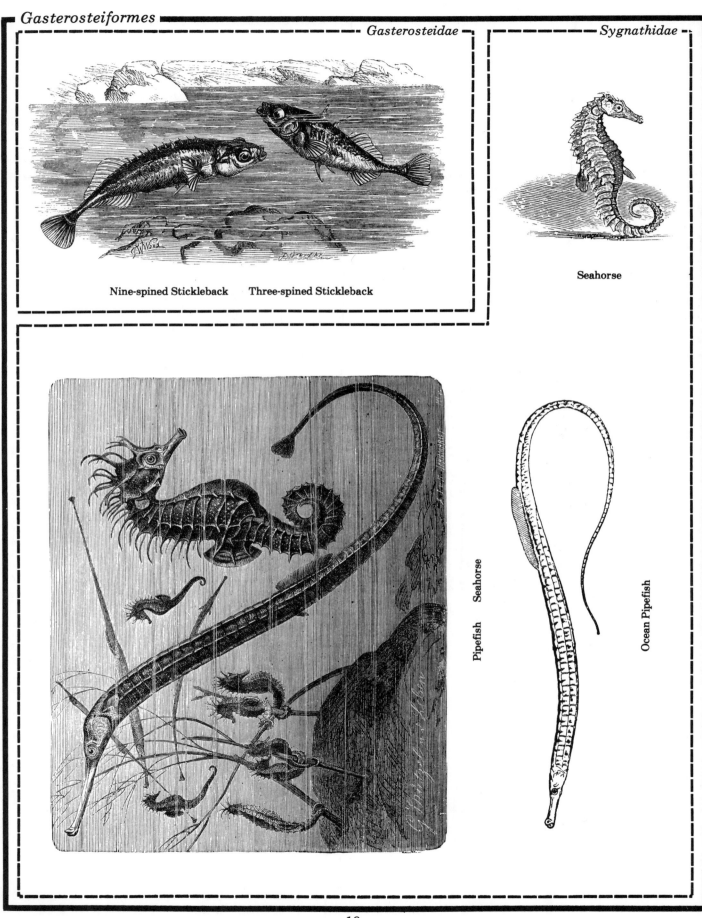

Gasterosteidae

Sygnathidae

Seahorse

Nine-spined Stickleback Three-spined Stickleback

Pipefish Seahorse

Ocean Pipefish

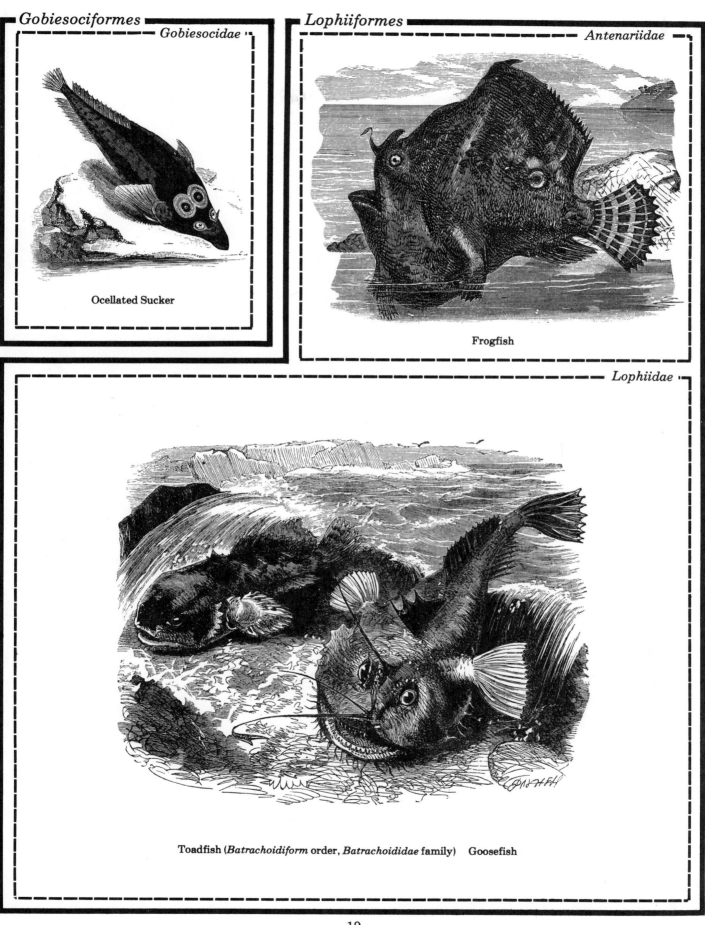

Gobiesociformes

Gobiesocidae

Ocellated Sucker

Lophiiformes

Antenariidae

Frogfish

Lophiidae

Toadfish (*Batrachoidiform* order, *Batrachoididae* family) Goosefish

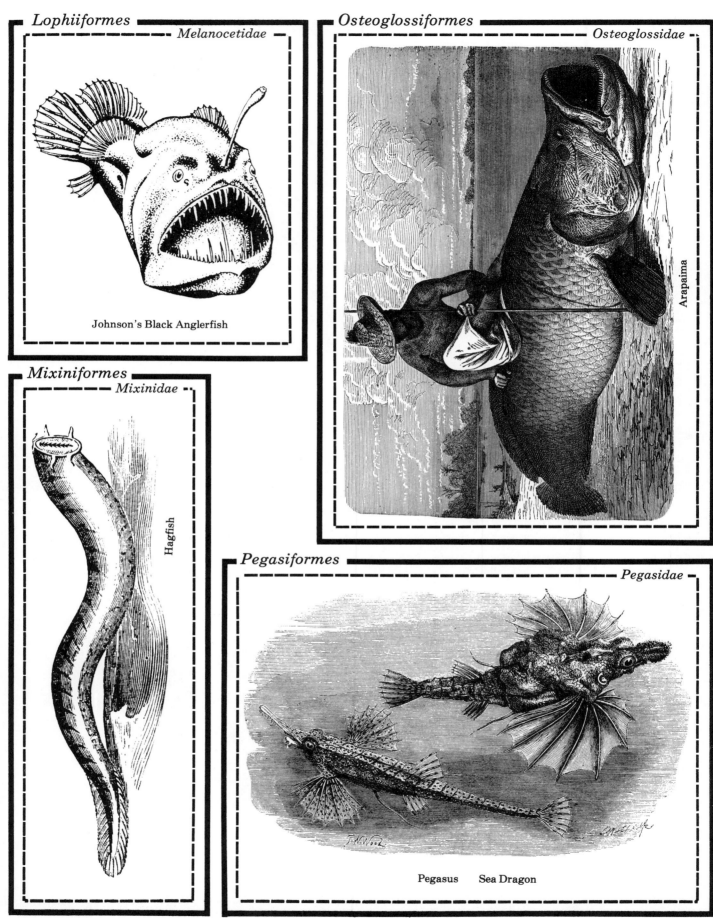

Lophiiformes
Melanocetidae

Johnson's Black Anglerfish

Mixiniformes
Mixinidae

Hagfish

Osteoglossiformes
Osteoglossidae

Arapaima

Pegasiformes
Pegasidae

Pegasus Sea Dragon

Perciformes

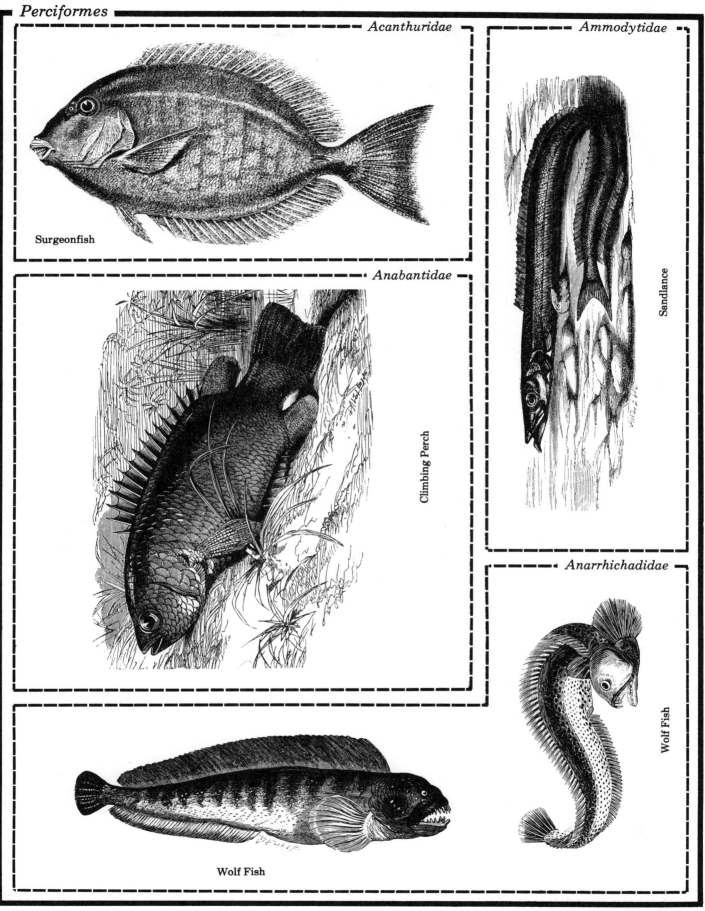

Acanthuridae

Surgeonfish

Ammodytidae

Sandlance

Anabantidae

Climbing Perch

Anarrhichadidae

Wolf Fish

Wolf Fish

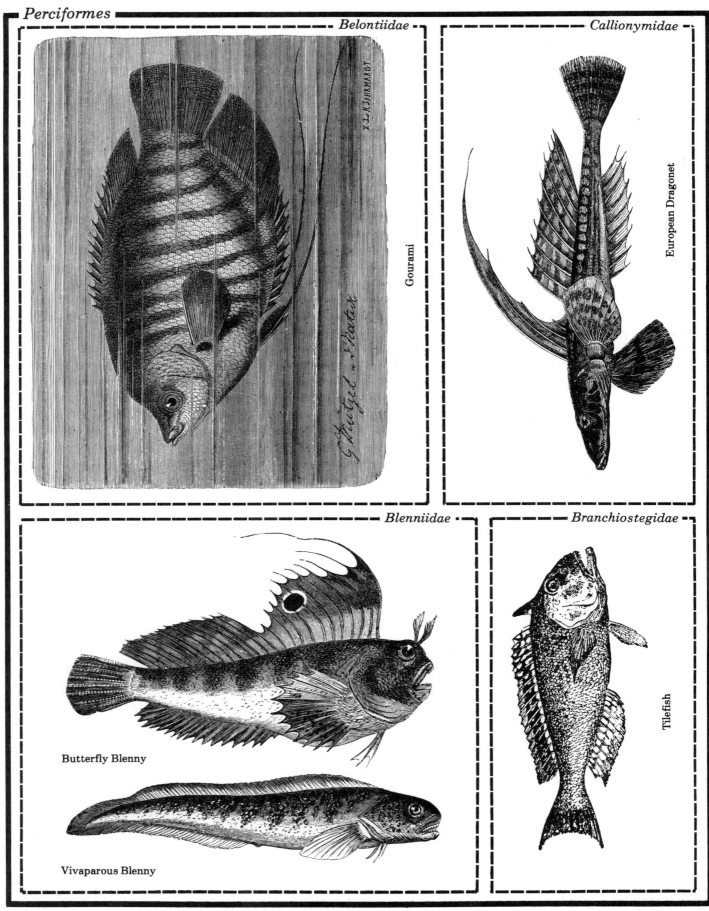

Belontiidae

Gourami

Callionymidae

European Dragonet

Blenniidae

Butterfly Blenny

Vivaparous Blenny

Branchiostegidae

Tilefish

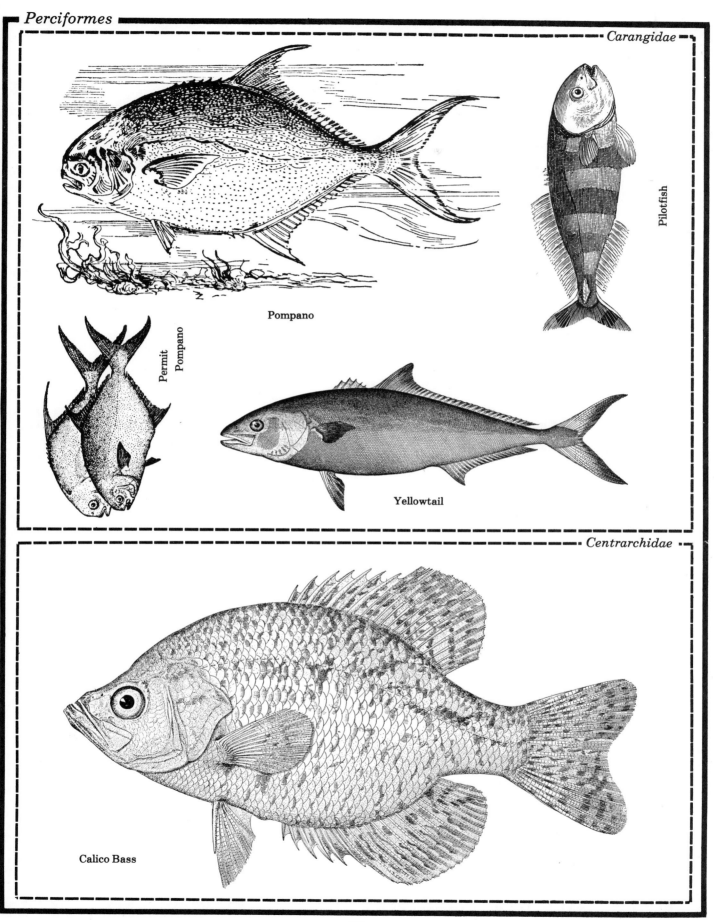

Carangidae

Pilotfish

Pompano

Permit Pompano

Yellowtail

Centrarchidae

Calico Bass

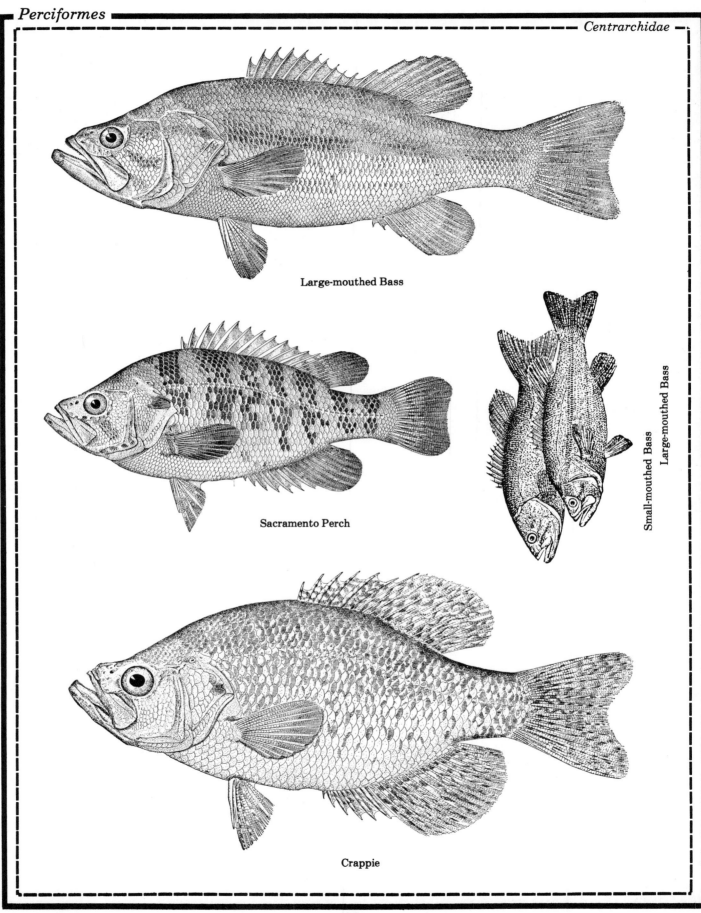

Large-mouthed Bass

Sacramento Perch

Small-mouthed Bass

Large-mouthed Bass

Crappie

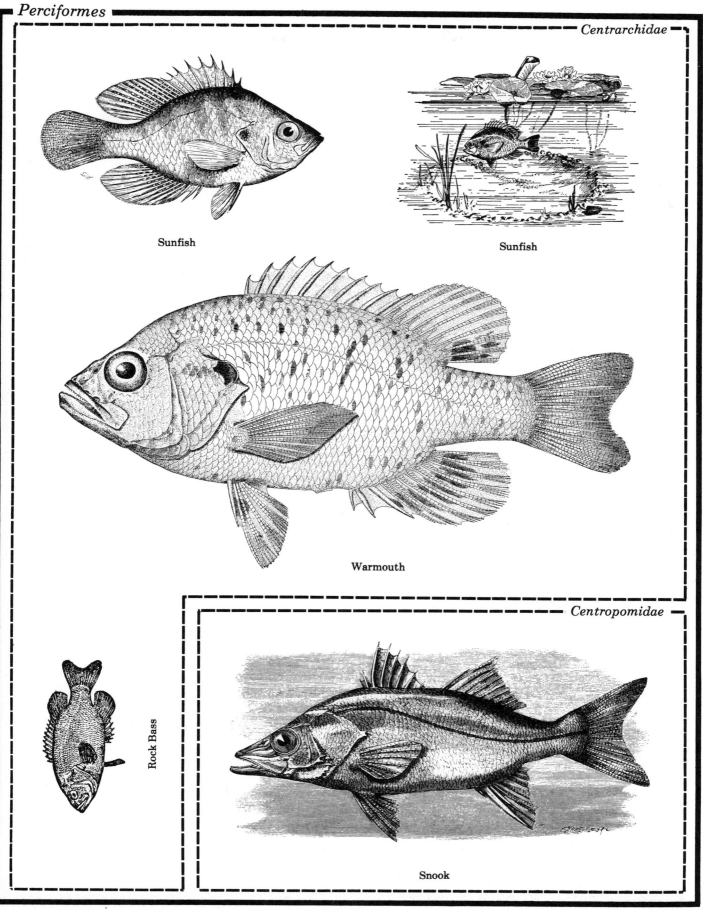

Sunfish

Sunfish

Warmouth

Rock Bass

Centropomidae

Snook

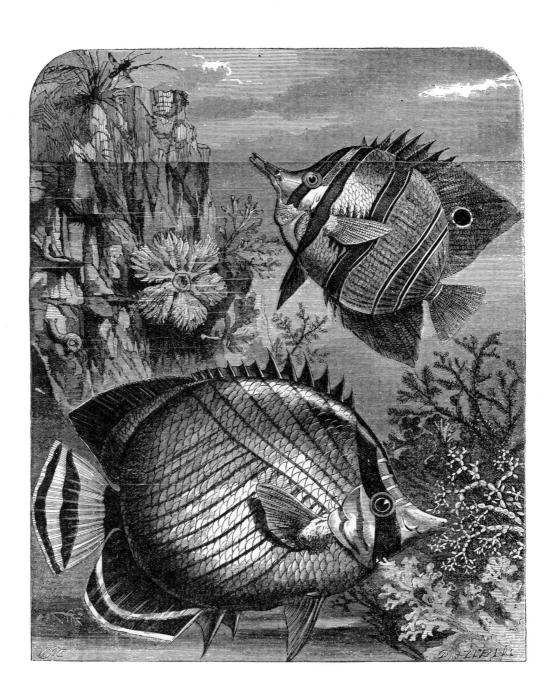

Copperband Butterflyfish

Wandering Butterflyfish

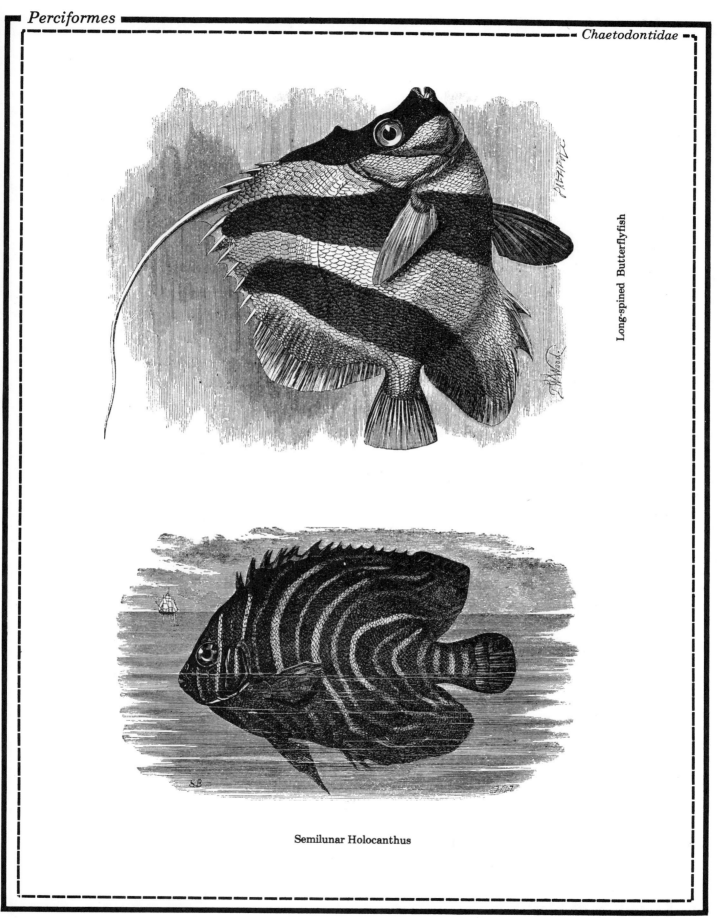

Long-spined Butterflyfish

Semilunar Holocanthus

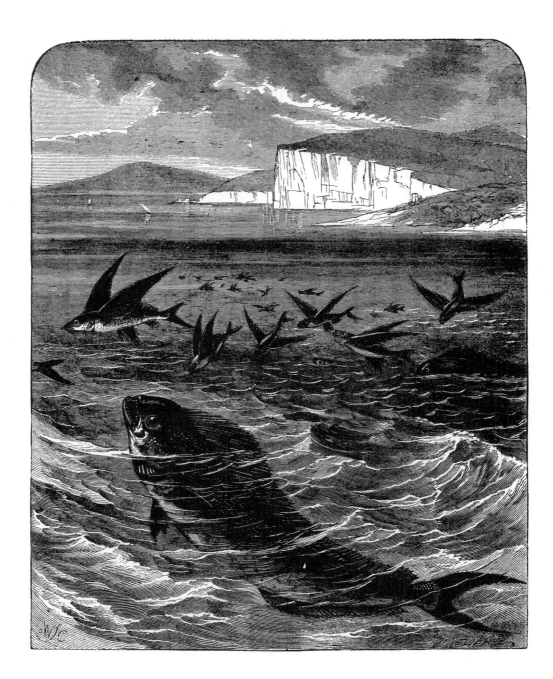

Dolphin

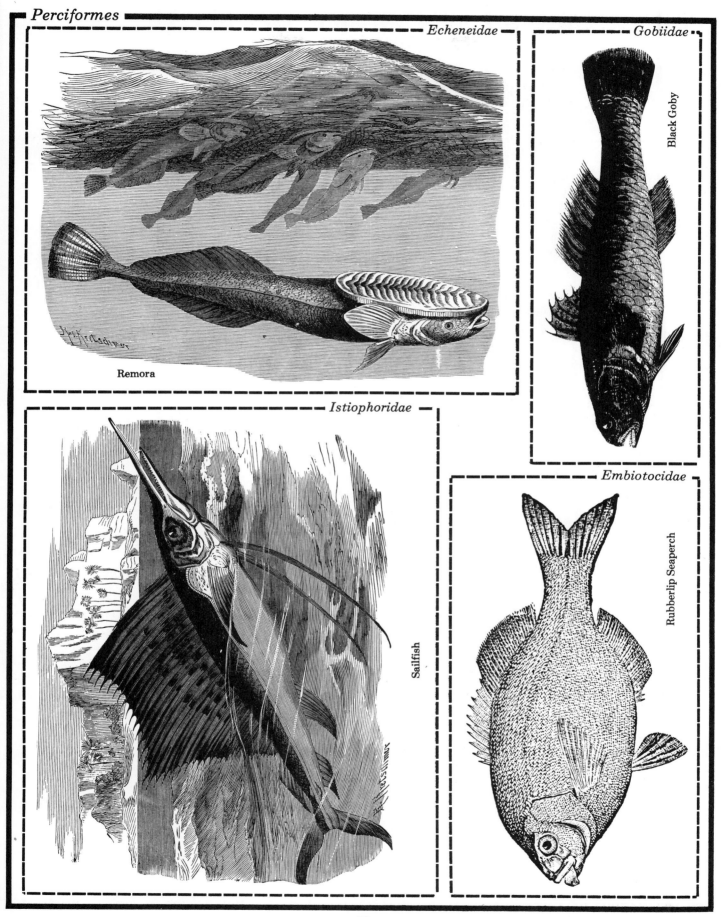

Perciformes

Echeneidae

Gobiidae

Black Goby

Remora

Istiophoridae

Sailfish

Embiotocidae

Rubberlip Seaperch

29

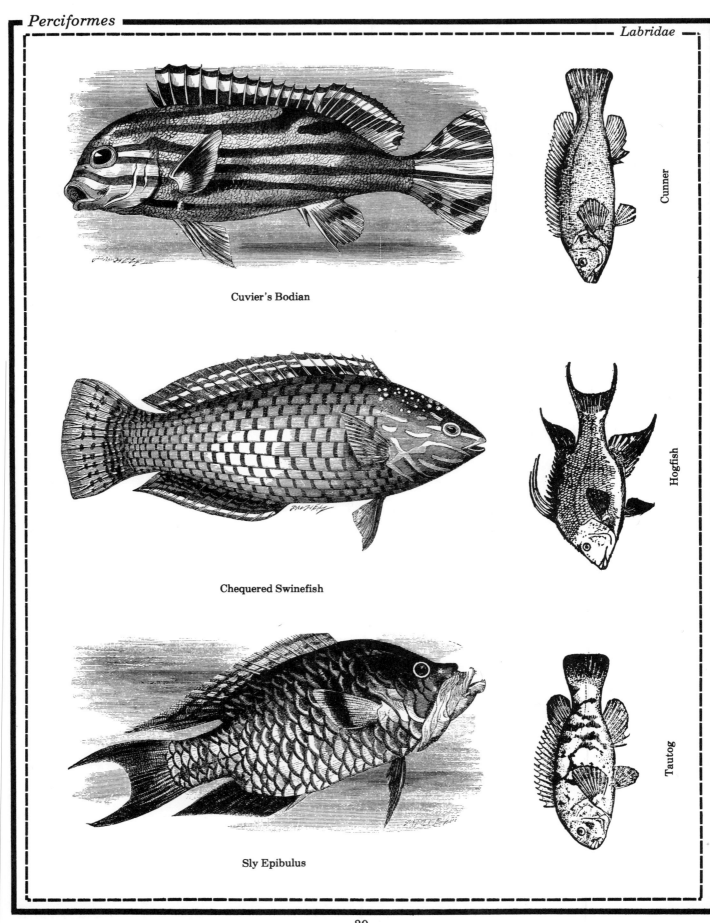

Cunner

Cuvier's Bodian

Hogfish

Chequered Swinefish

Tautog

Sly Epibulus

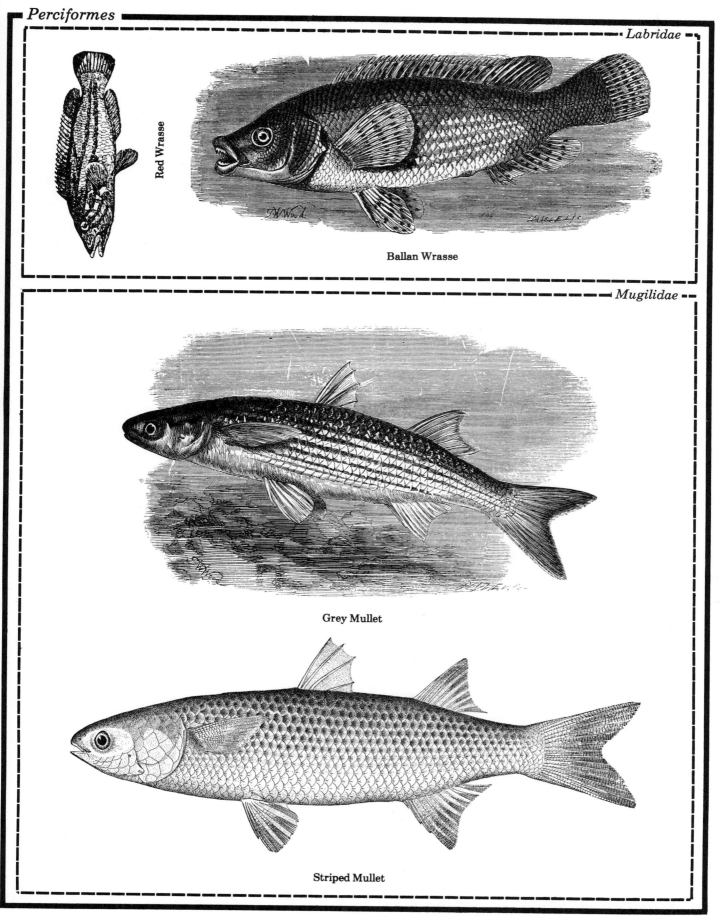

Red Wrasse

Ballan Wrasse

Grey Mullet

Striped Mullet

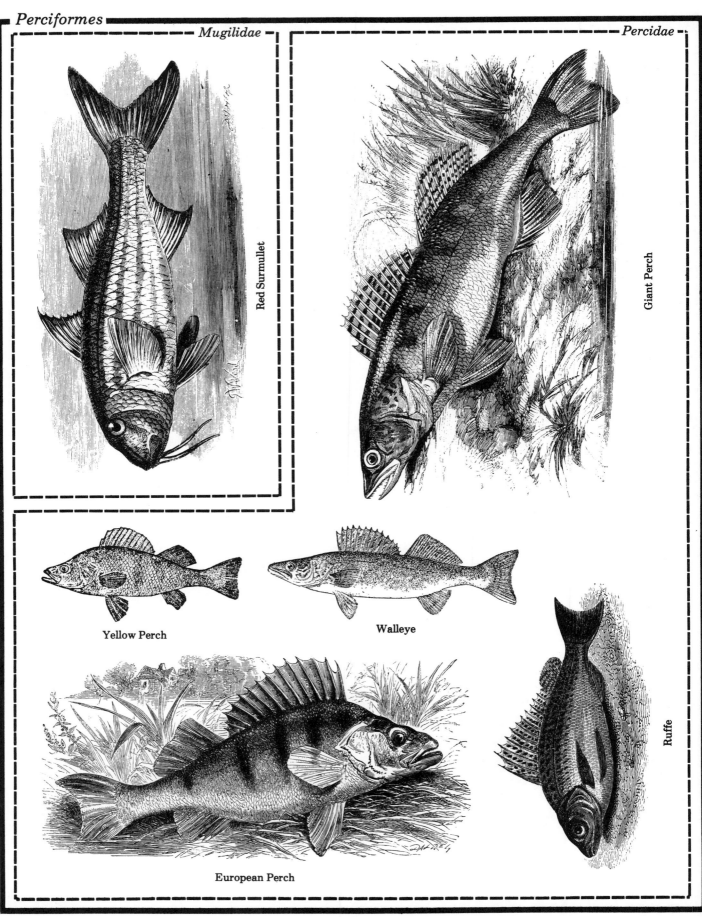

Perciformes

Mugilidae

Percidae

Red Surmullet

Giant Perch

Yellow Perch

Walleye

Ruffe

European Perch

Perciformes

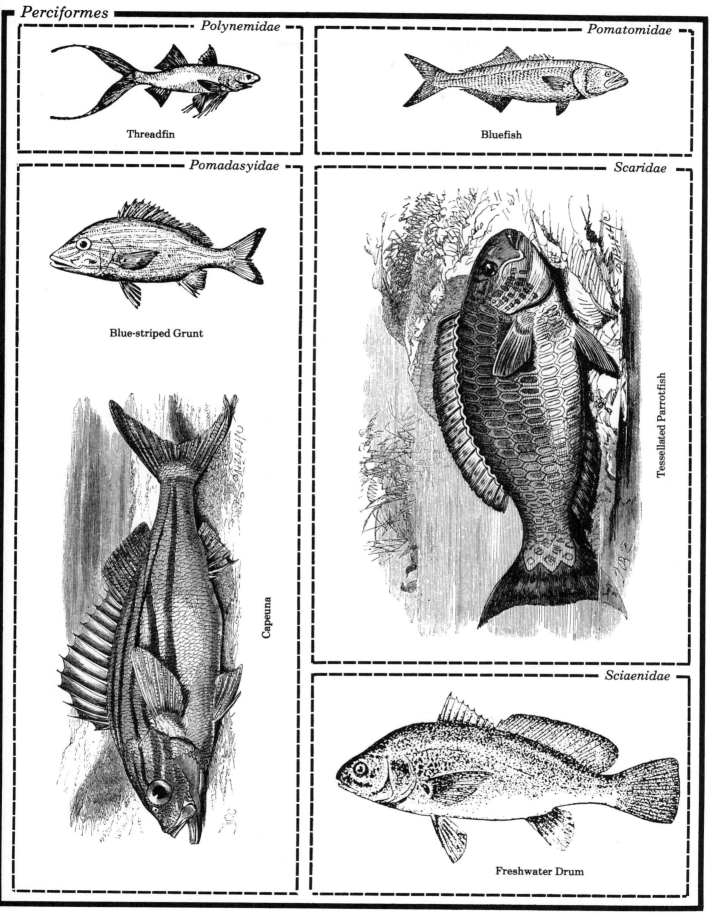

Polynemidae

Threadfin

Pomatomidae

Bluefish

Pomadasyidae

Blue-striped Grunt

Capeuna

Scaridae

Tessellated Parrotfish

Sciaenidae

Freshwater Drum

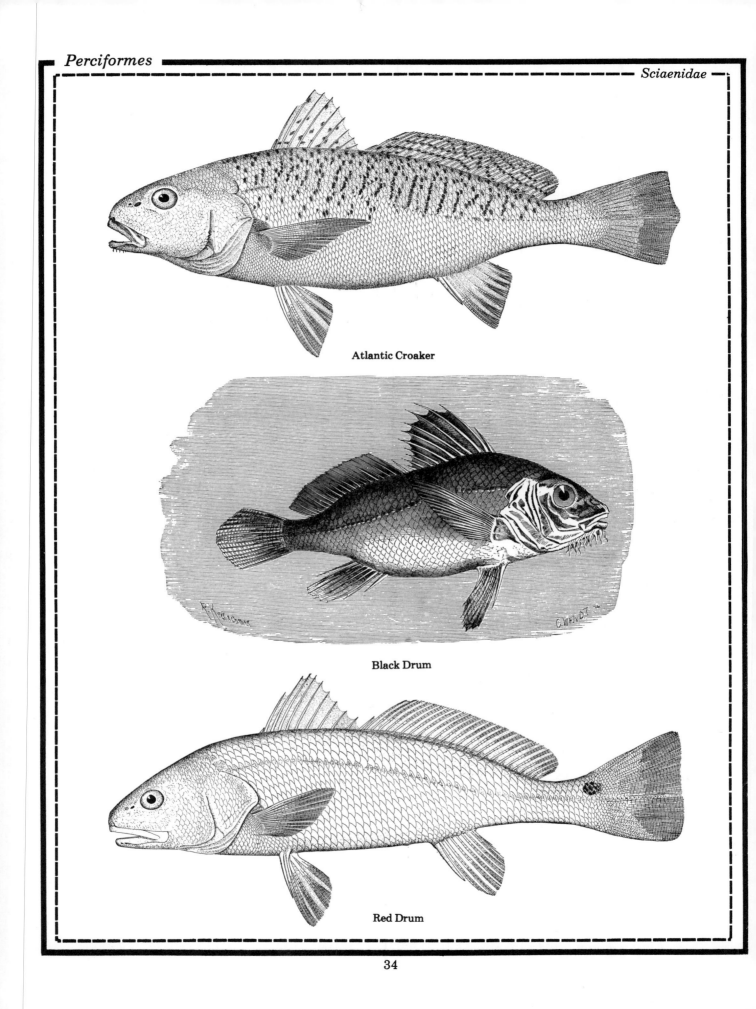

Atlantic Croaker

Black Drum

Red Drum

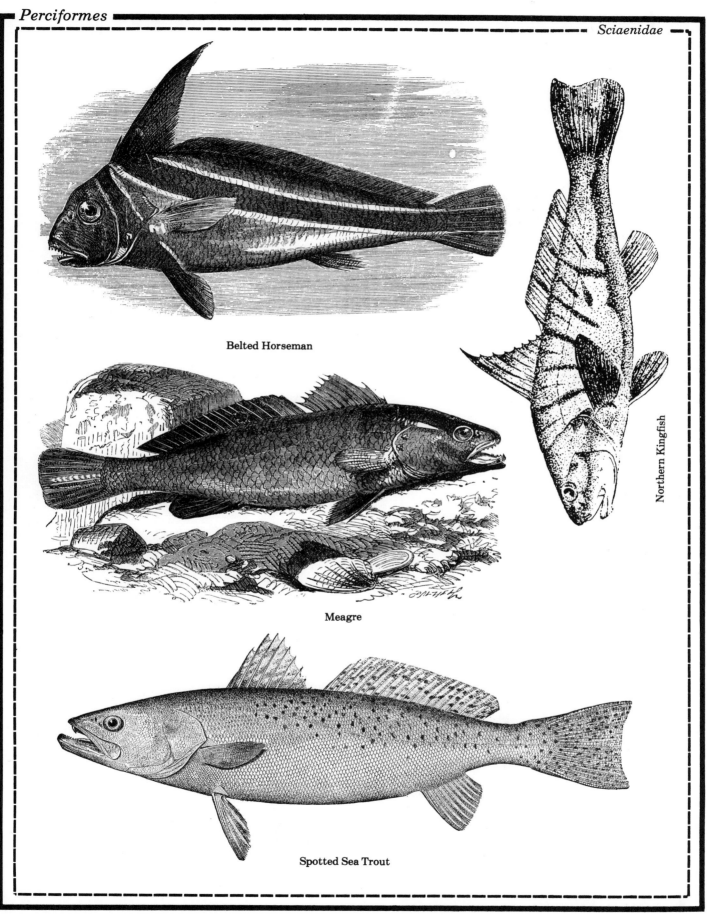

Belted Horseman

Northern Kingfish

Meagre

Spotted Sea Trout

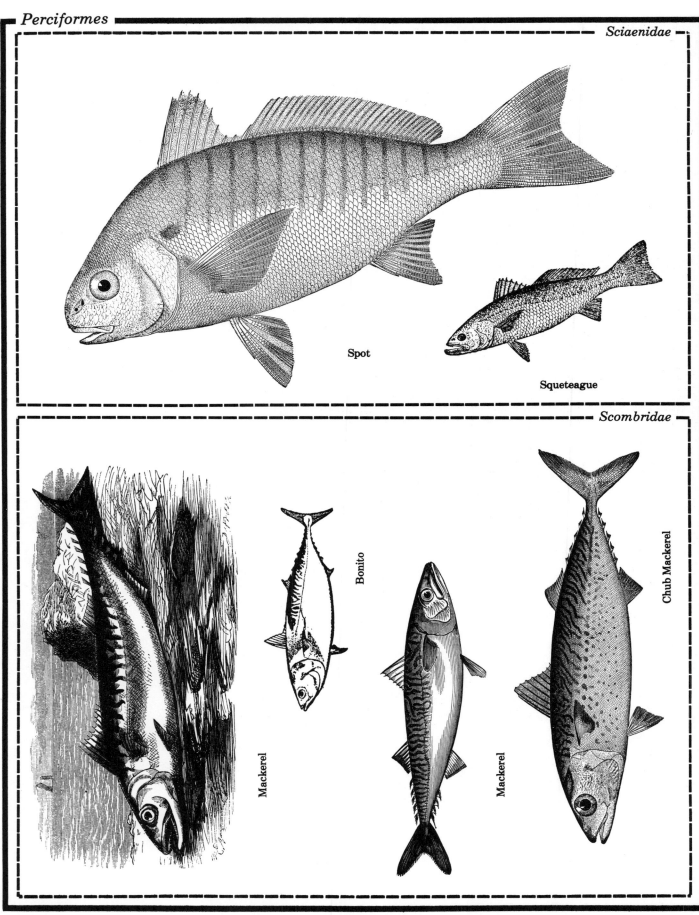

Spot

Squeteague

Bonito

Chub Mackerel

Mackerel

Mackerel

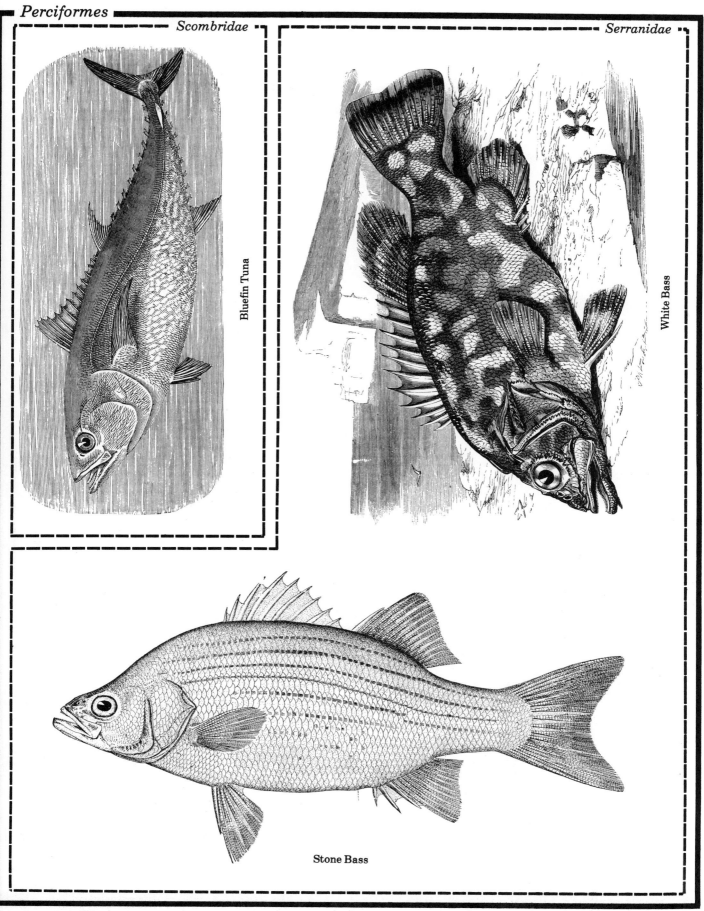

Perciformes

Scombridae

Bluefin Tuna

Serranidae

White Bass

Stone Bass

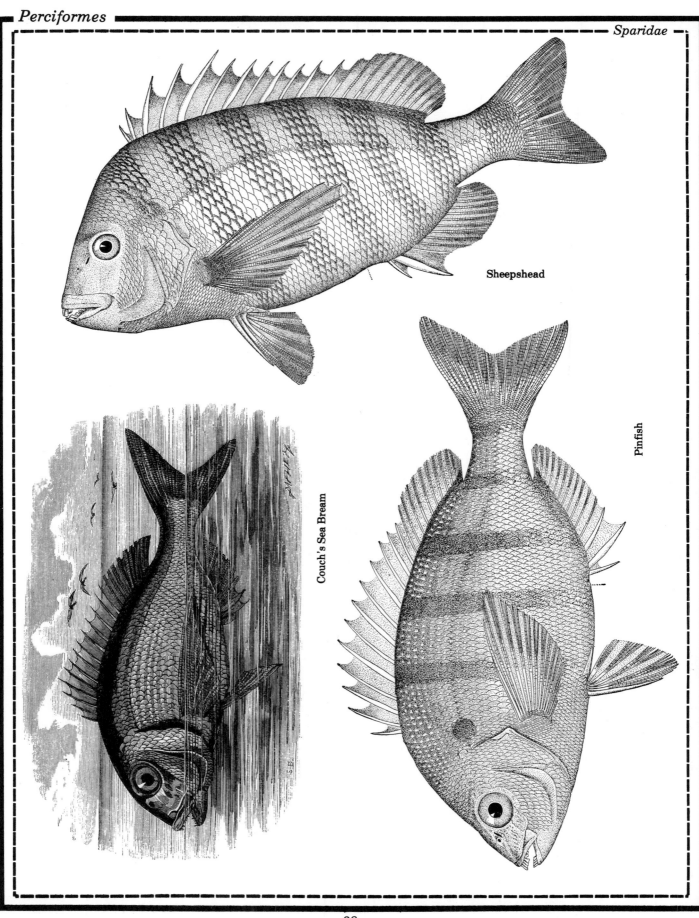

Sheepshead

Pinfish

Couch's Sea Bream

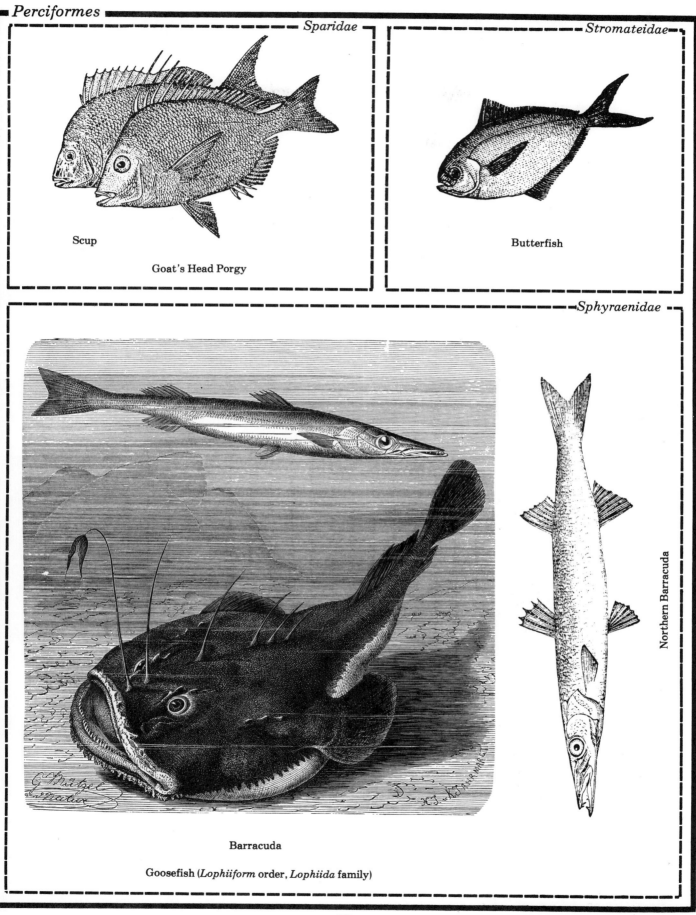

Perciformes

Sparidae

Scup

Goat's Head Porgy

Stromateidae

Butterfish

Sphyraenidae

Northern Barracuda

Barracuda

Goosefish (*Lophiiform* order, *Lophiida* family)

Archerfish

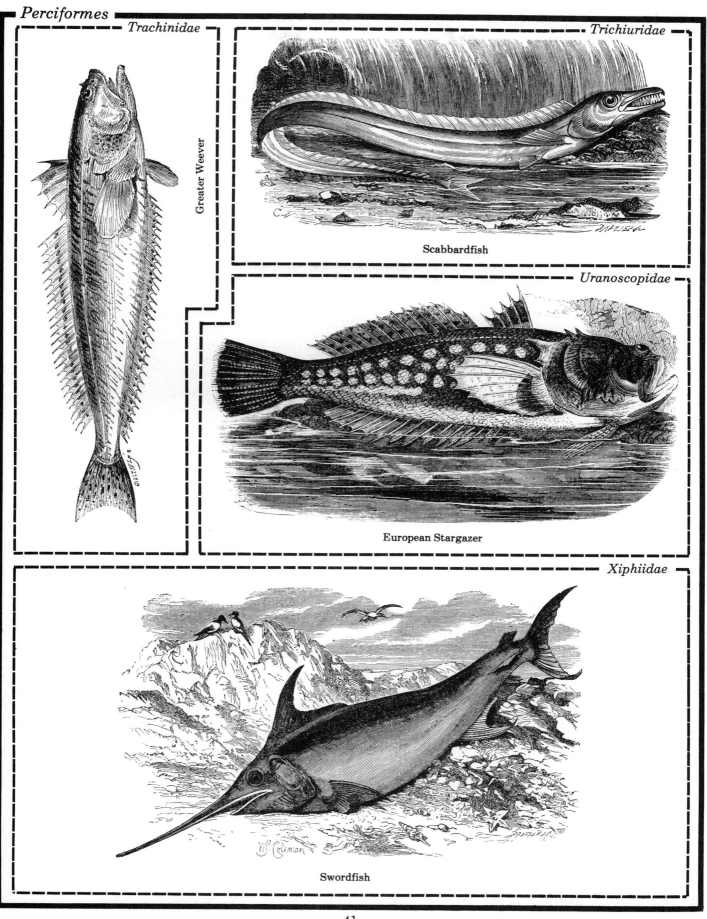

Perciformes

Trachinidae

Trichiuridae

Greater Weever

Scabbardfish

Uranoscopidae

European Stargazer

Xiphiidae

Swordfish

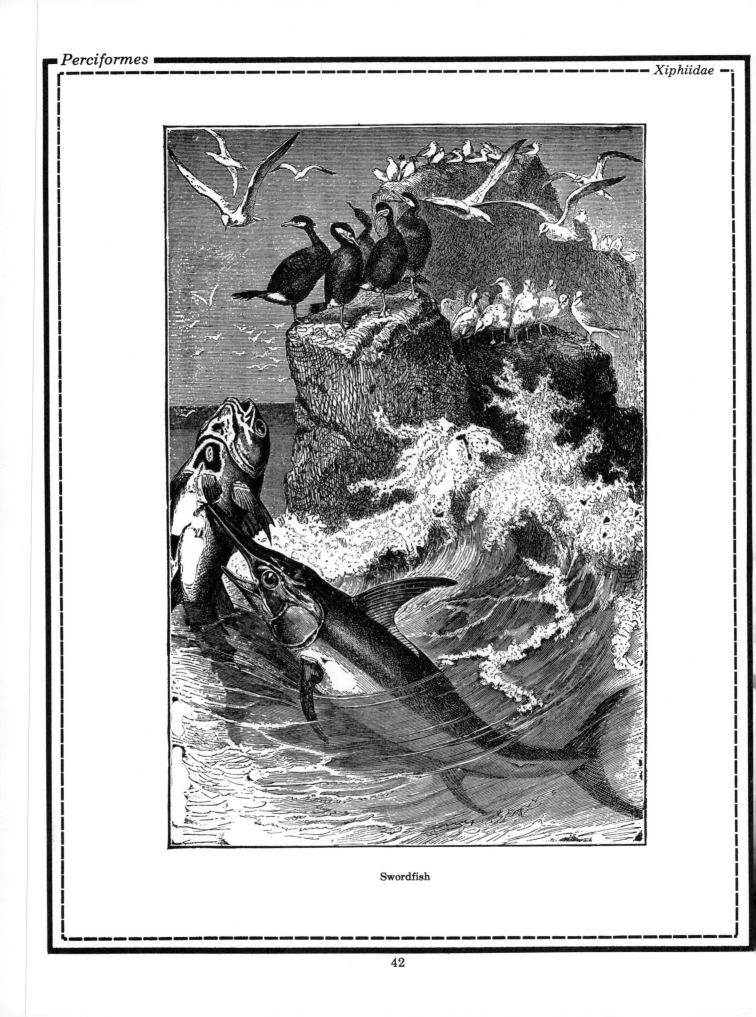

Swordfish

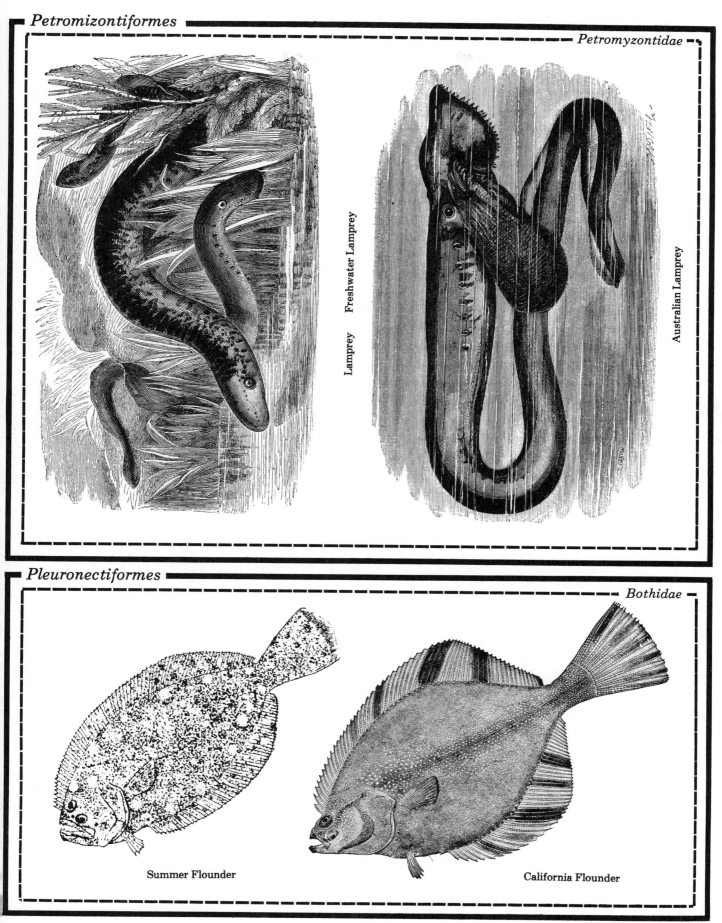

Petromizontiformes ━━ *Petromyzontidae*

Lamprey Freshwater Lamprey

Australian Lamprey

Pleuronectiformes ━━ *Bothidae*

Summer Flounder

California Flounder

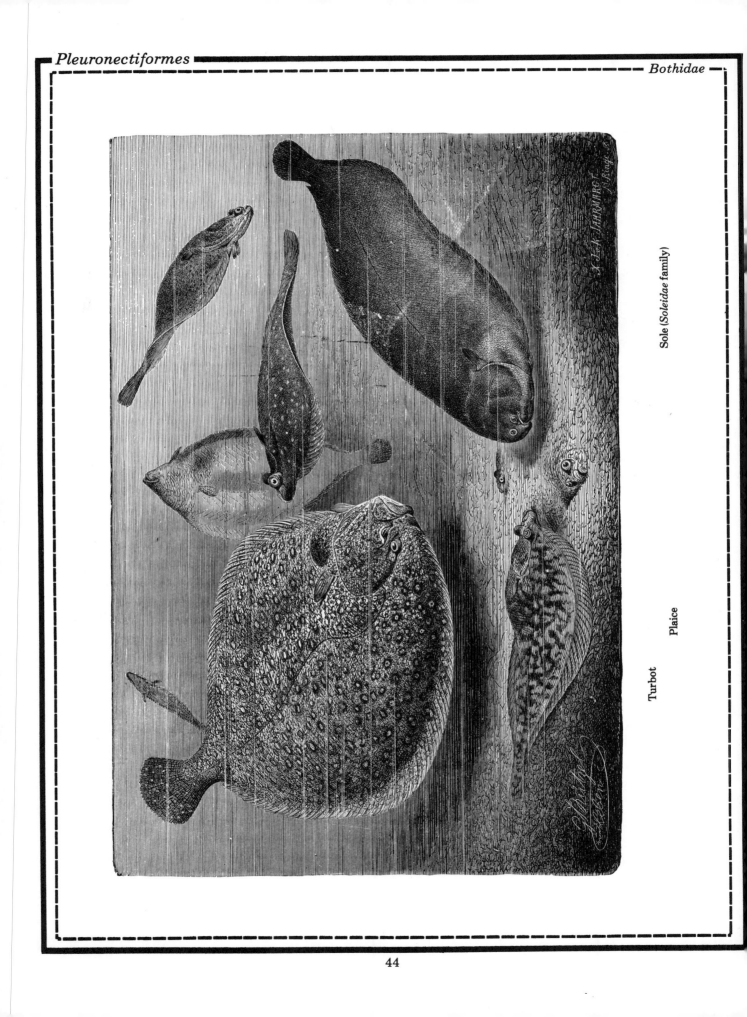

Sole (*Soleidae* family)

Turbot

Plaice

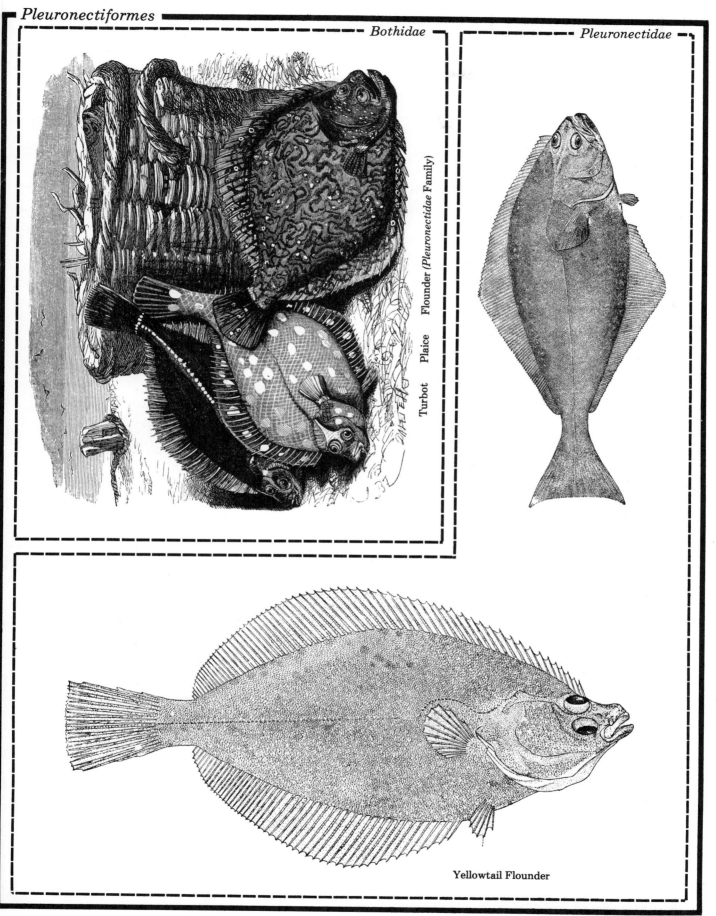

Pleuronectiformes

Bothidae

Pleuronectidae

Turbot Plaice Flounder (Pleuronectidae Family)

Yellowtail Flounder

45

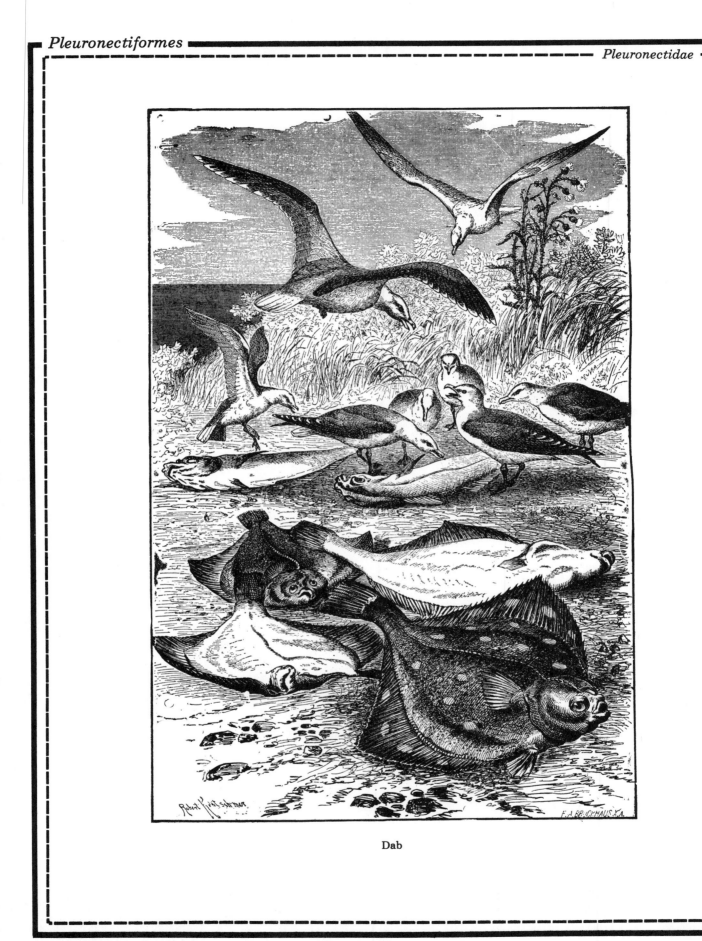

Dab

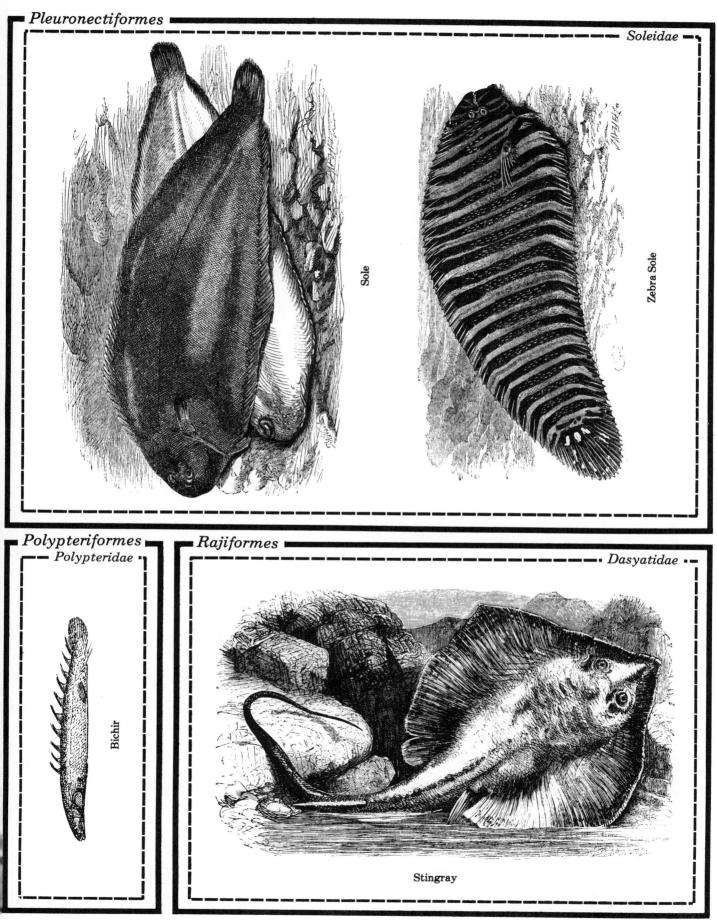

Pleuronectiformes

Soleidae

Sole

Zebra Sole

Polypteriformes

Polypteridae

Bichir

Rajiformes

Dasyatidae

Stingray

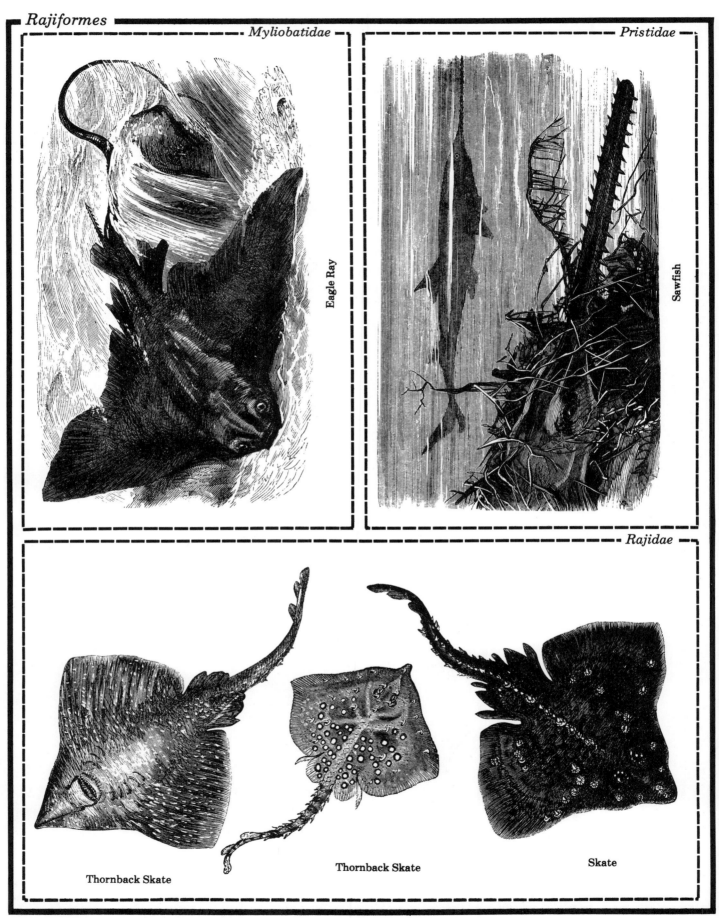

Myliobatidae

Pristidae

Eagle Ray

Sawfish

Rajidae

Thornback Skate

Thornback Skate

Skate

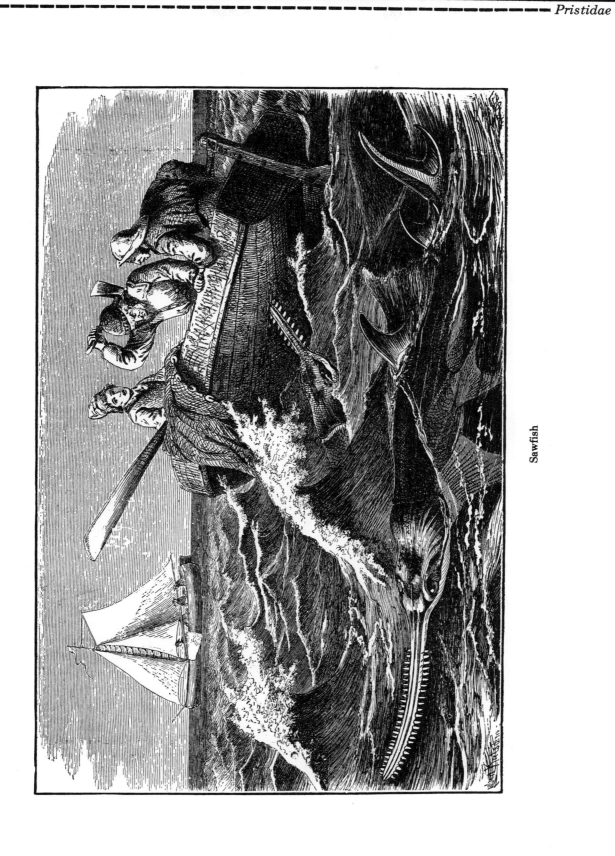

Sawfish

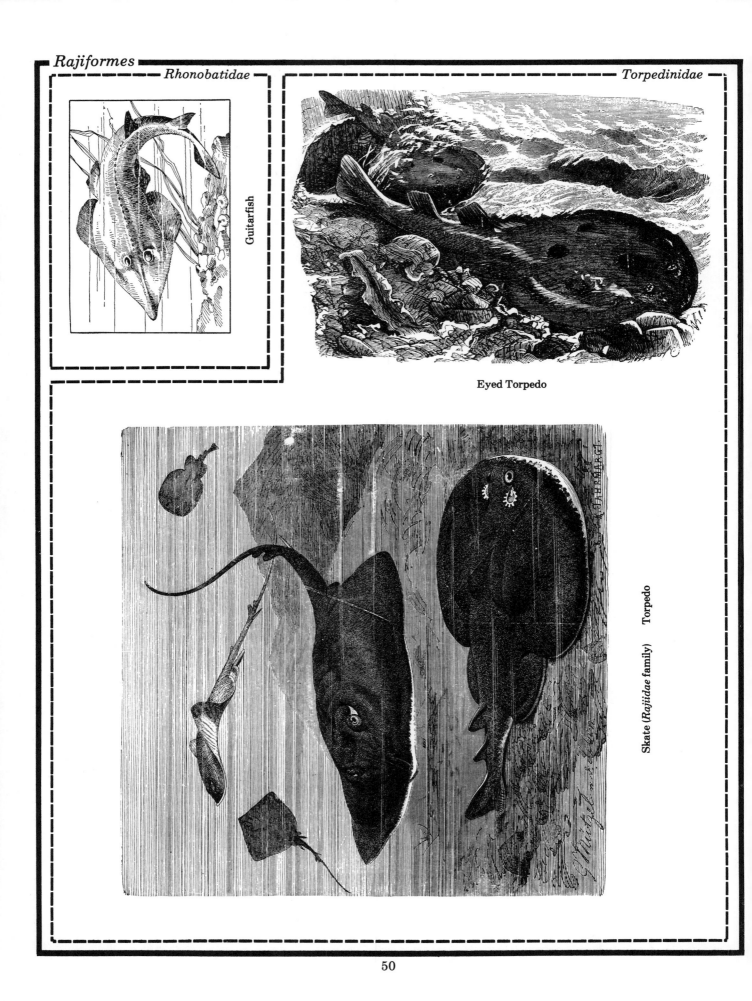

Rhonobatidae

Torpedinidae

Guitarfish

Eyed Torpedo

Skate (*Rajiidae* family) Torpedo

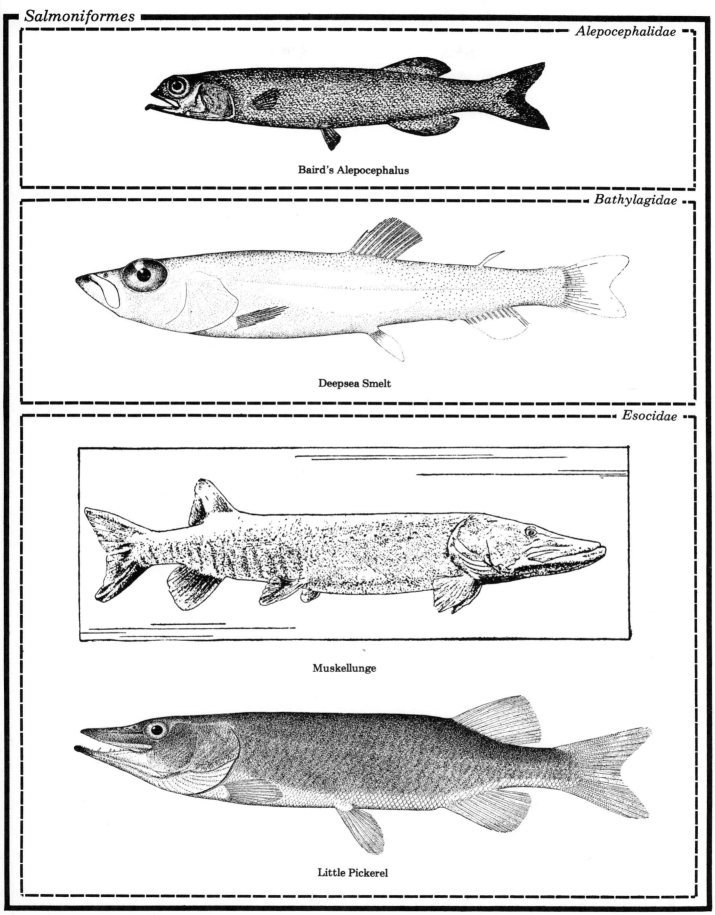

Alepocephalidae

Baird's Alepocephalus

Bathylagidae

Deepsea Smelt

Esocidae

Muskellunge

Little Pickerel

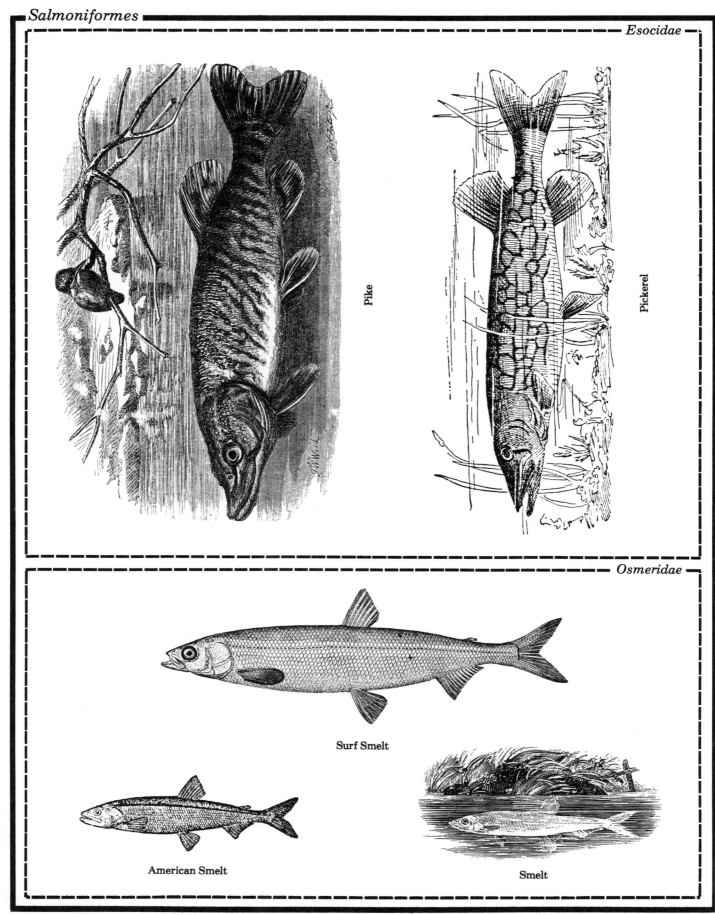

Pike

Pickerel

Surf Smelt

American Smelt

Smelt

Chum

Cisco

Grayling

Inconnu

Pink Salmon

VASEY S.C.

Atlantic Salmon

Chinook Salmon

Chinook Salmon, young

53

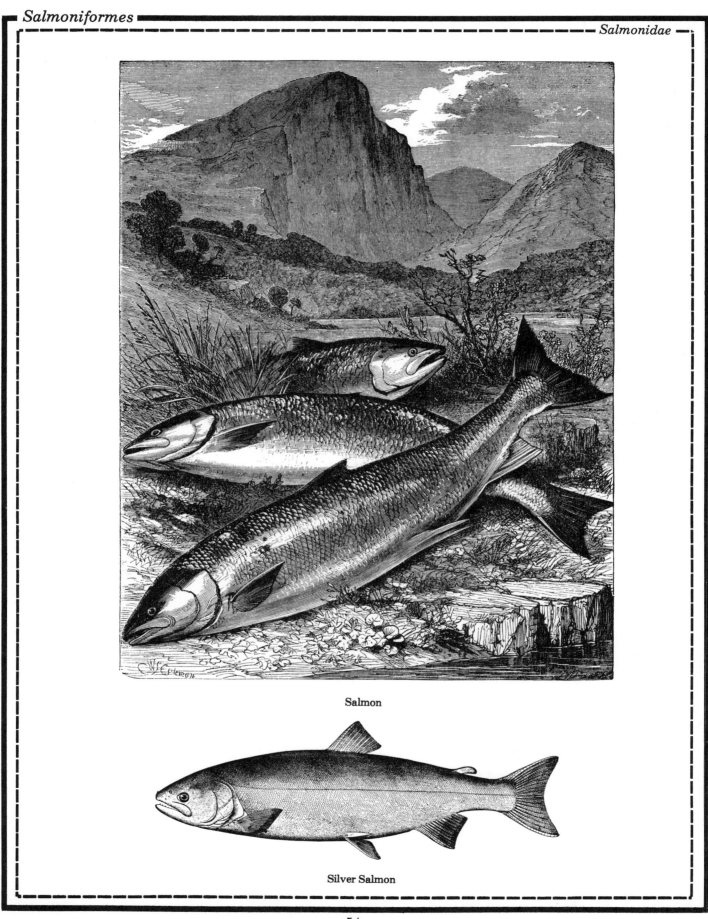

Salmon

Silver Salmon

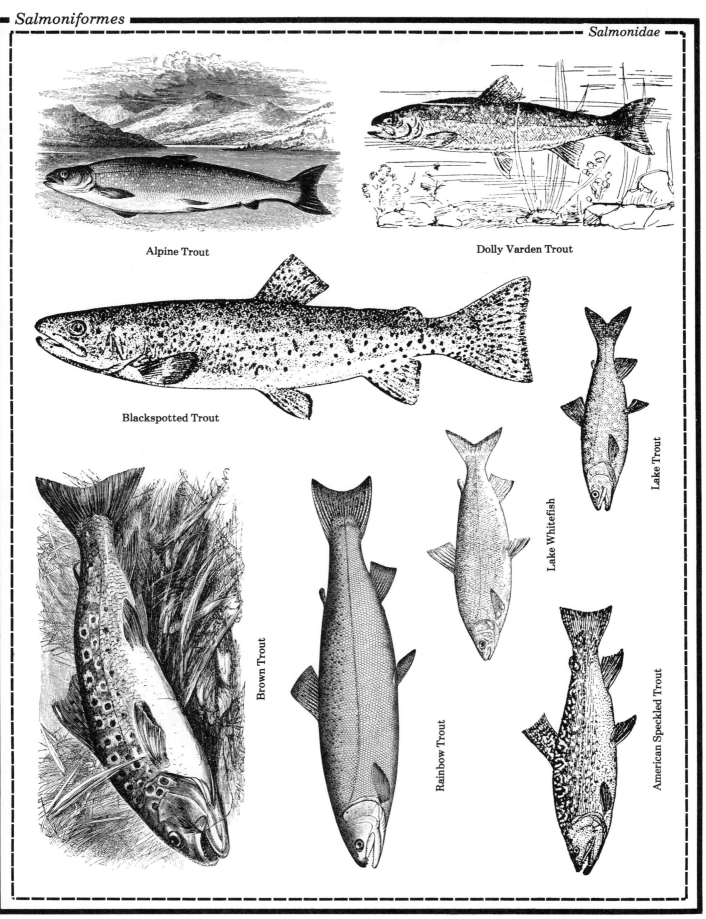

Alpine Trout

Dolly Varden Trout

Blackspotted Trout

Lake Trout

Brown Trout

Lake Whitefish

Rainbow Trout

American Speckled Trout

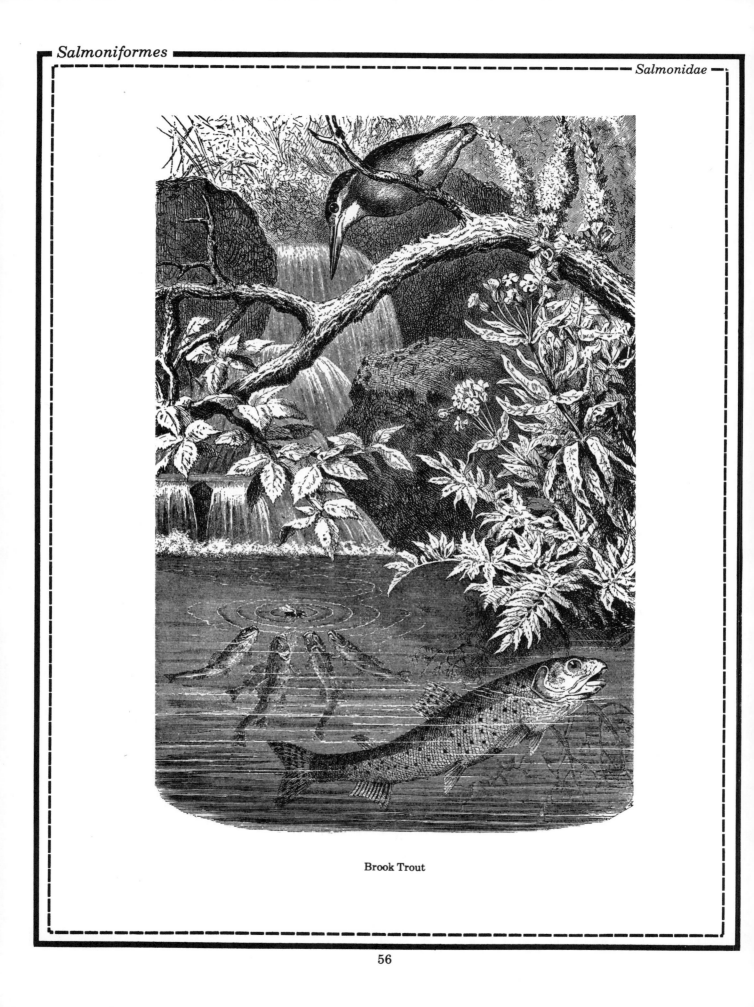

Brook Trout

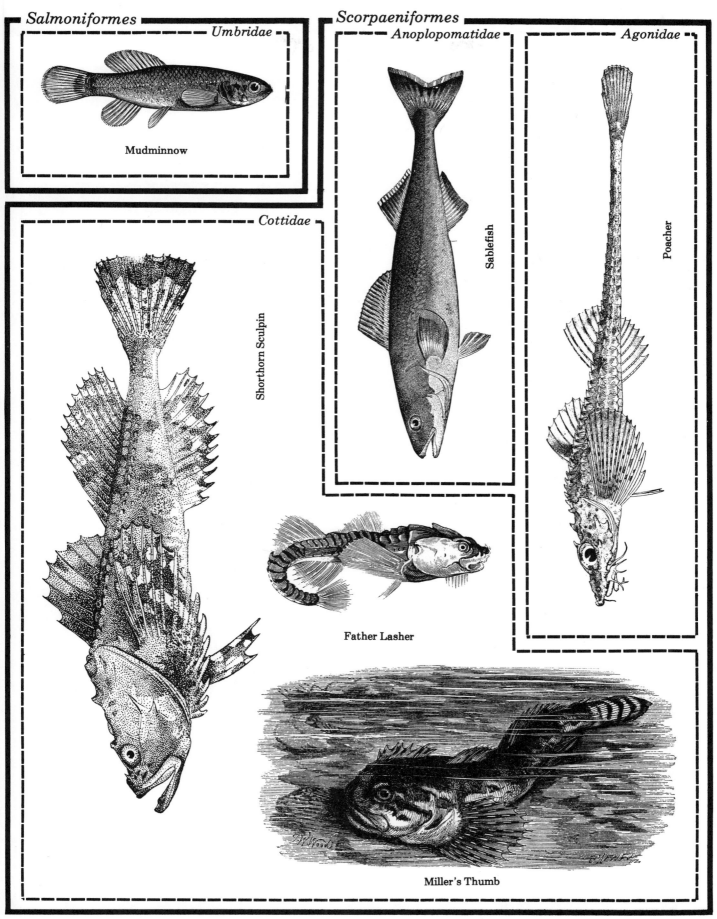

Umbridae

Mudminnow

Anoplopomatidae

Agonidae

Sablefish

Poacher

Cottidae

Shorthorn Sculpin

Father Lasher

Miller's Thumb

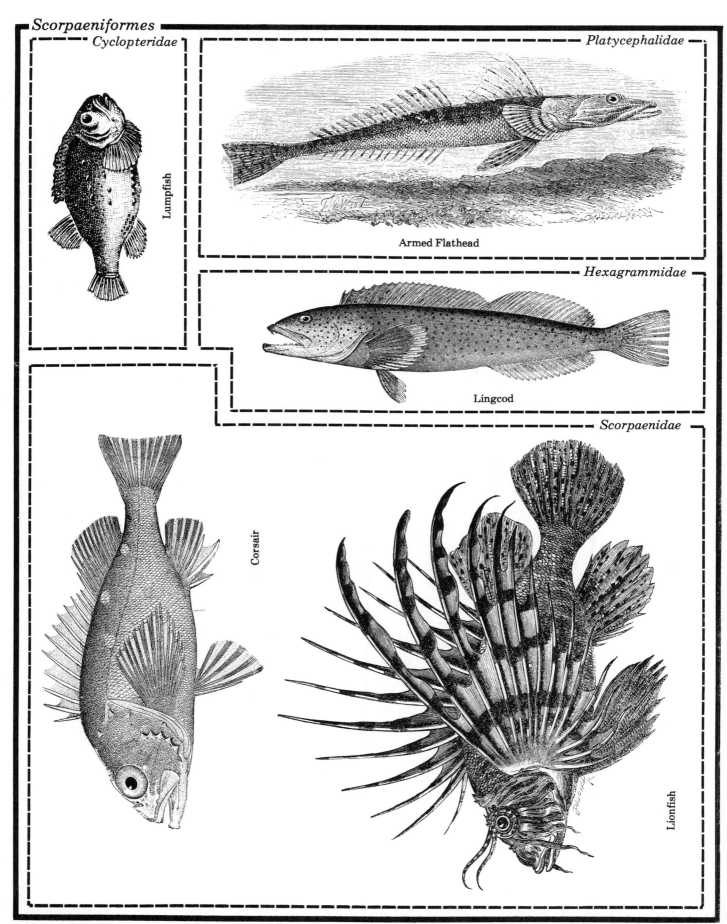

Scorpaeniformes

Cyclopteridae
Lumpfish

Platycephalidae
Armed Flathead

Hexagrammidae
Lingcod

Scorpaenidae
Corsair

Lionfish

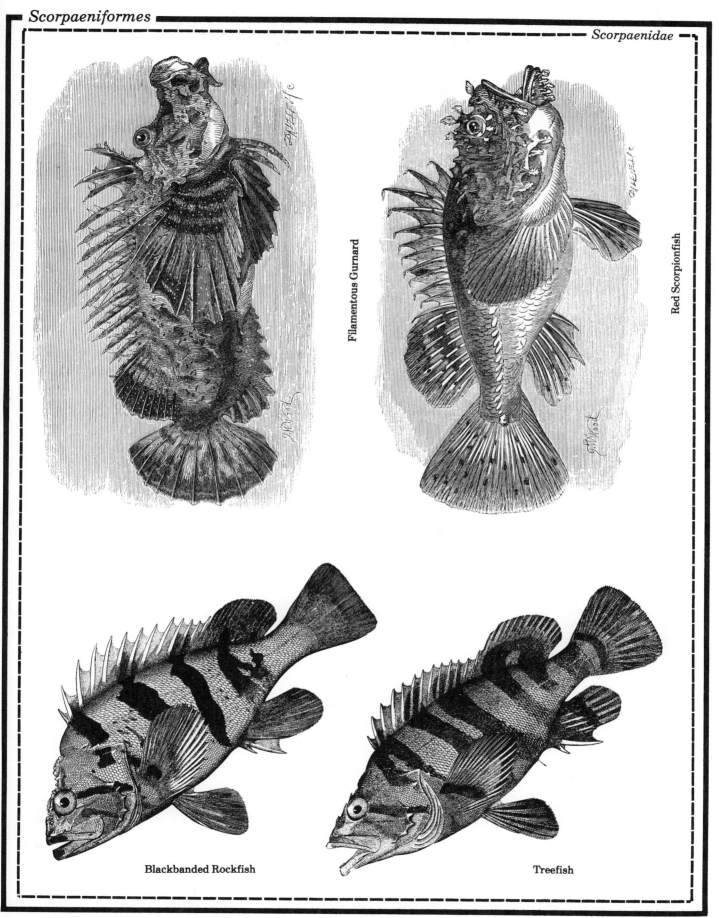

Filamentous Gurnard

Red Scorpionfish

Blackbanded Rockfish

Treefish

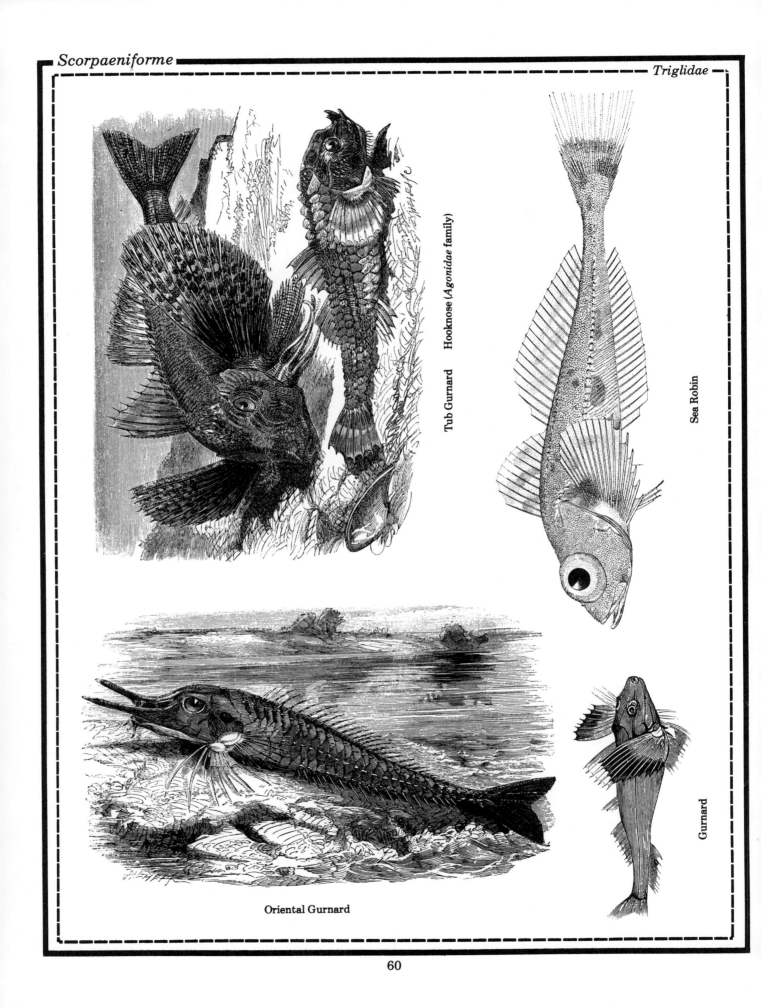

Tub Gurnard Hooknose (*Agonidae* family)

Sea Robin

Oriental Gurnard

Gurnard

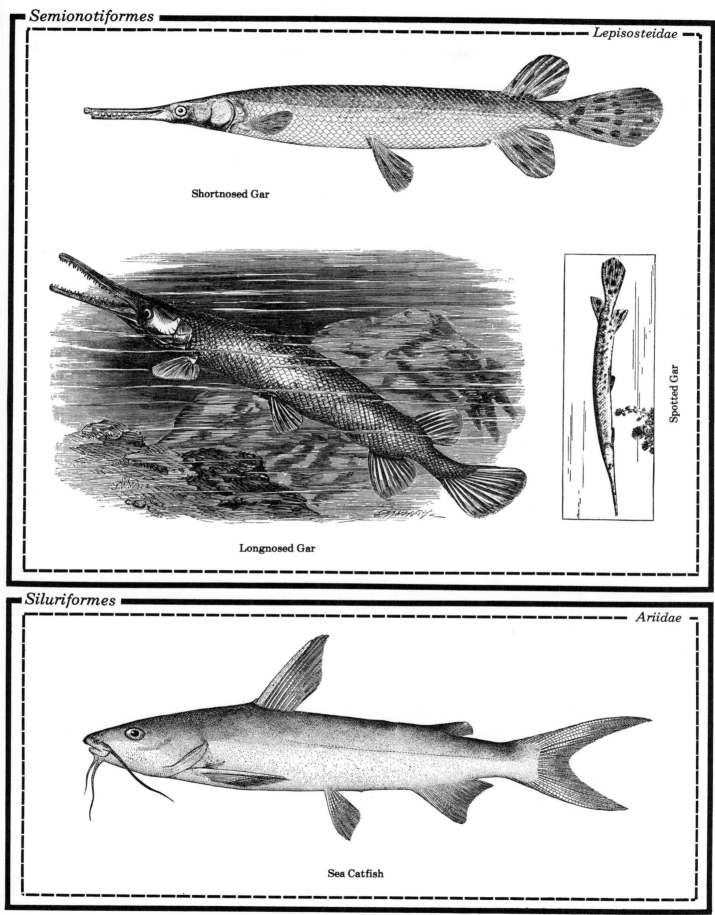

Semionotiformes

Lepisosteidae

Shortnosed Gar

Longnosed Gar

Spotted Gar

Siluriformes

Ariidae

Sea Catfish

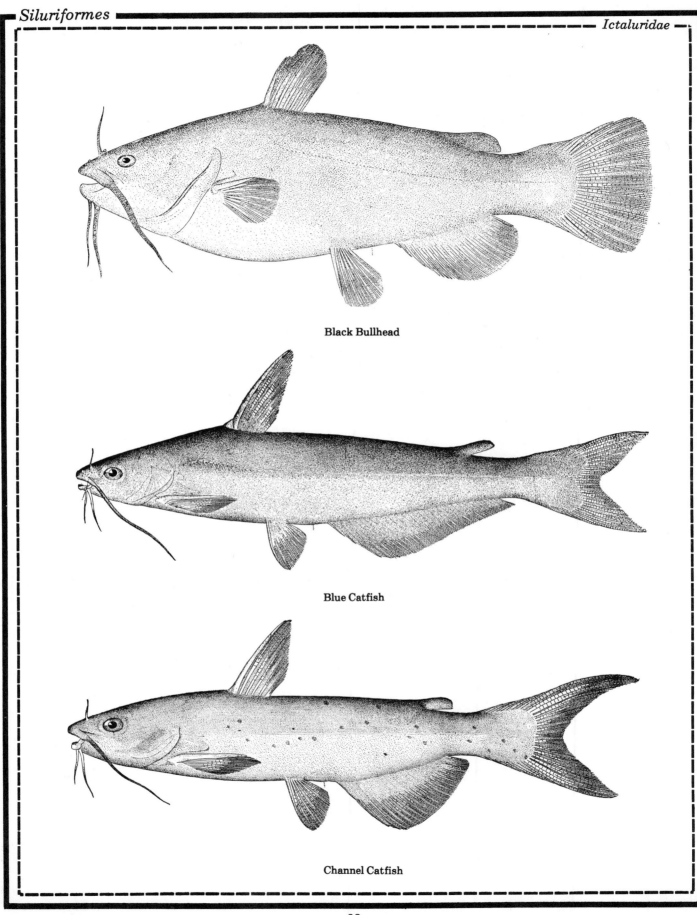

Black Bullhead

Blue Catfish

Channel Catfish

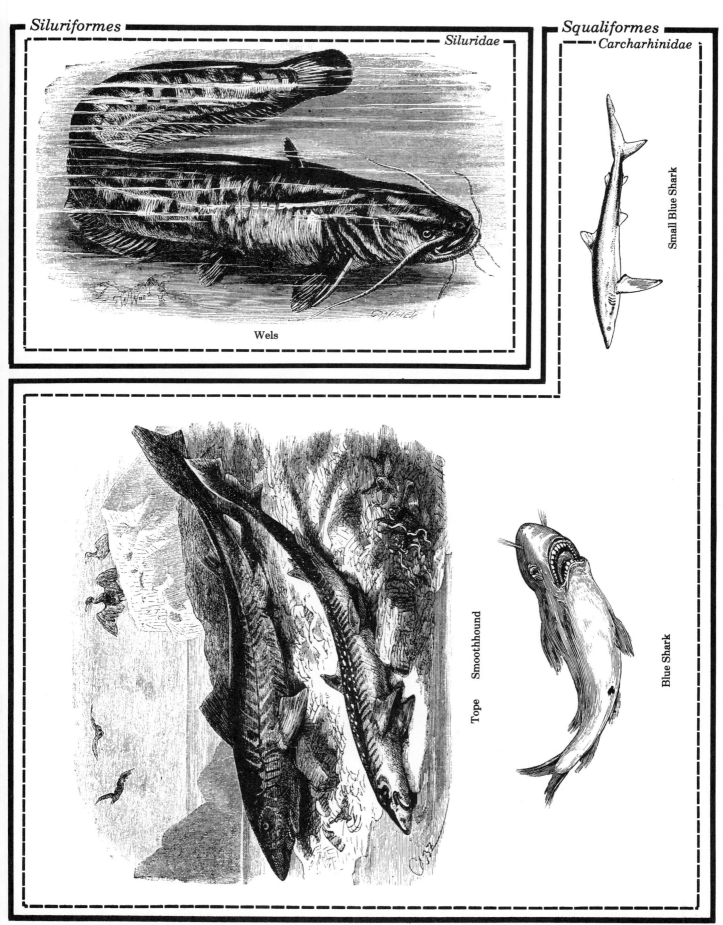

Siluriformes

Siluridae

Wels

Squaliformes

Carcharhinidae

Small Blue Shark

Tope Smoothhound

Blue Shark

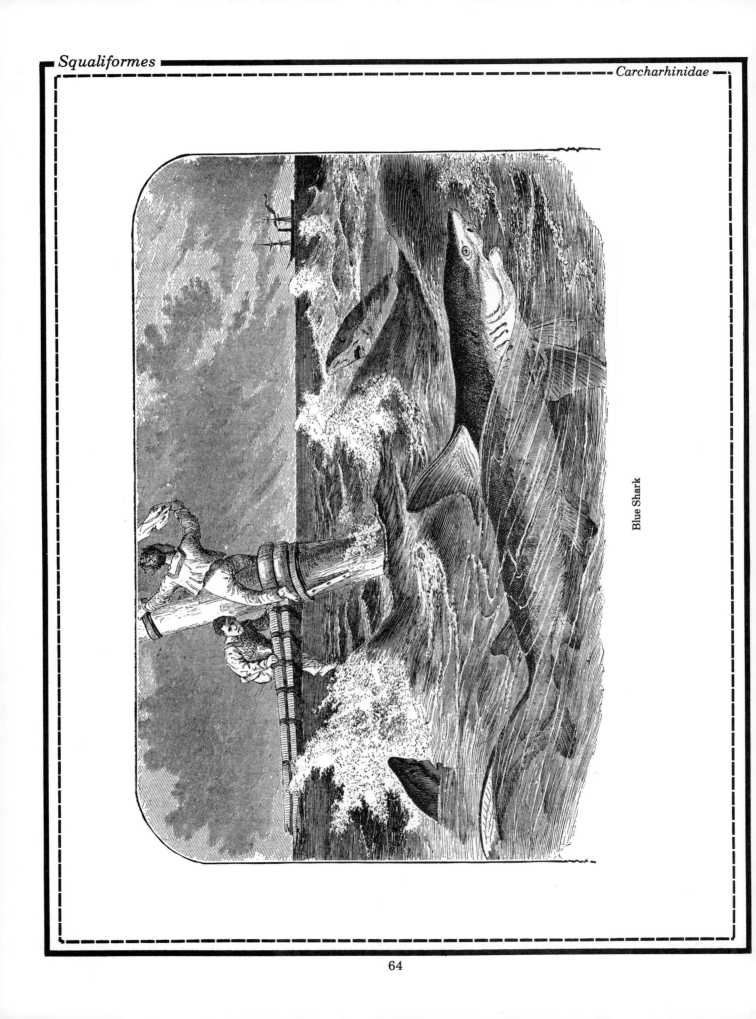

Blue Shark

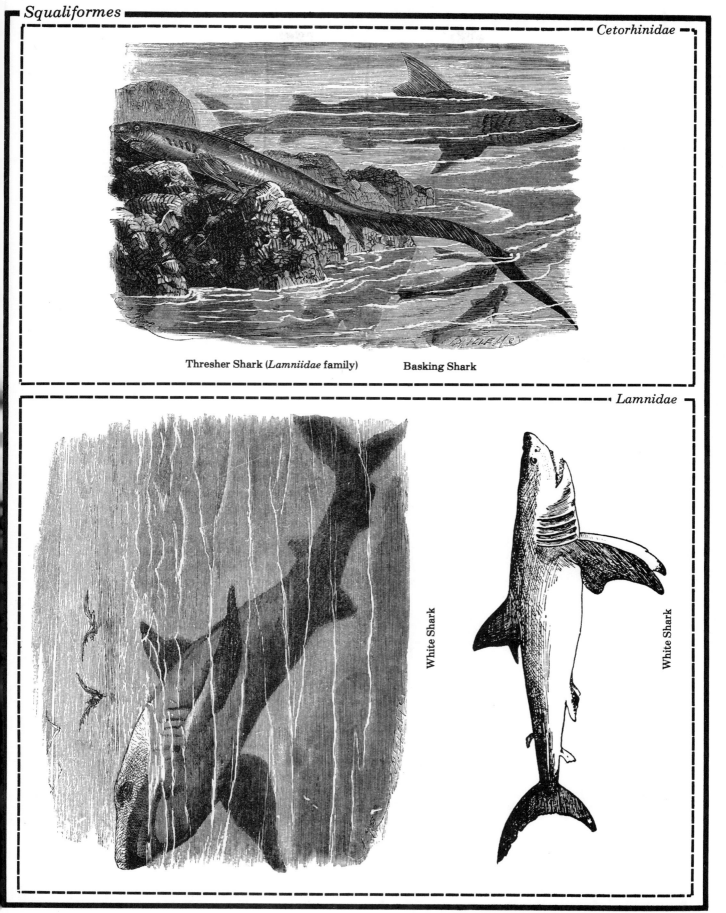

Thresher Shark (*Lamniidae* family) Basking Shark

White Shark

White Shark

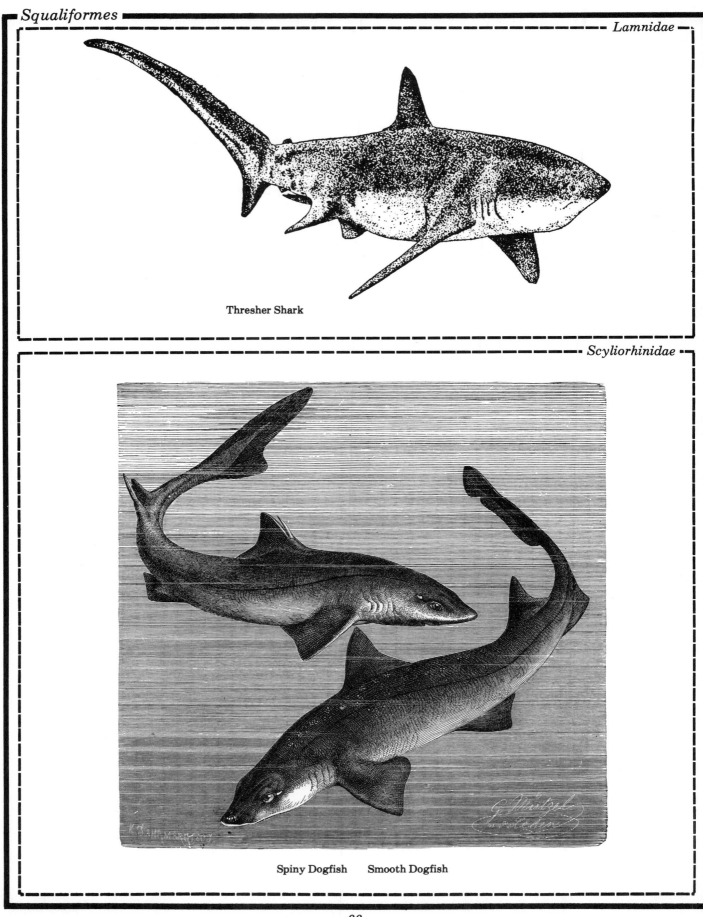

Thresher Shark

Spiny Dogfish Smooth Dogfish

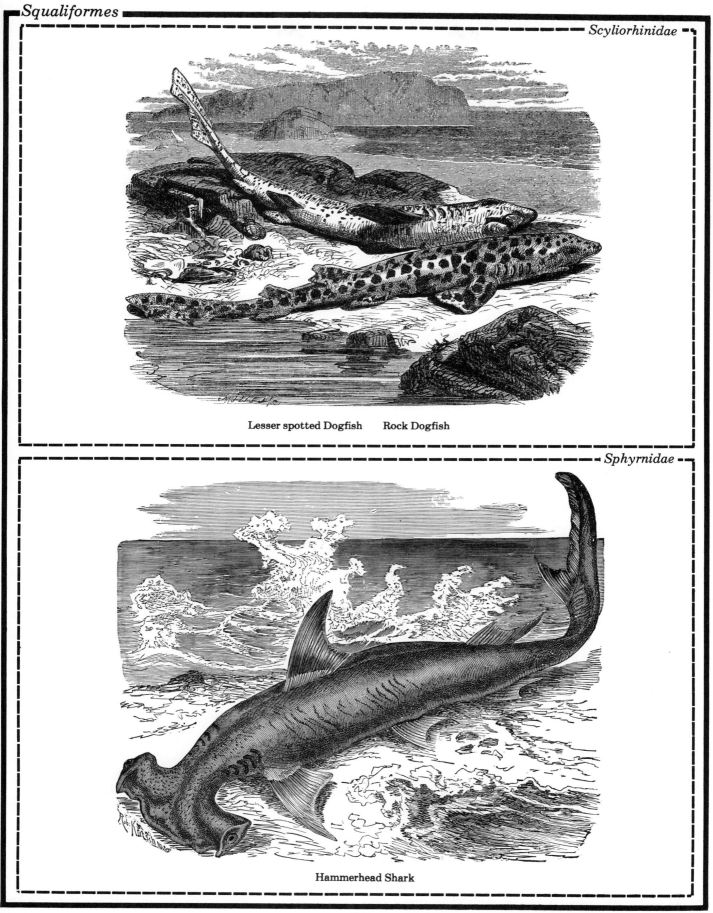

Lesser spotted Dogfish Rock Dogfish

Hammerhead Shark

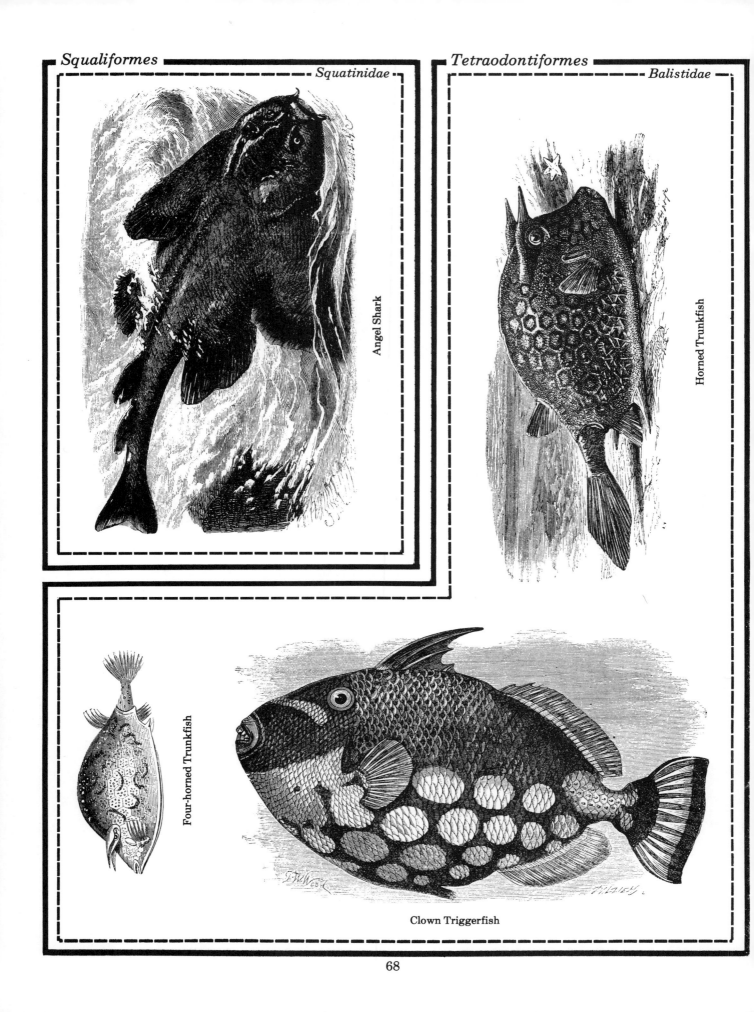

Squaliformes

— *Squatinidae* —

Angel Shark

Tetraodontiformes

— *Balistidae* —

Horned Trunkfish

Four-horned Trunkfish

Clown Triggerfish

68

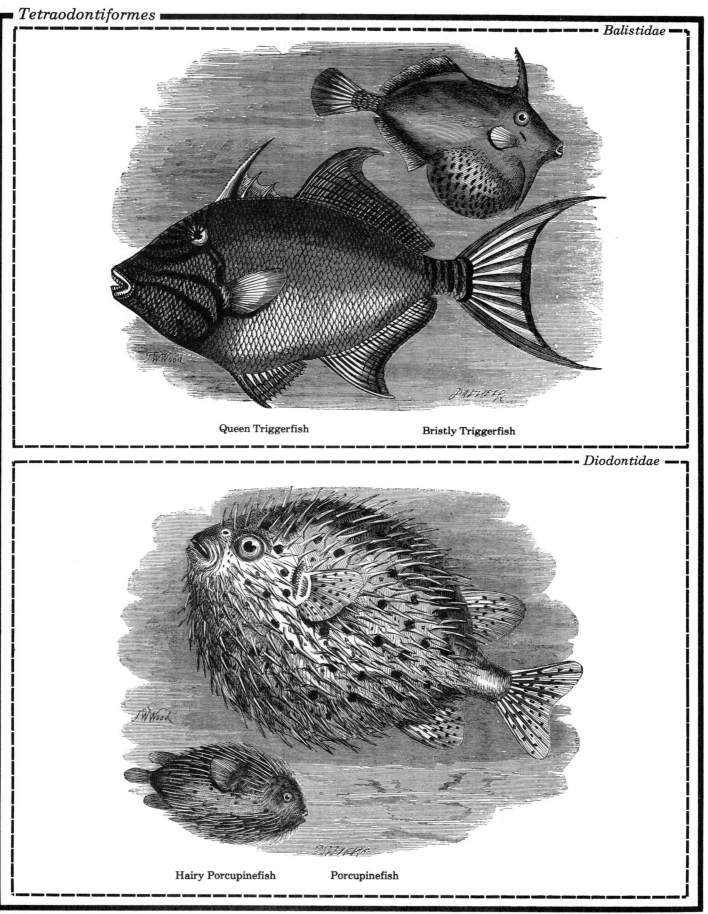

Queen Triggerfish **Bristly Triggerfish**

Hairy Porcupinefish **Porcupinefish**

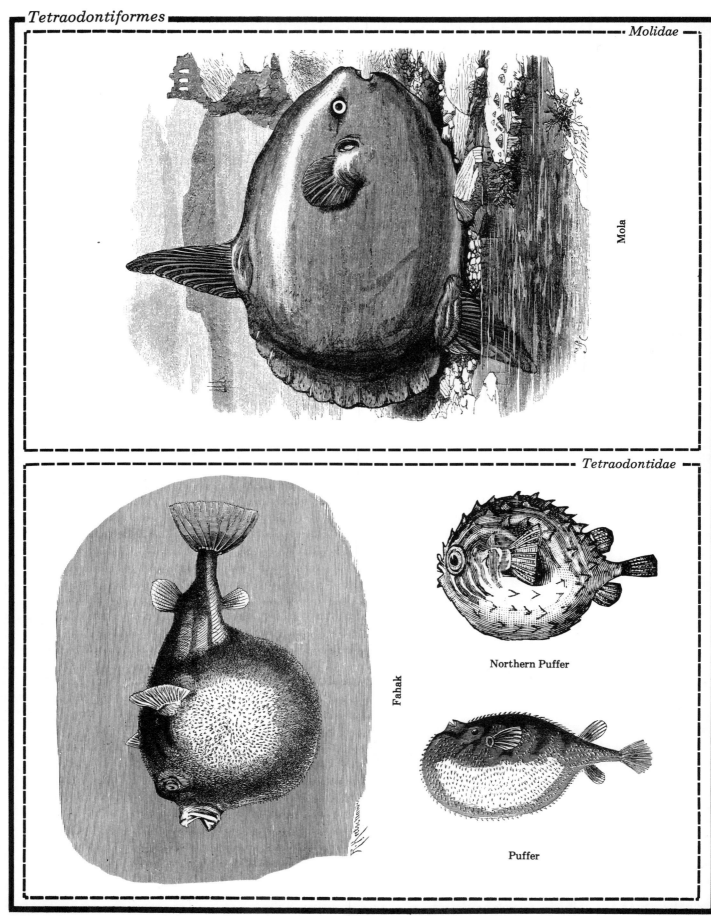

Mola

Fahak

Northern Puffer

Puffer

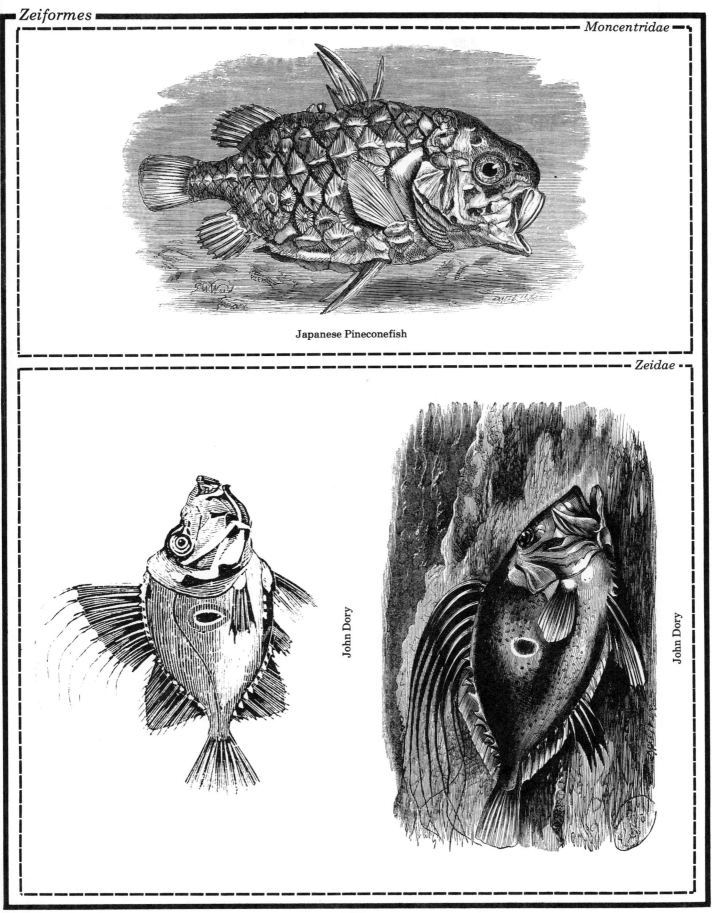

Japanese Pineconefish

John Dory

John Dory

AMPHIBIANS

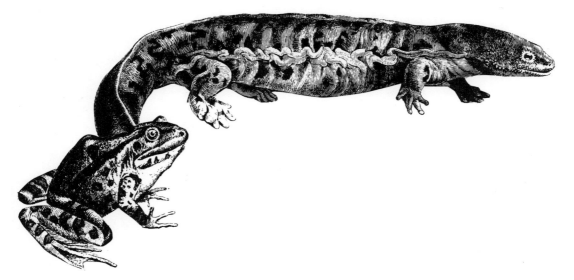

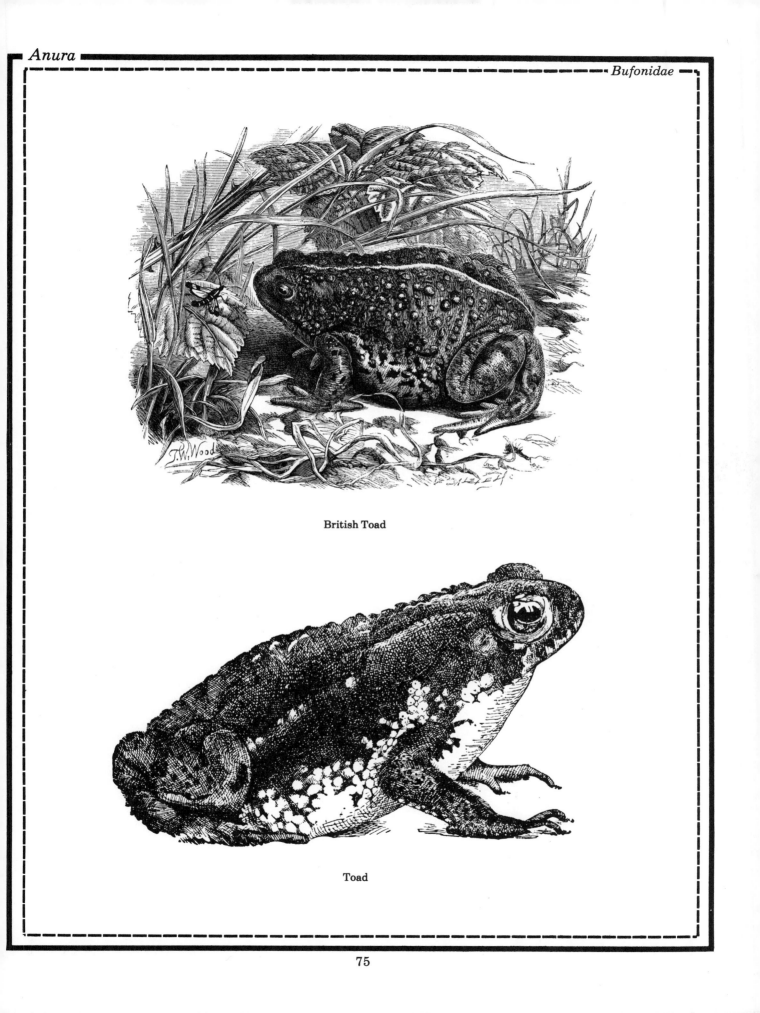

British Toad

Toad

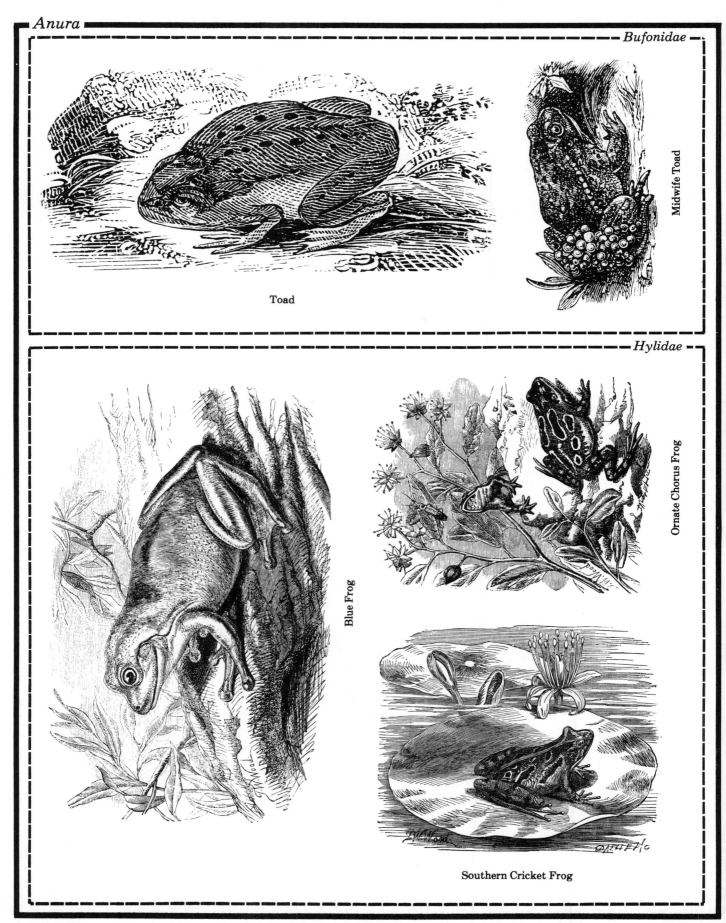

Toad

Midwife Toad

Blue Frog

Ornate Chorus Frog

Southern Cricket Frog

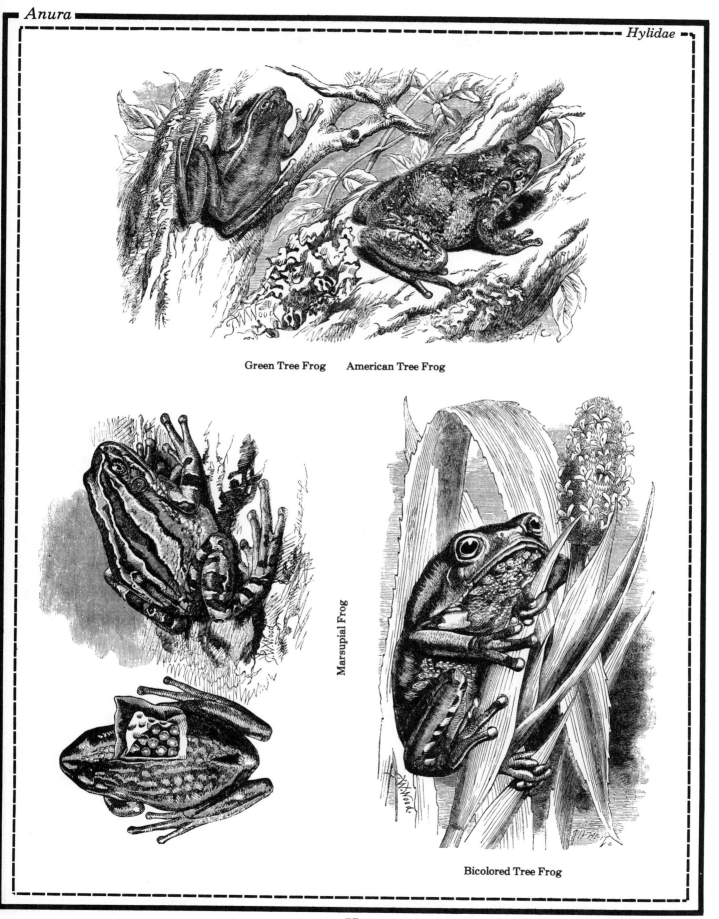

Green Tree Frog American Tree Frog

Marsupial Frog

Bicolored Tree Frog

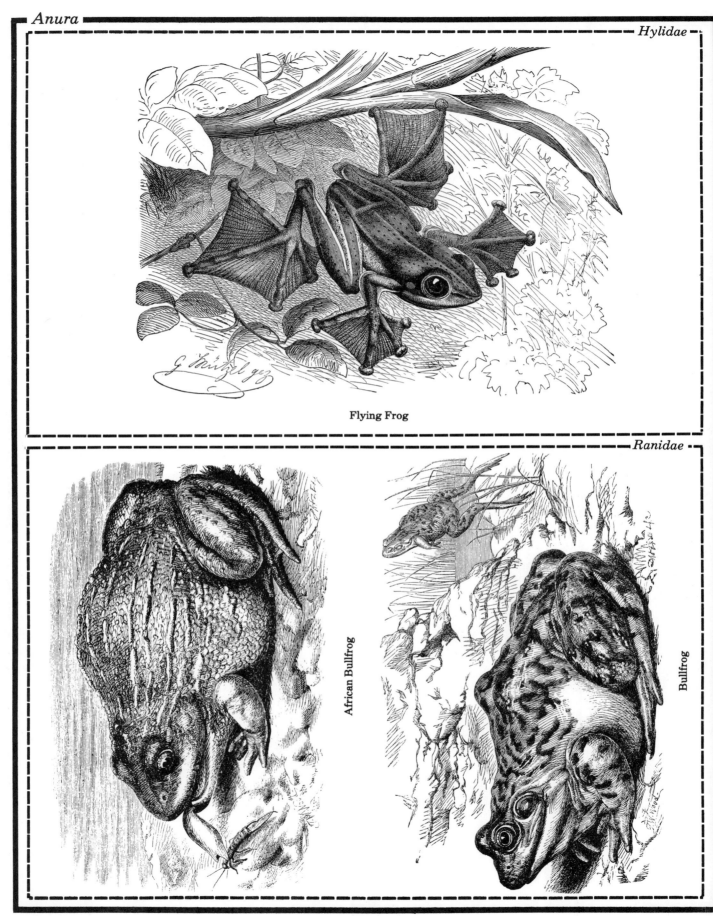

Flying Frog

African Bullfrog

Bullfrog

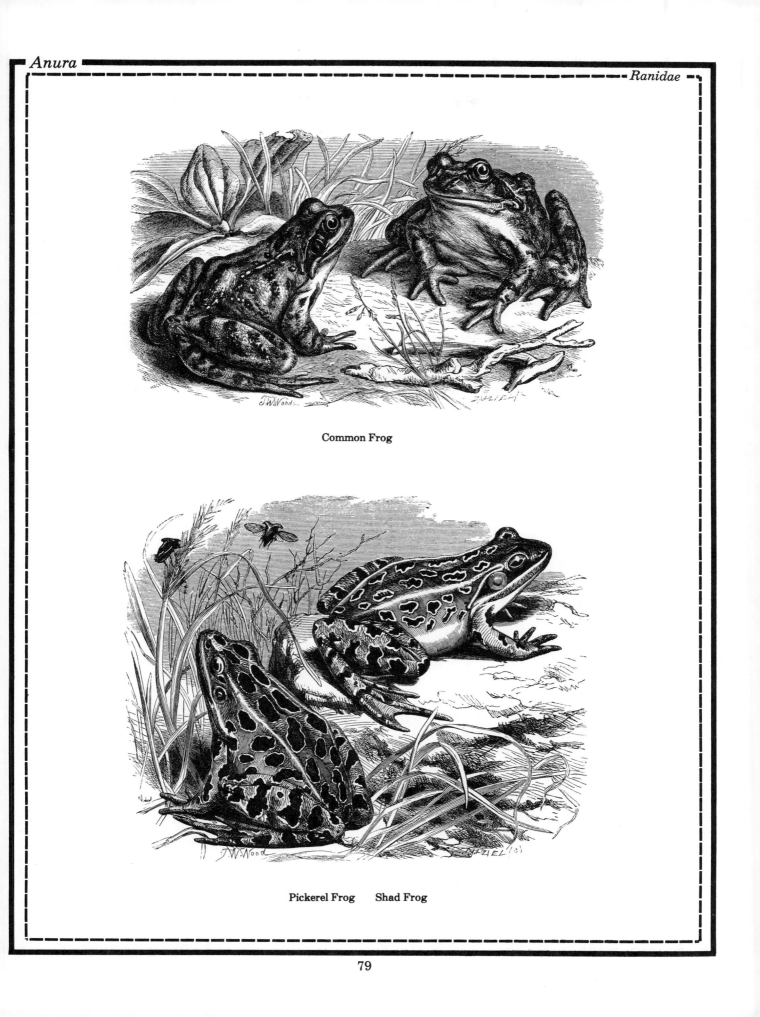

Common Frog

Pickerel Frog Shad Frog

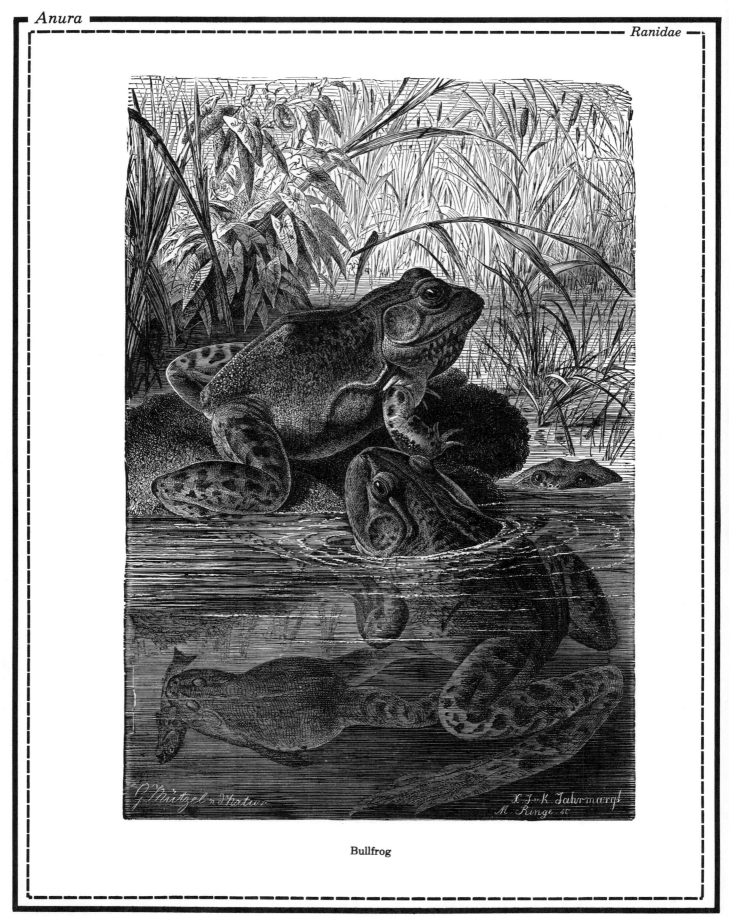

Bullfrog

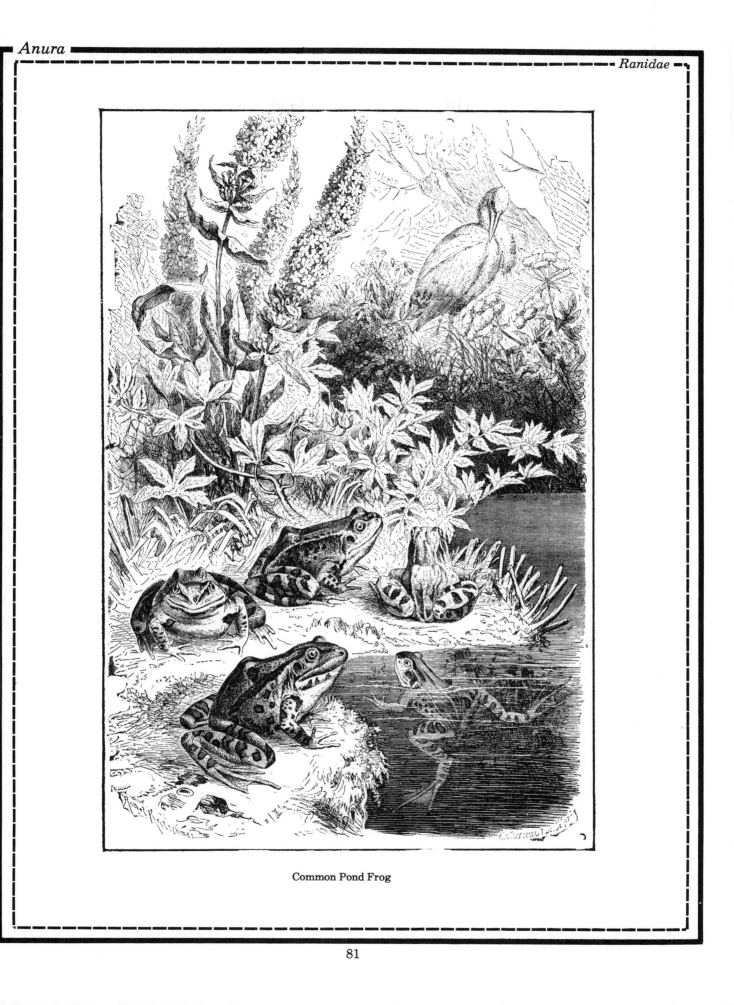

Common Pond Frog

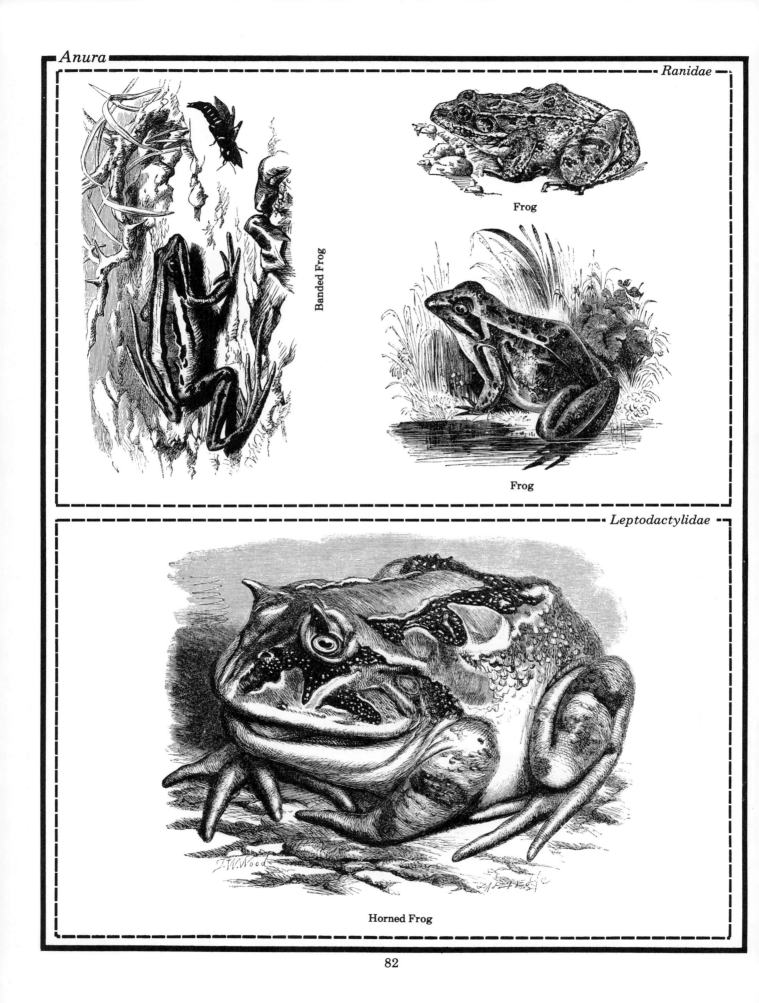

Frog

Banded Frog

Frog

Horned Frog

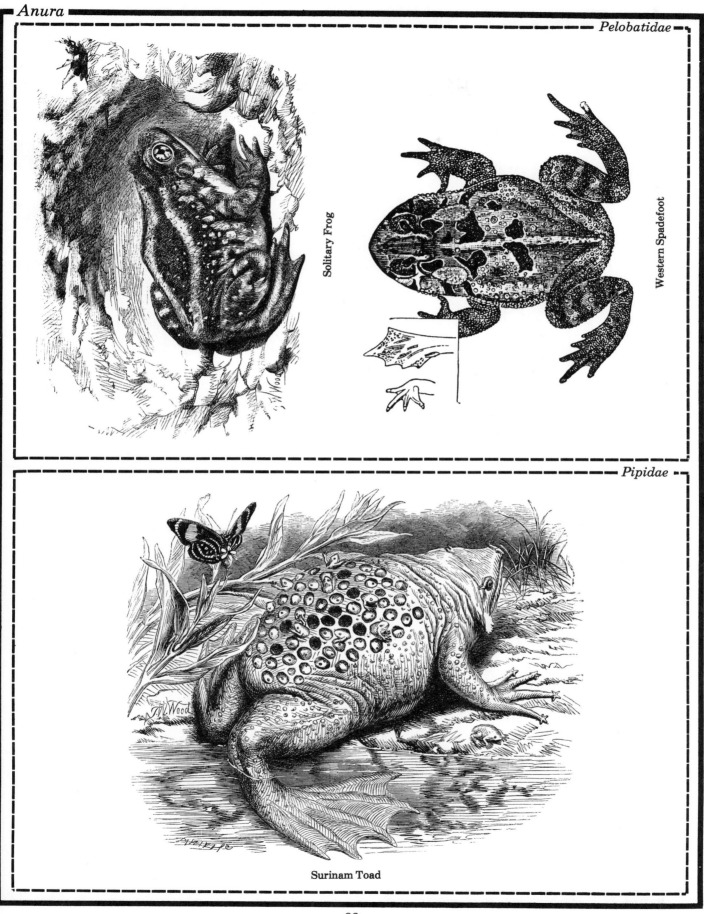

Solitary Frog

Western Spadefoot

Surinam Toad

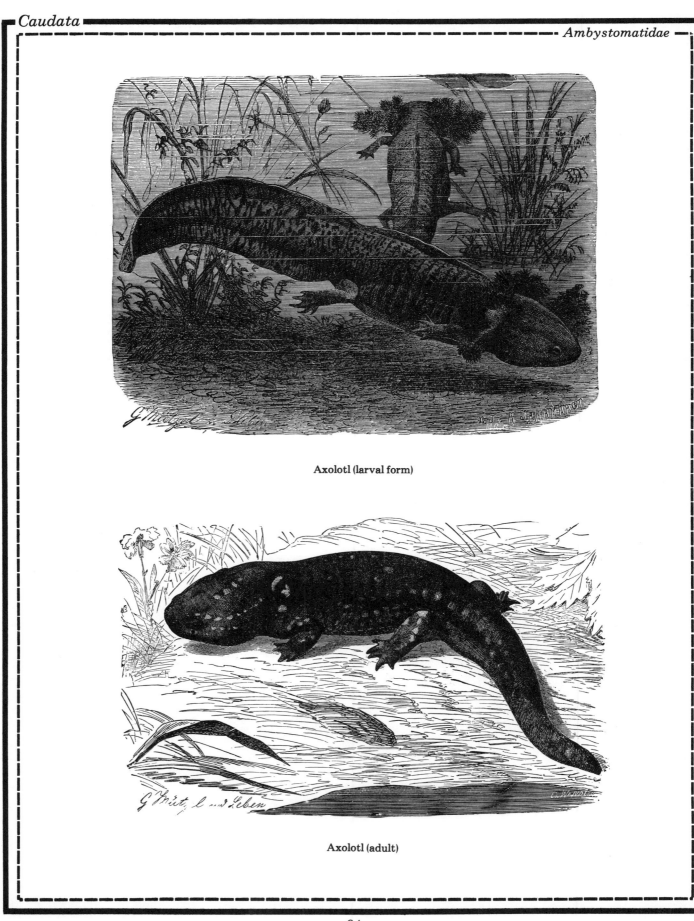

Axolotl (larval form)

Axolotl (adult)

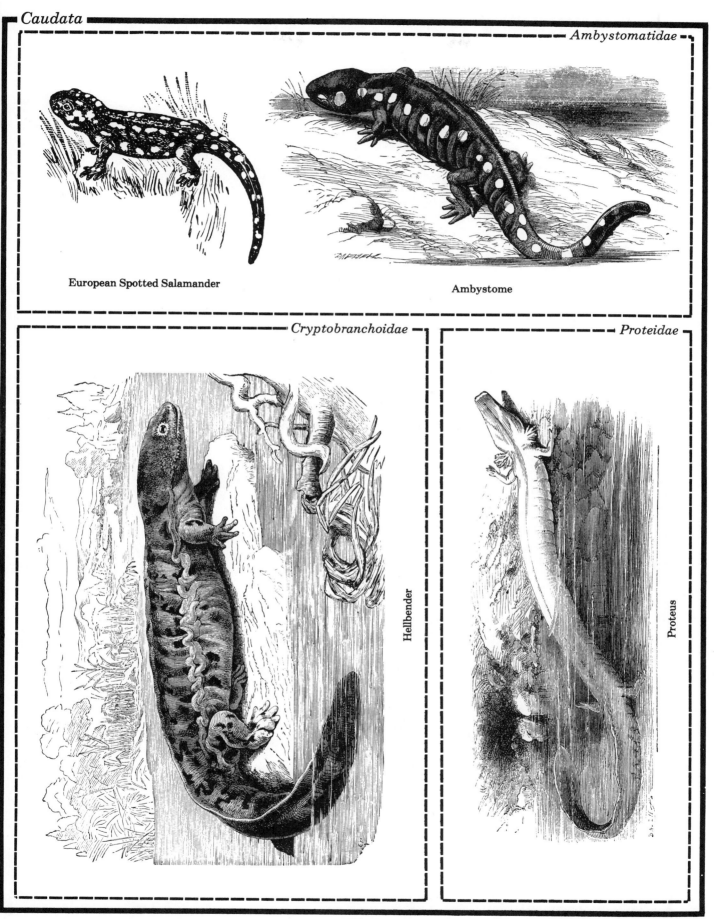

Caudata

Ambystomatidae

European Spotted Salamander

Ambystome

Cryptobranchoidae

Proteidae

Hellbender

Proteus

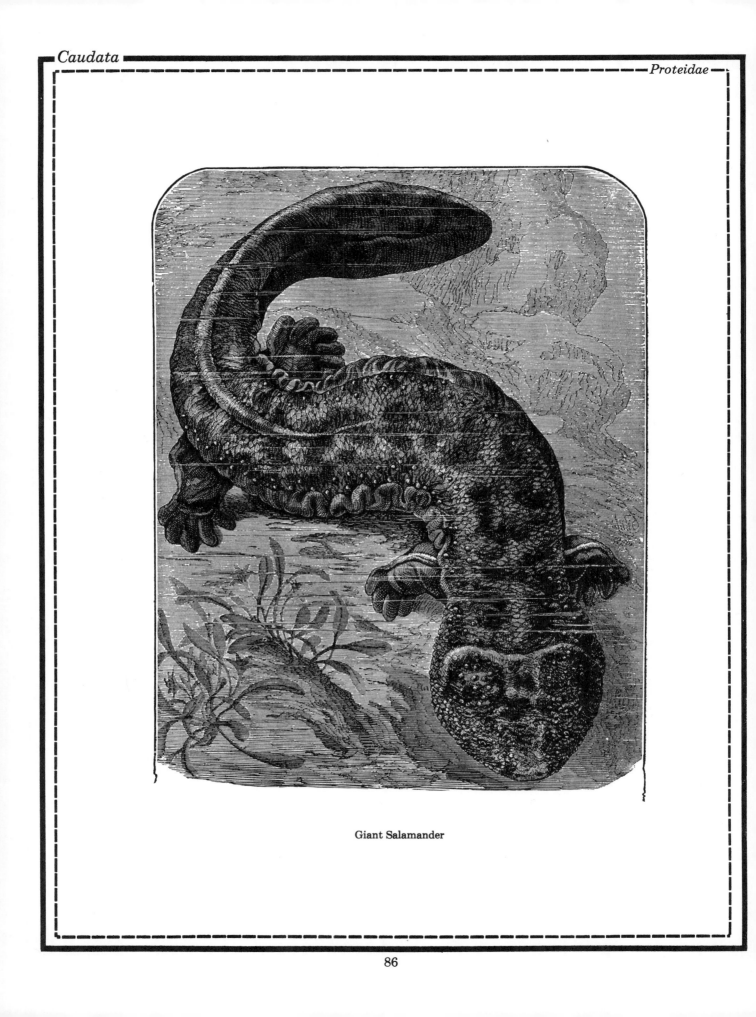

Giant Salamander

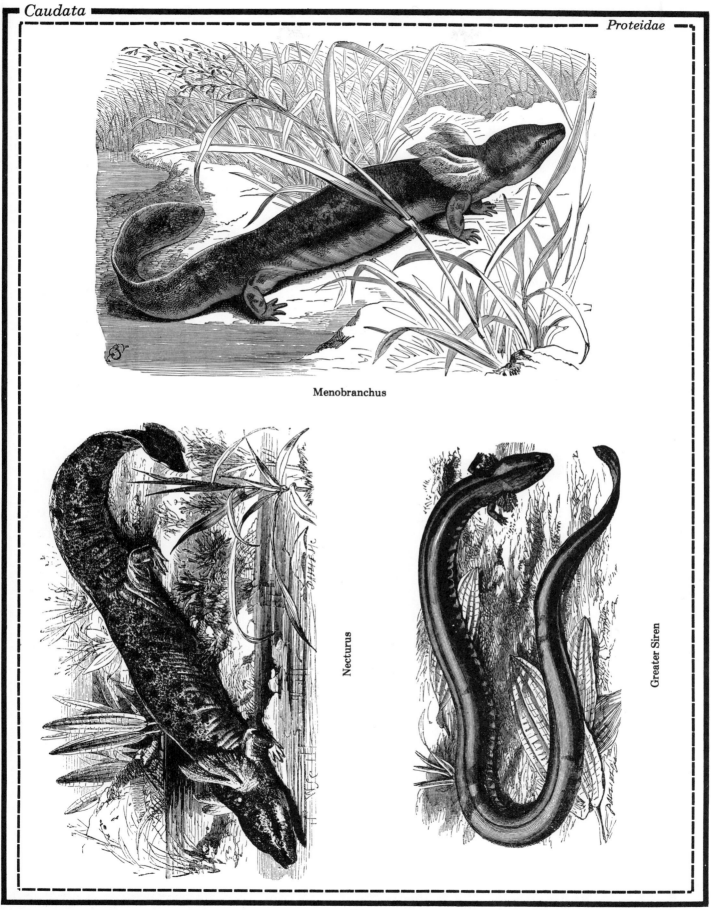

Menobranchus

Necturus

Greater Siren

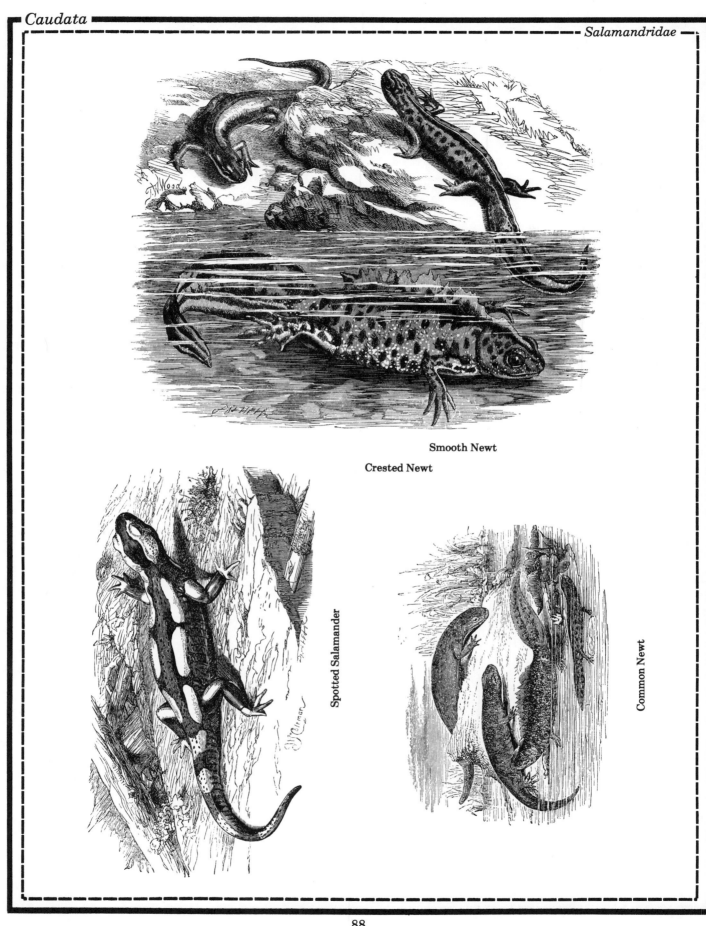

Smooth Newt

Crested Newt

Spotted Salamander

Common Newt

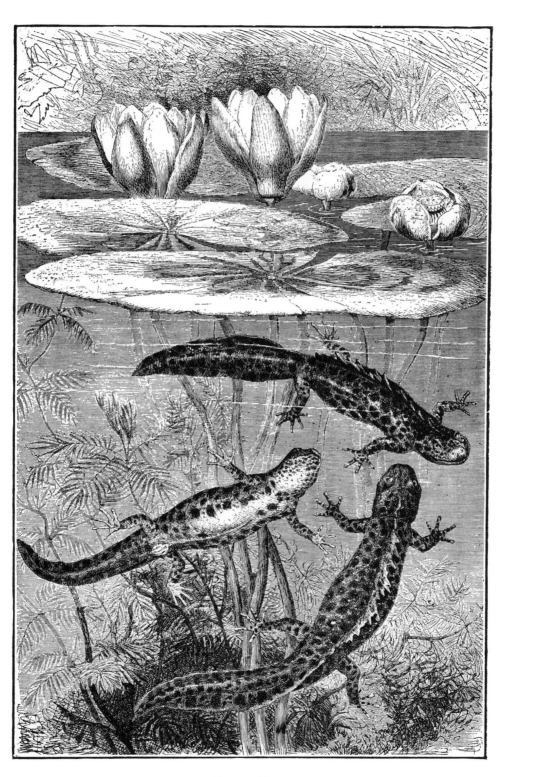

Common Newt

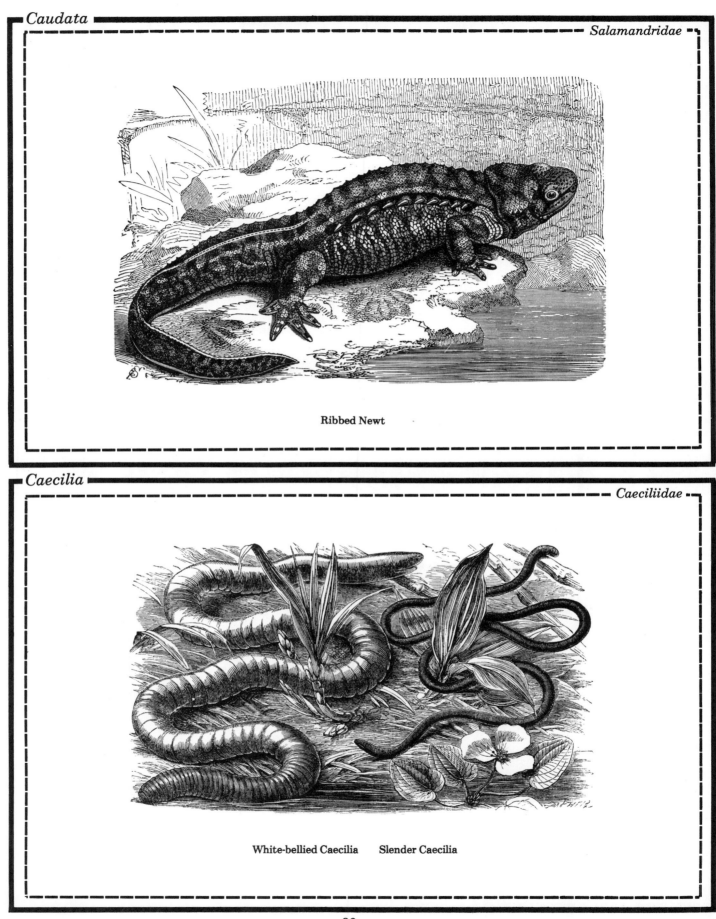

Ribbed Newt

White-bellied Caecilia **Slender Caecilia**

REPTILES

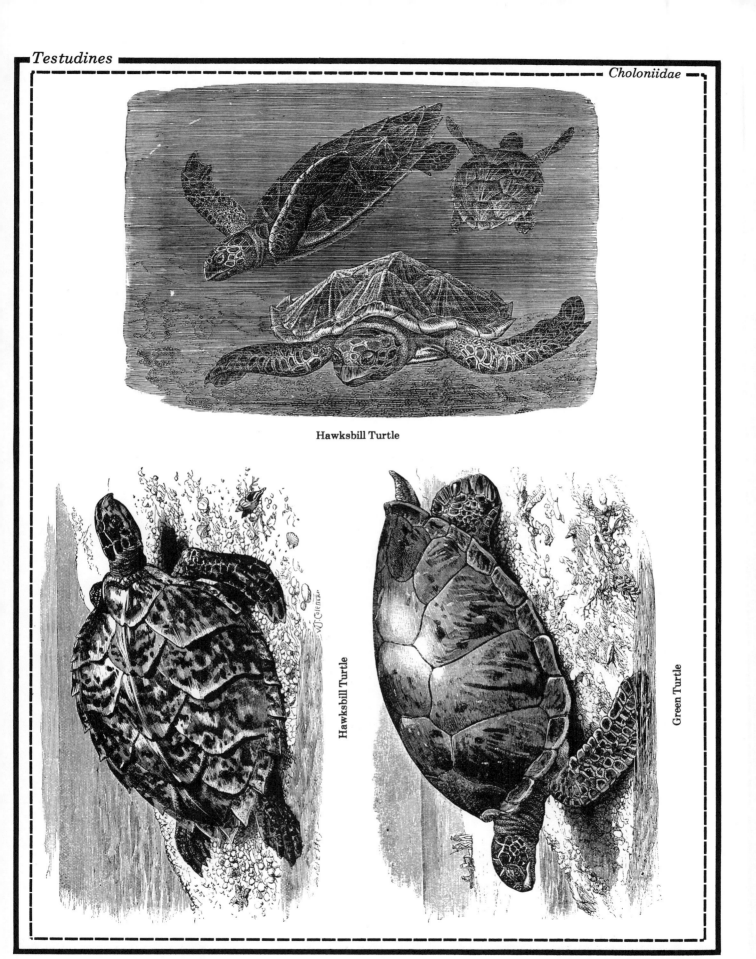

Hawksbill Turtle

Hawksbill Turtle

Green Turtle

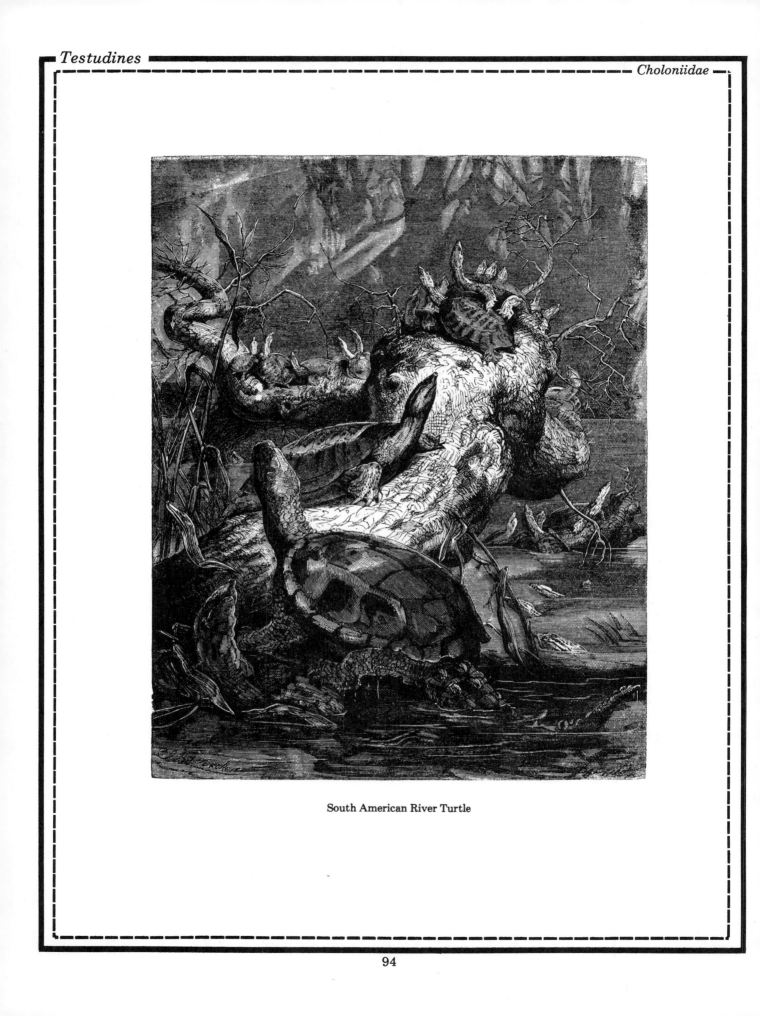

South American River Turtle

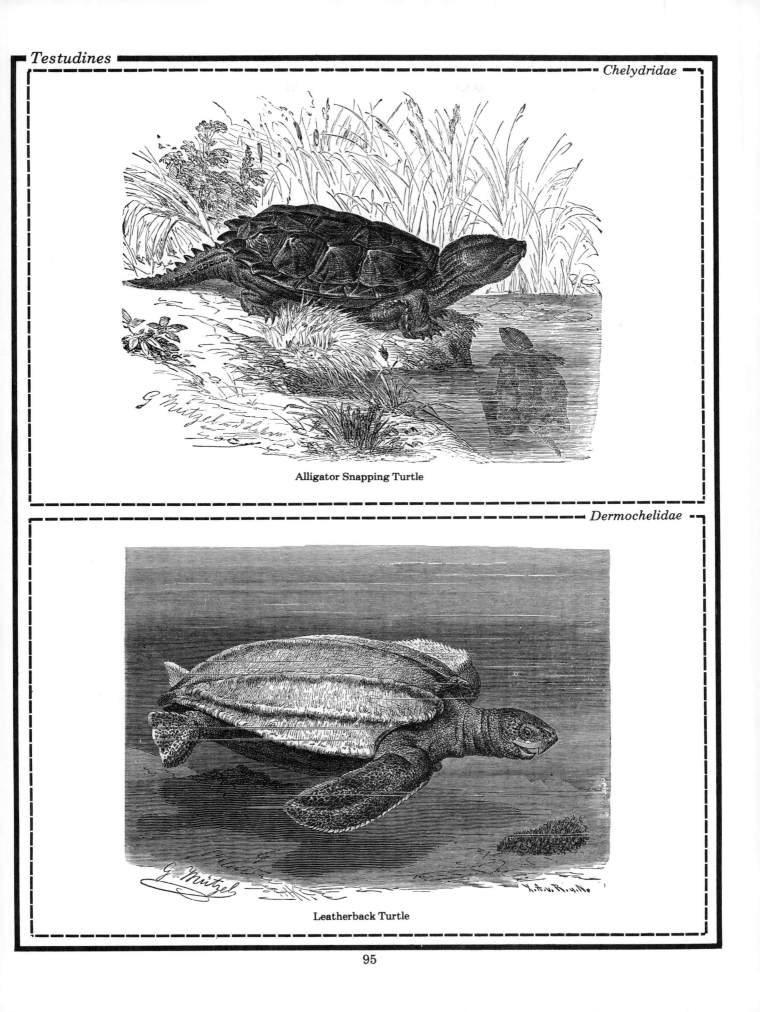

Alligator Snapping Turtle

Leatherback Turtle

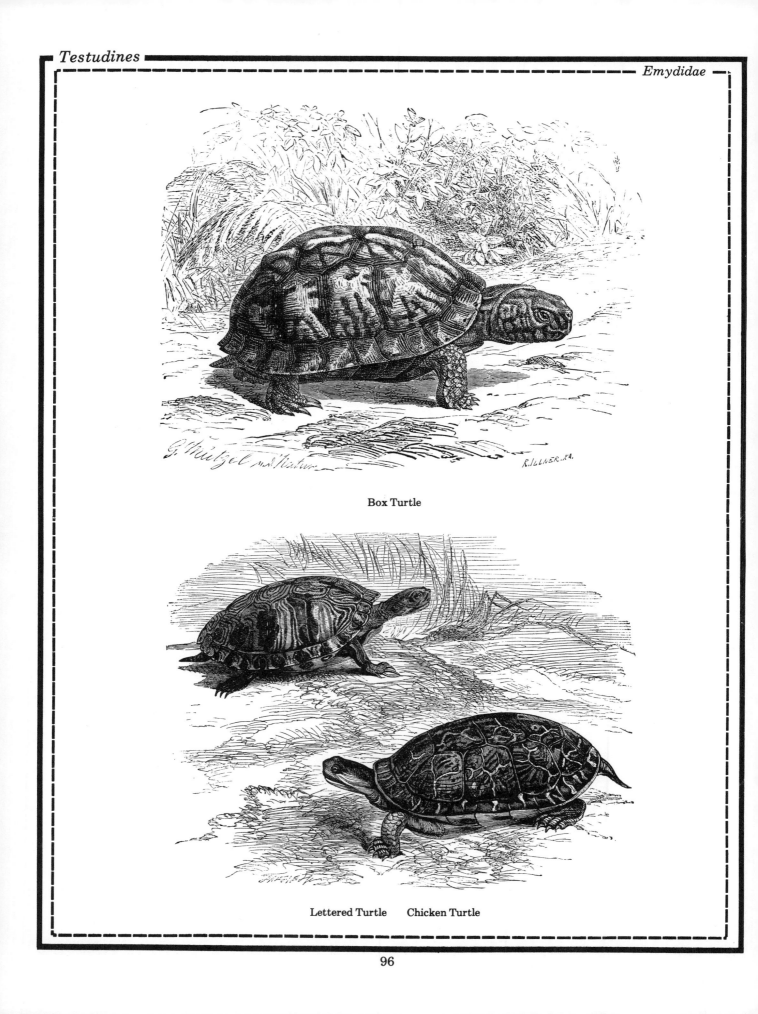

Box Turtle

Lettered Turtle Chicken Turtle

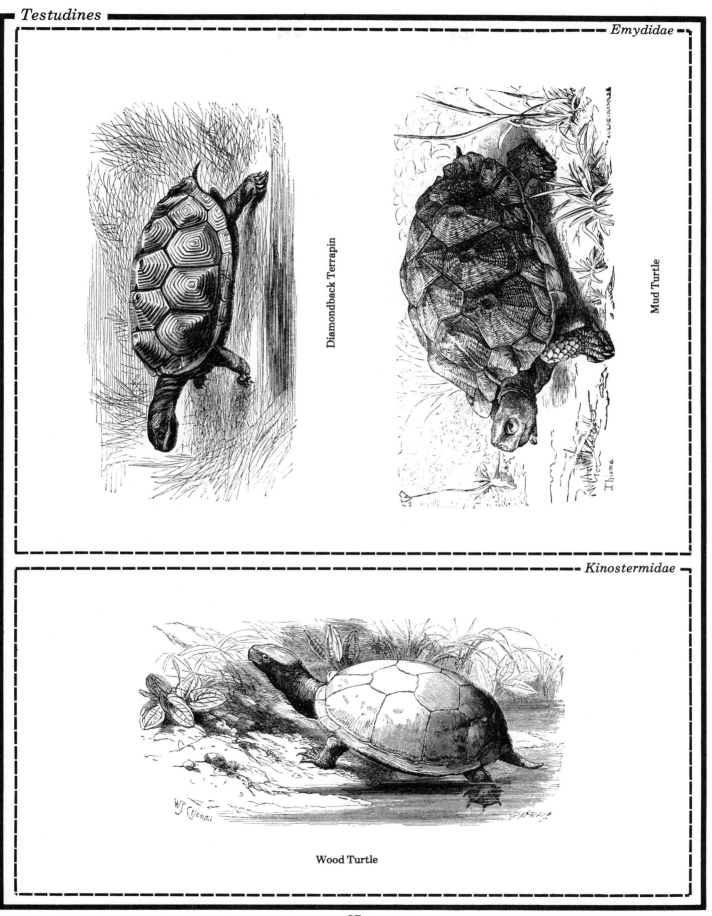

Diamondback Terrapin

Mud Turtle

Wood Turtle

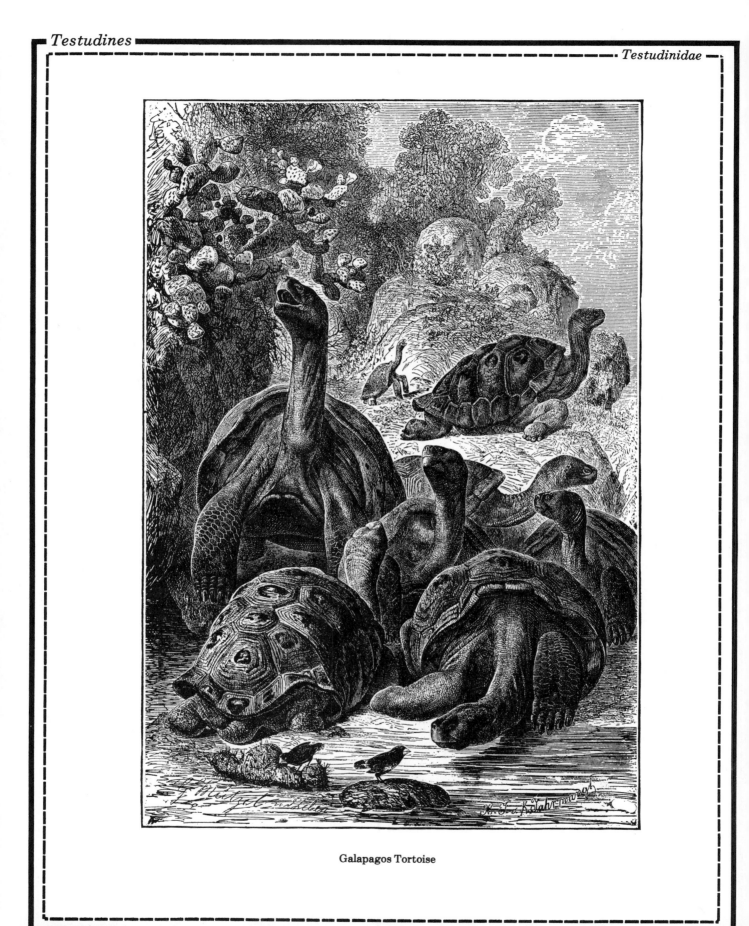

Galapagos Tortoise

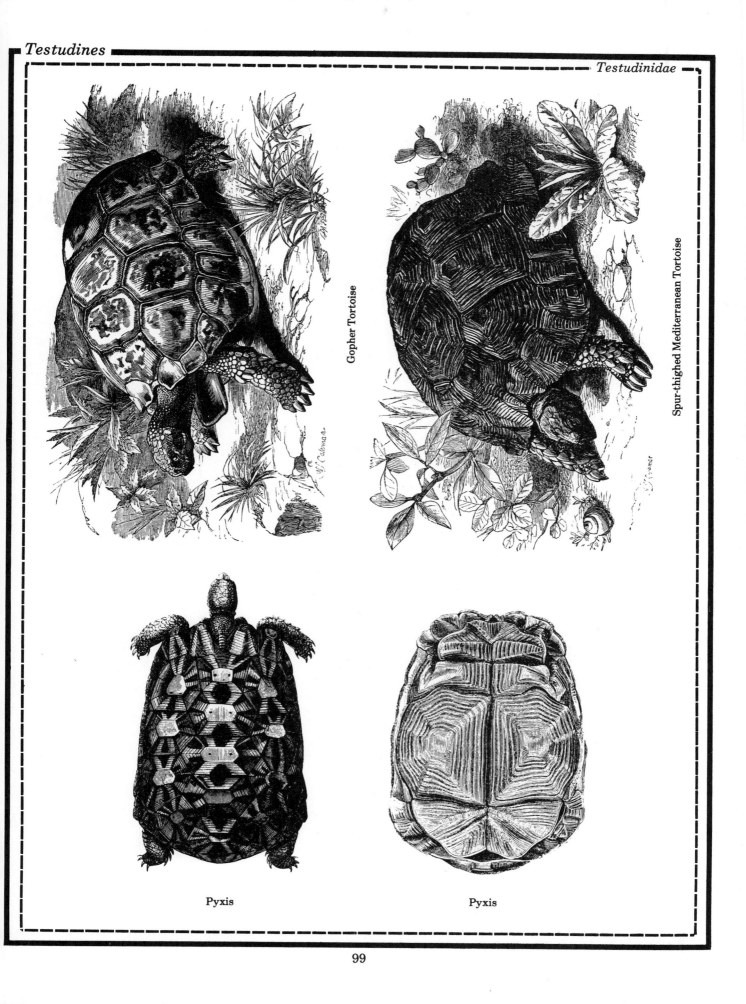

Gopher Tortoise

Spur-thighed Mediterranean Tortoise

Pyxis

Pyxis

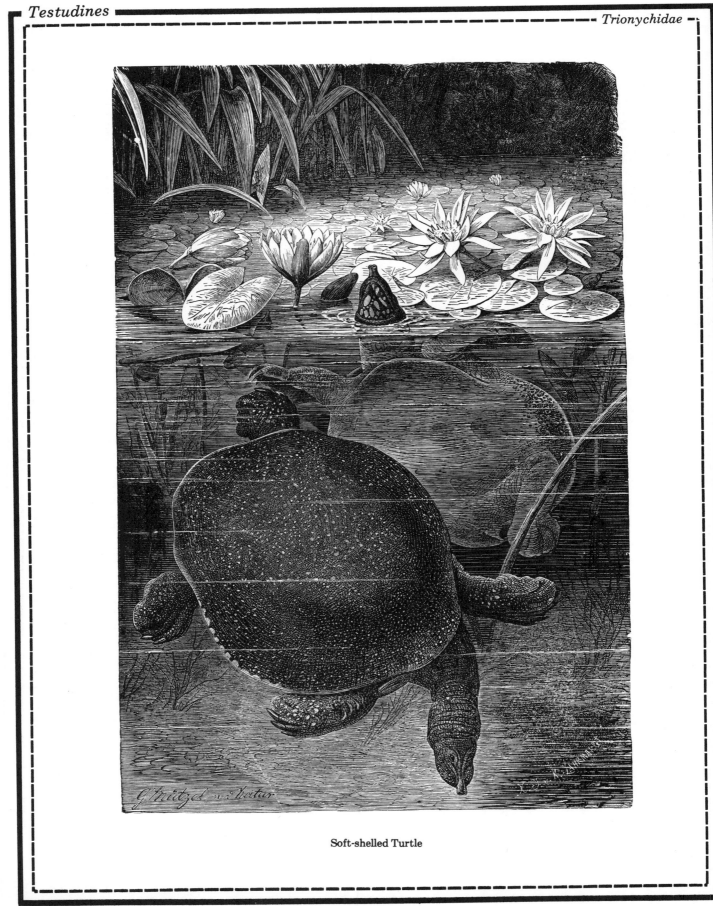

Soft-shelled Turtle

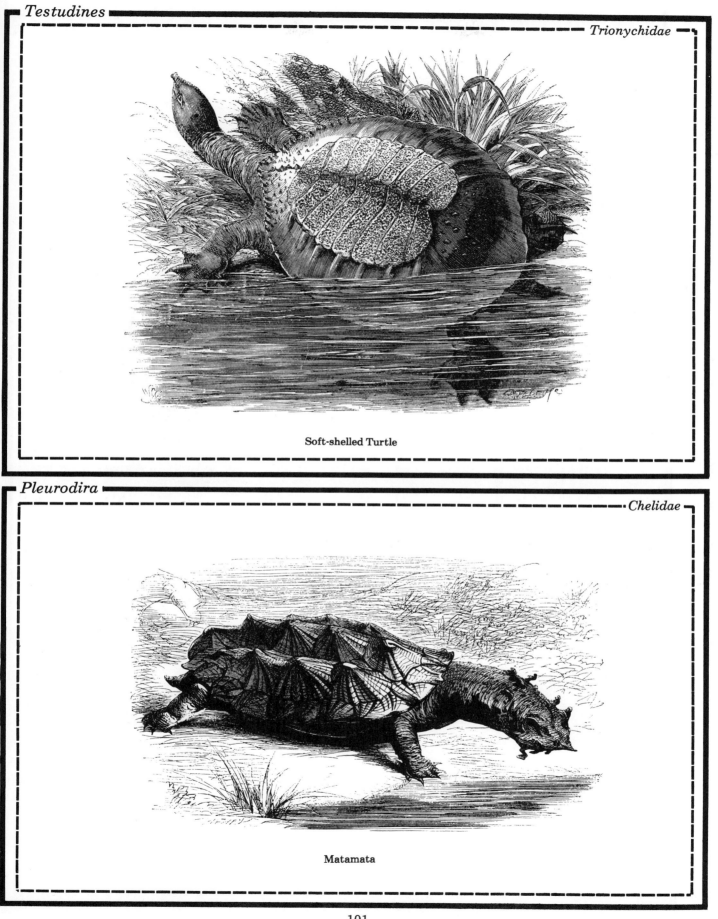

Soft-shelled Turtle

Matamata

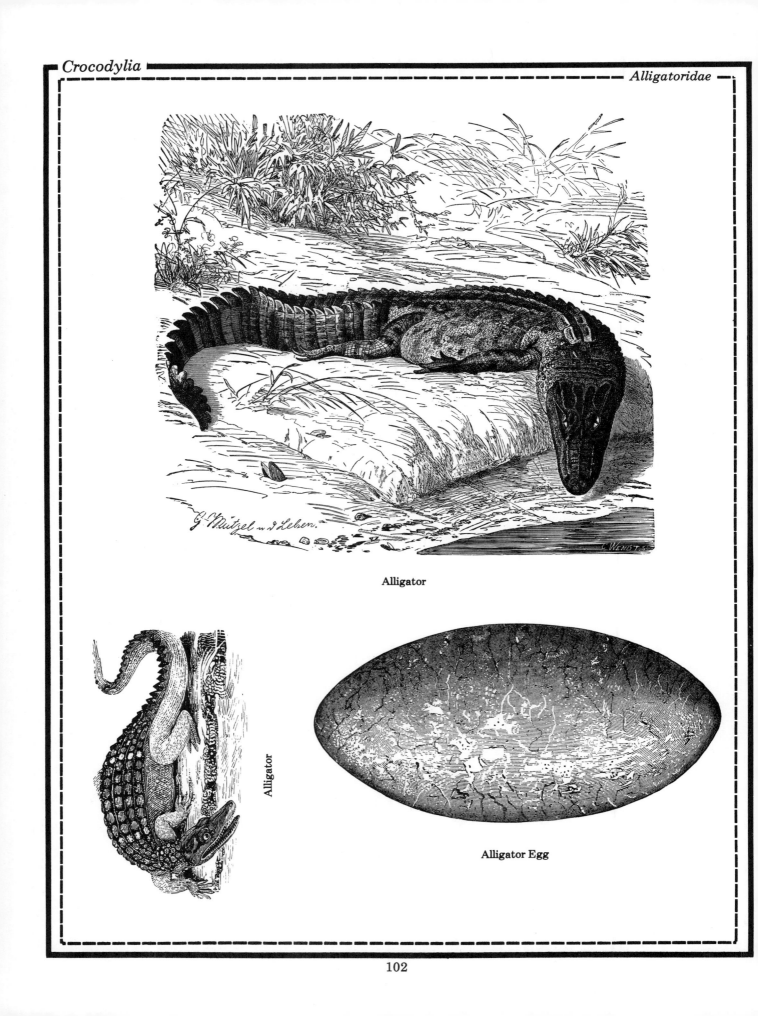

Alligator

Alligator

Alligator Egg

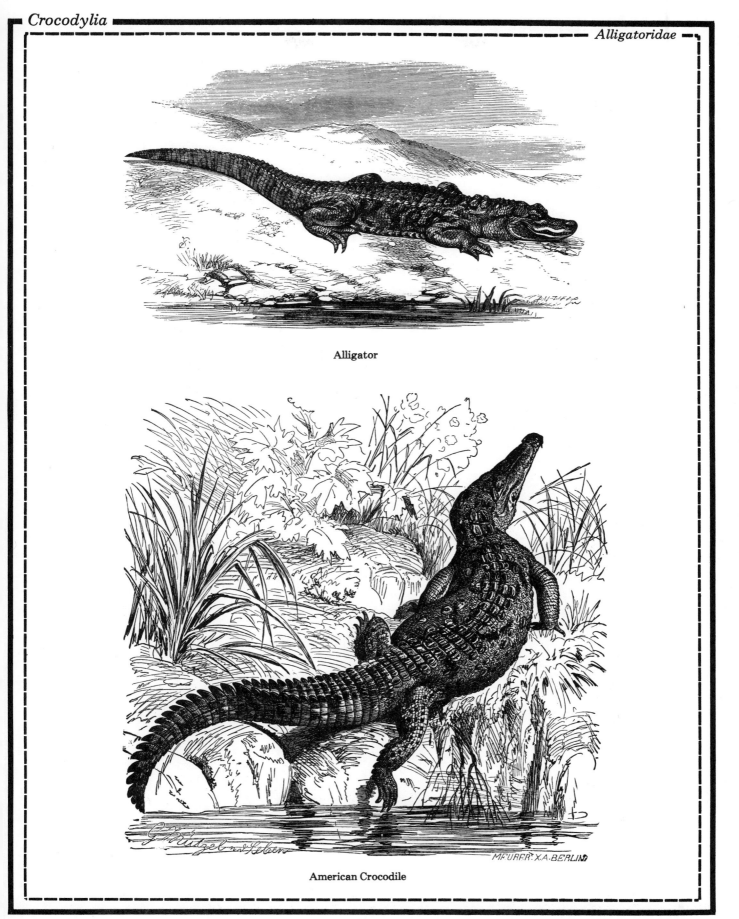

Alligator

American Crocodile

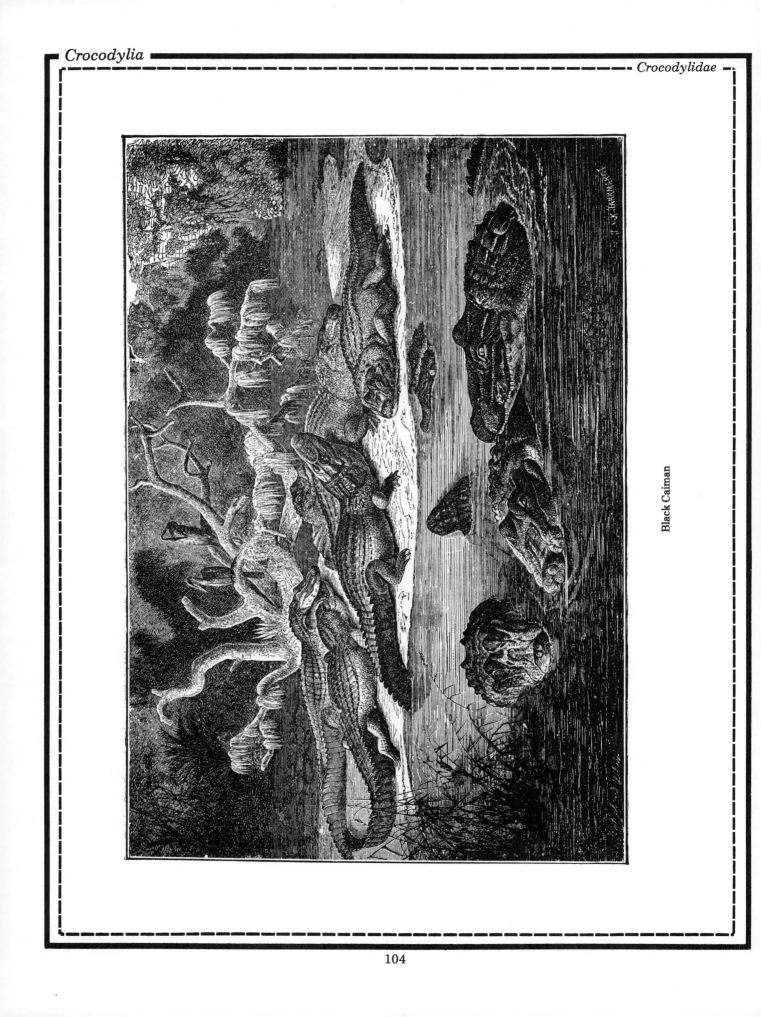

Black Caiman

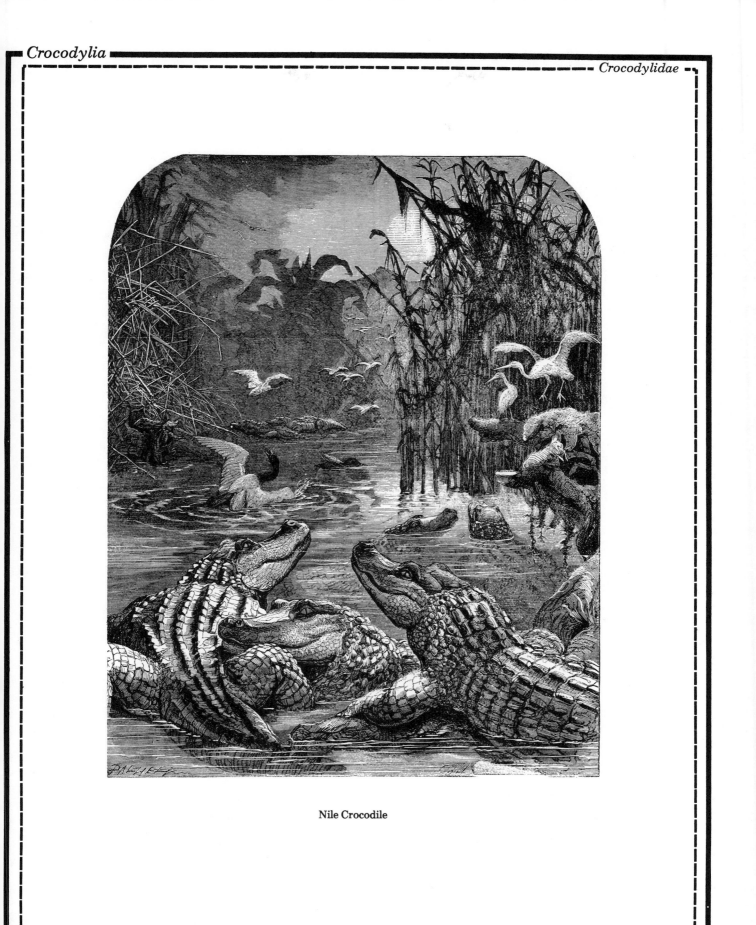

Nile Crocodile

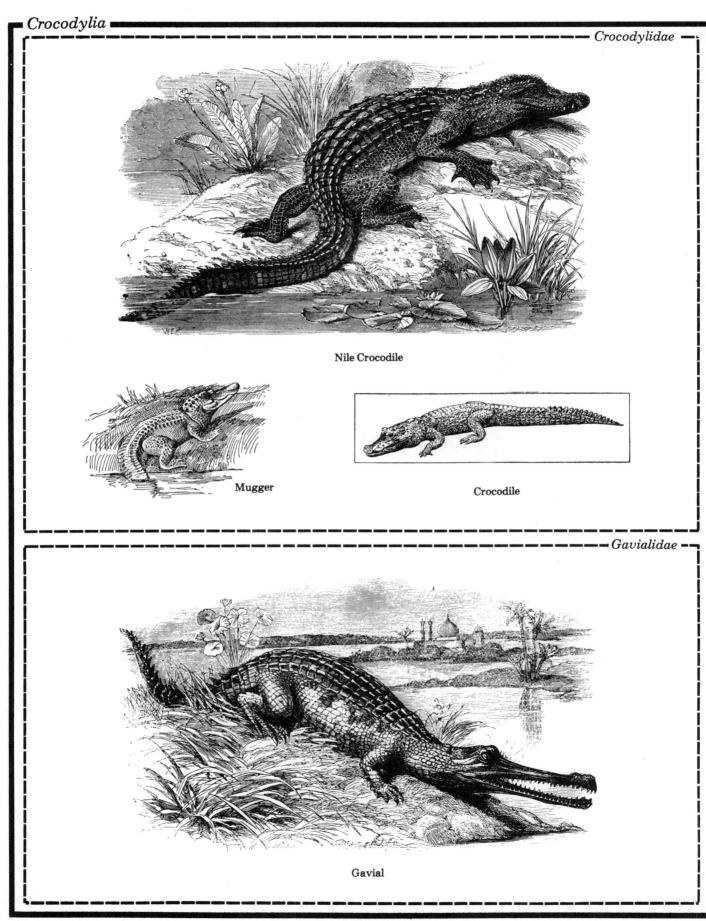

Nile Crocodile

Mugger

Crocodile

Gavial

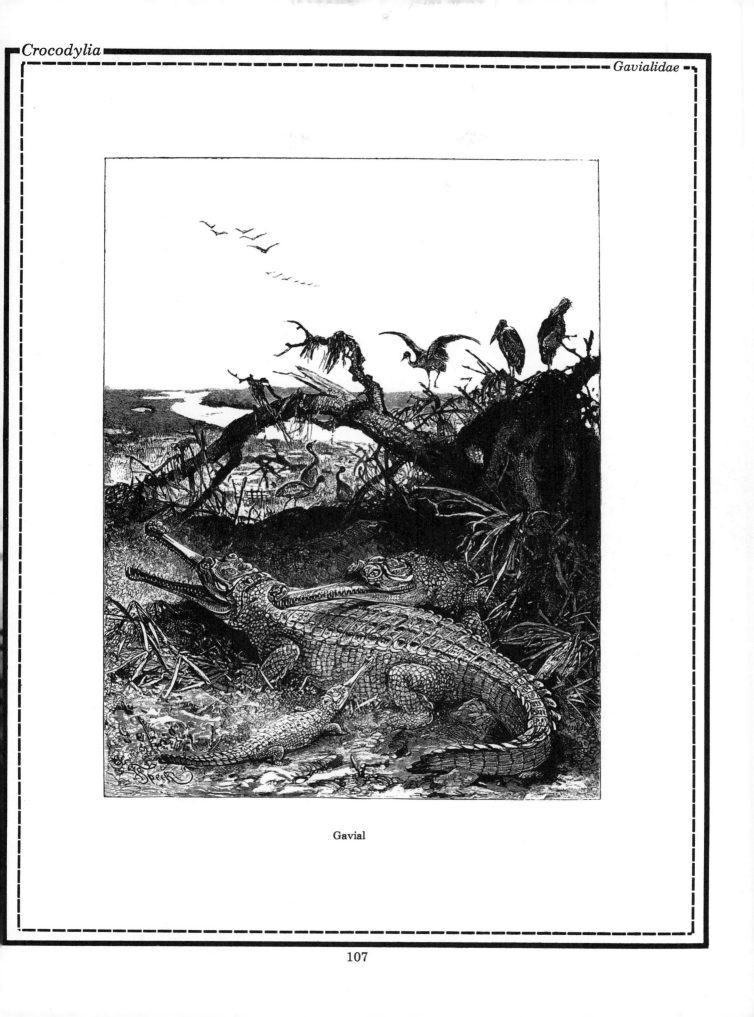

Gavial

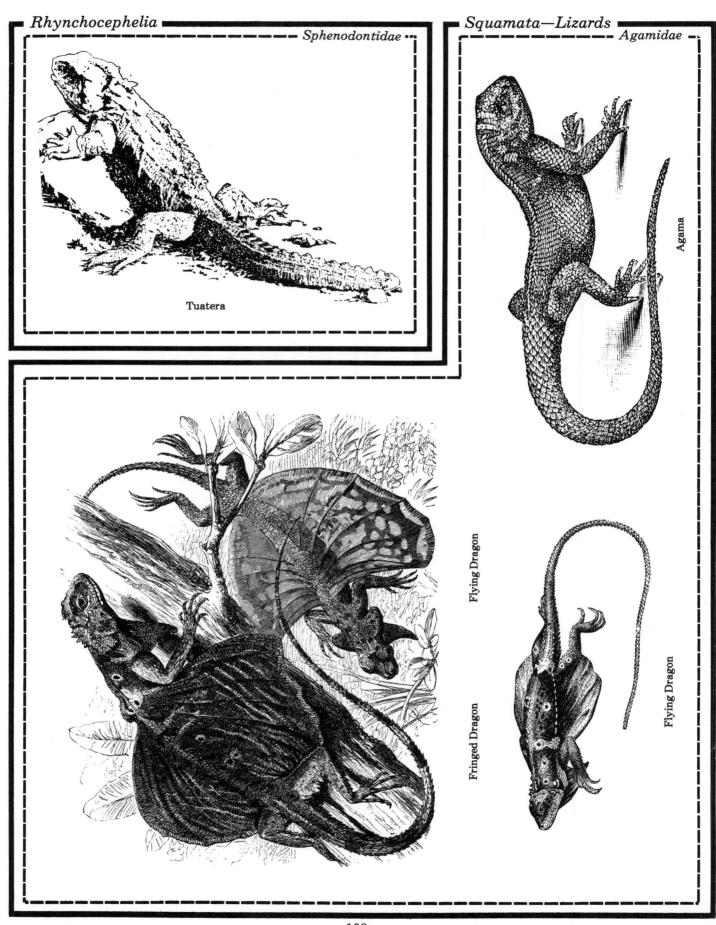

Tuatera

Agama

Flying Dragon

Fringed Dragon

Flying Dragon

Flying Dragon

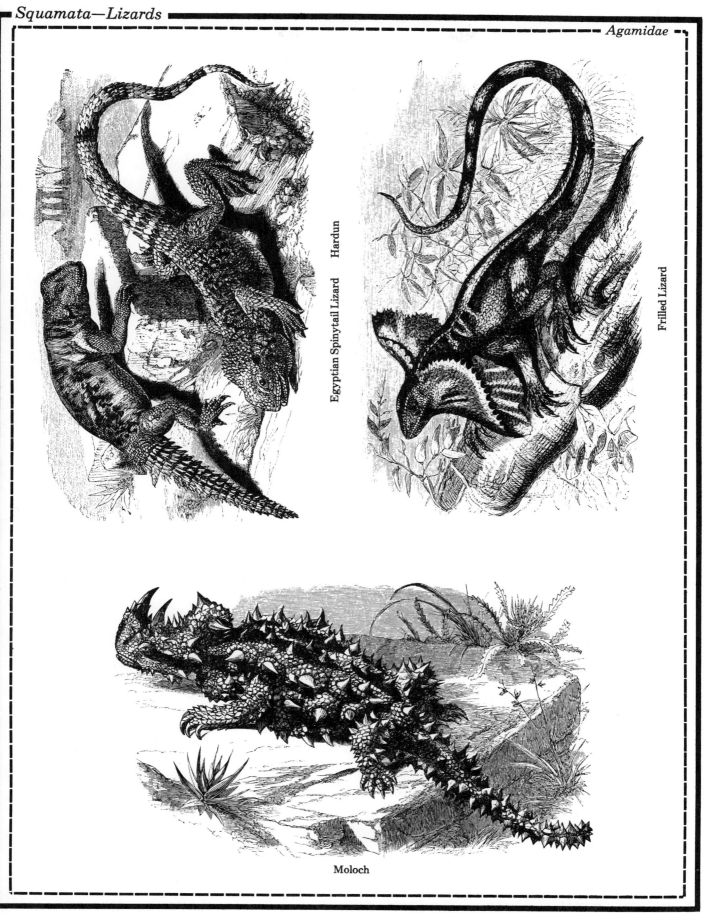

Hardun

Egyptian Spinytail Lizard

Frilled Lizard

Moloch

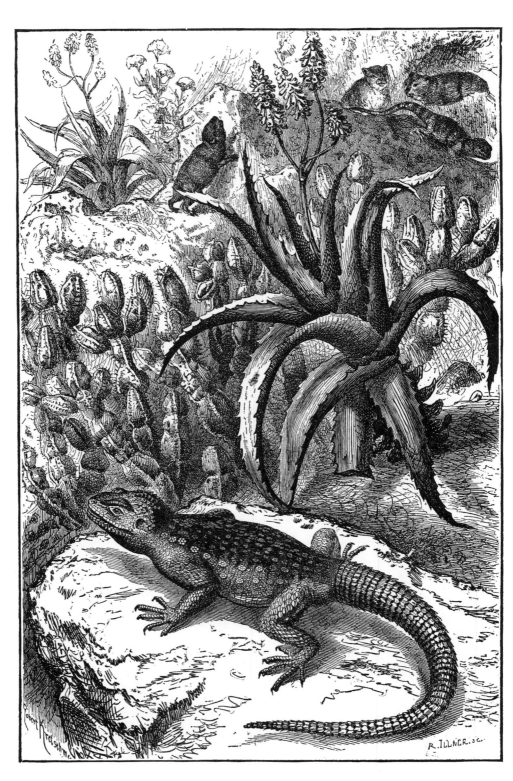

Hardun

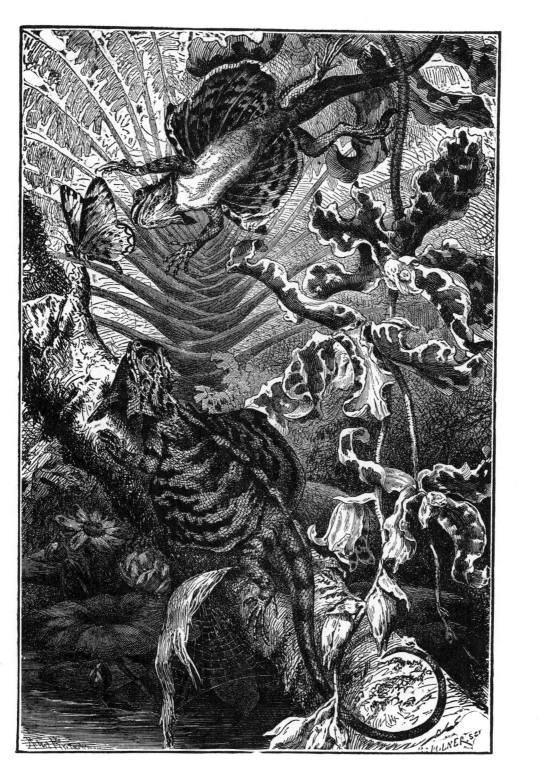

Flying Dragon

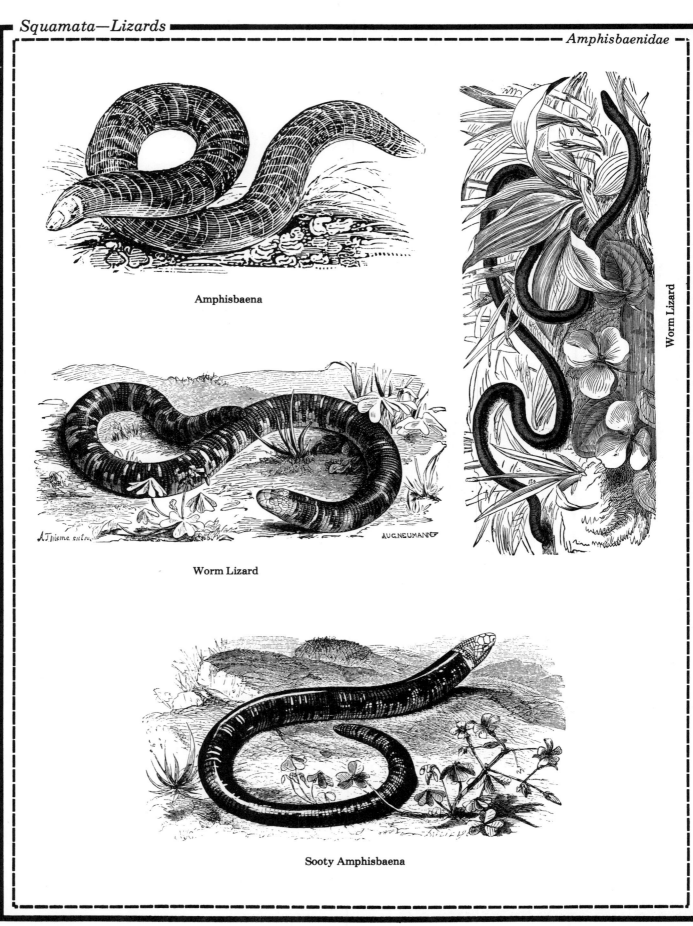

Amphisbaena

Worm Lizard

Worm Lizard

Sooty Amphisbaena

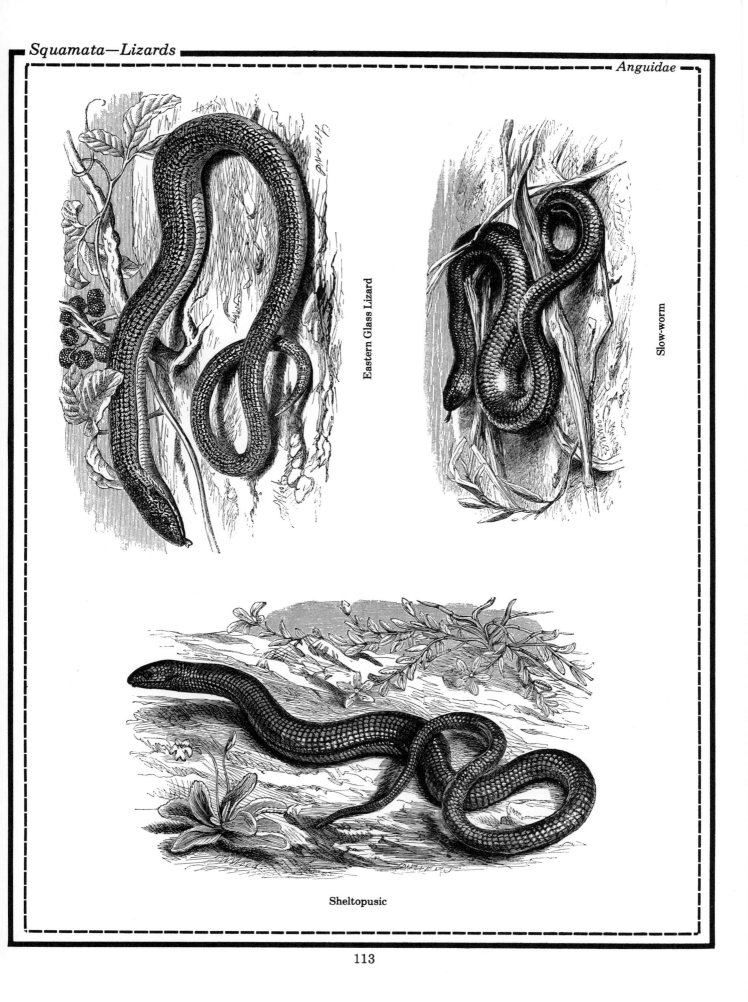

Eastern Glass Lizard

Slow-worm

Sheltopusic

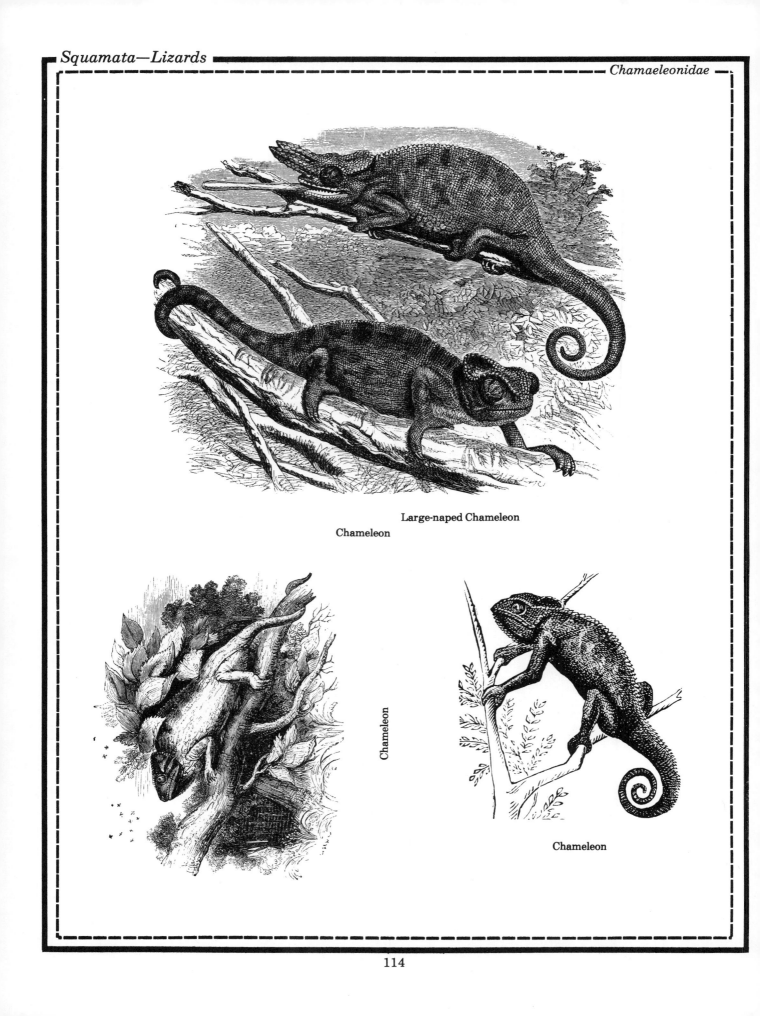

Large-naped Chameleon

Chameleon

Chameleon

Chameleon

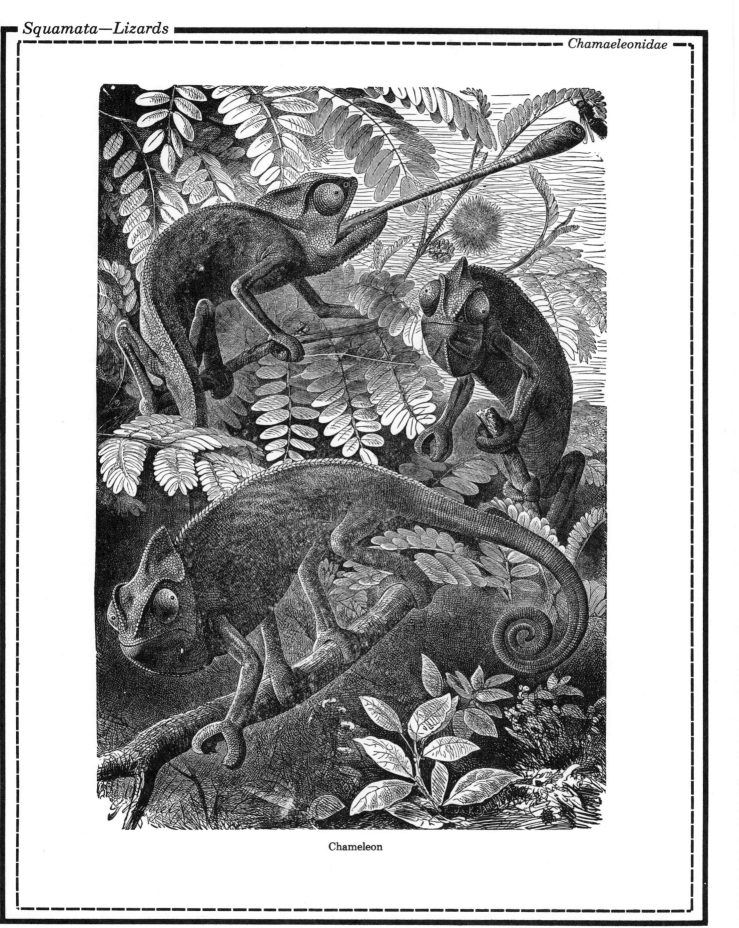

Chameleon

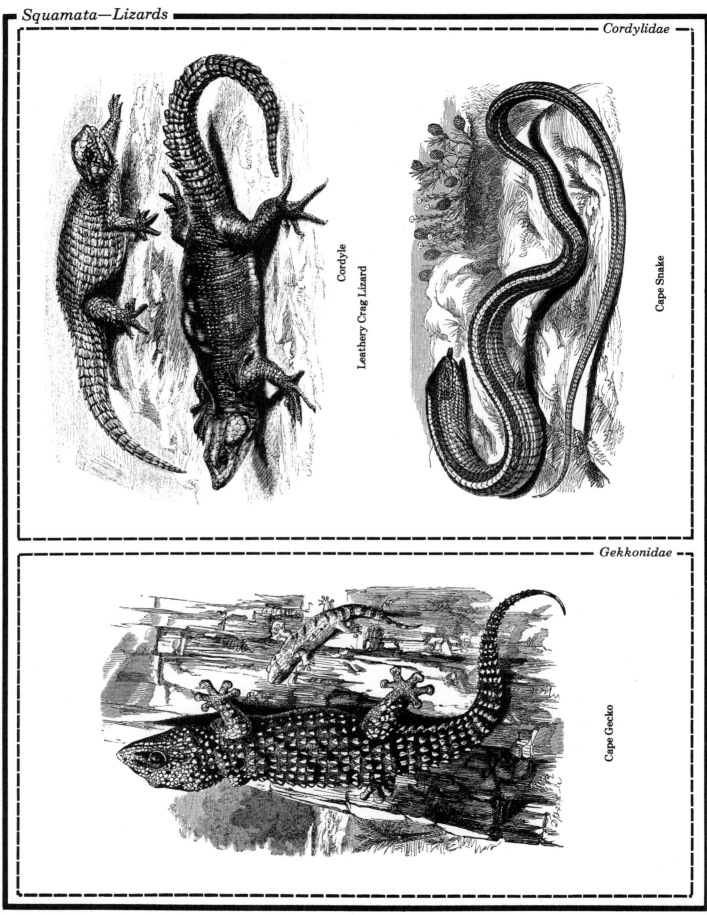

Cordyle

Leathery Crag Lizard

Cape Snake

Cape Gecko

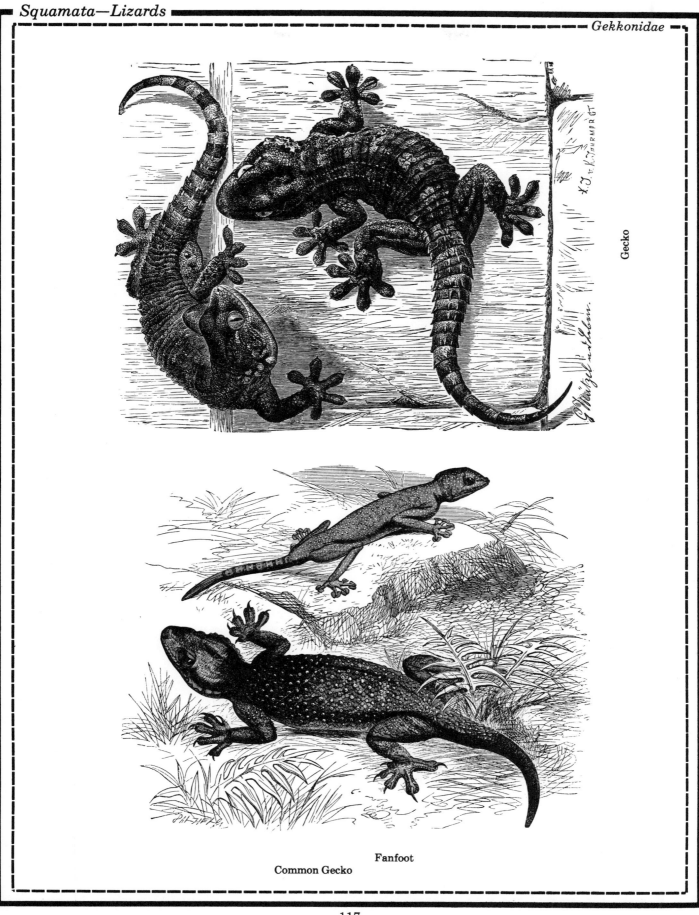

Gecko

Fanfoot

Common Gecko

Gekkonidae

Helodermatidae

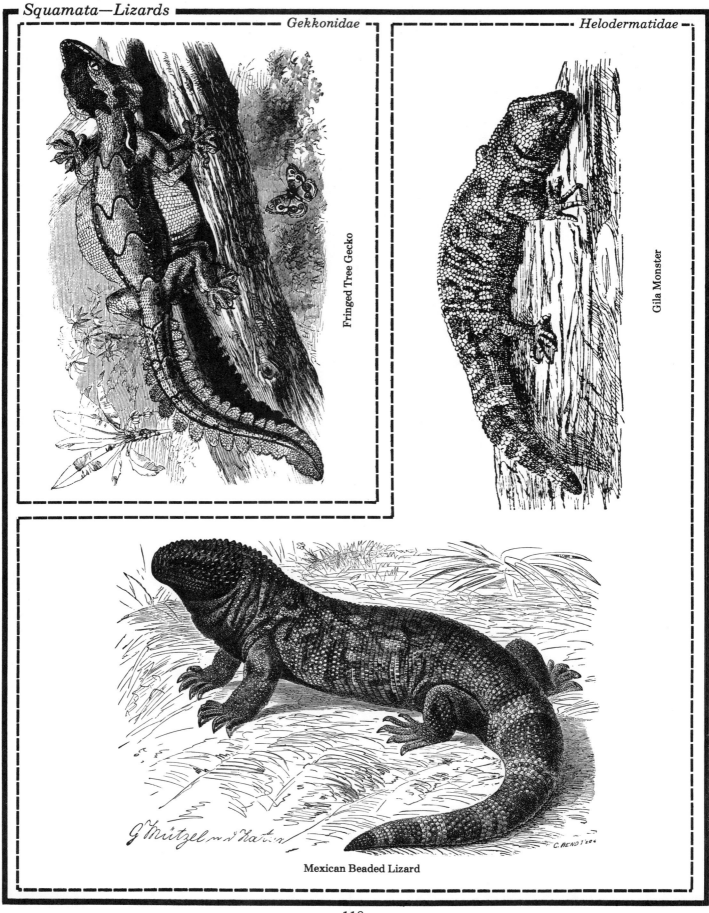

Fringed Tree Gecko

Gila Monster

Mexican Beaded Lizard

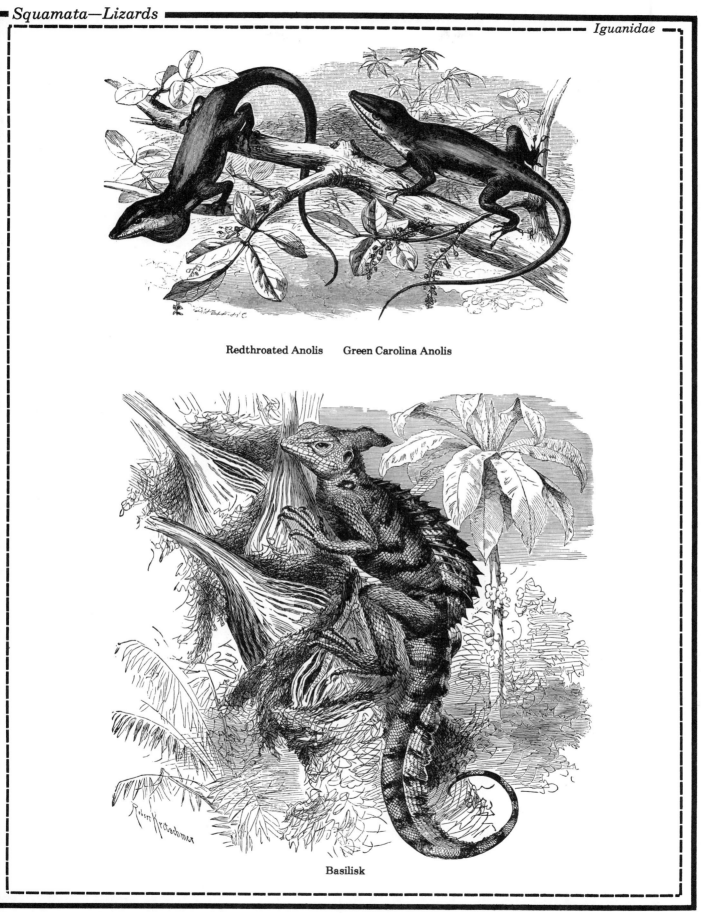

Redthroated Anolis Green Carolina Anolis

Basilisk

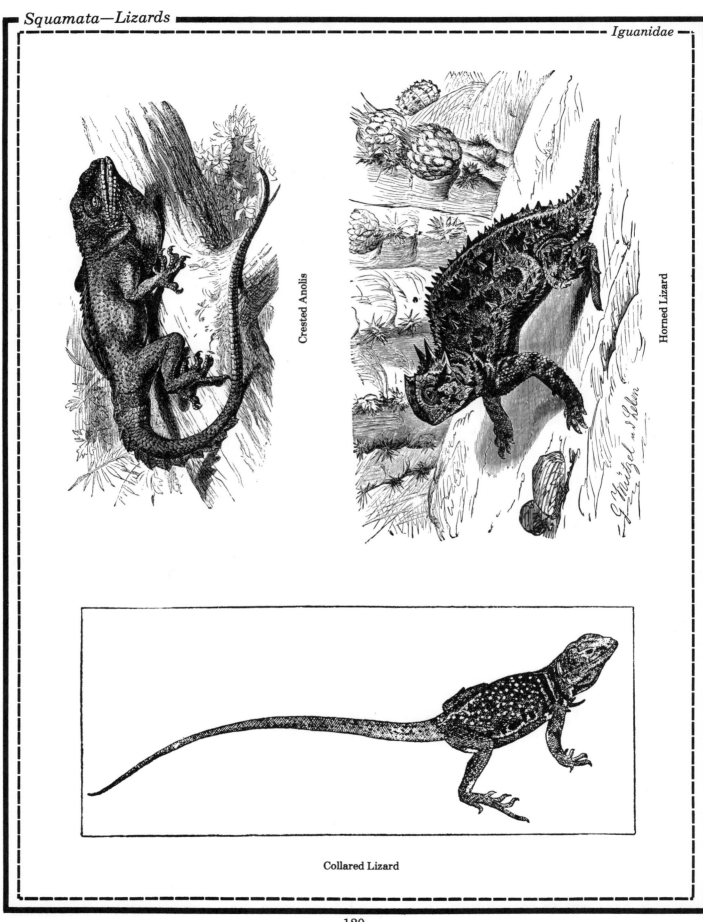

Crested Anolis

Horned Lizard

Collared Lizard

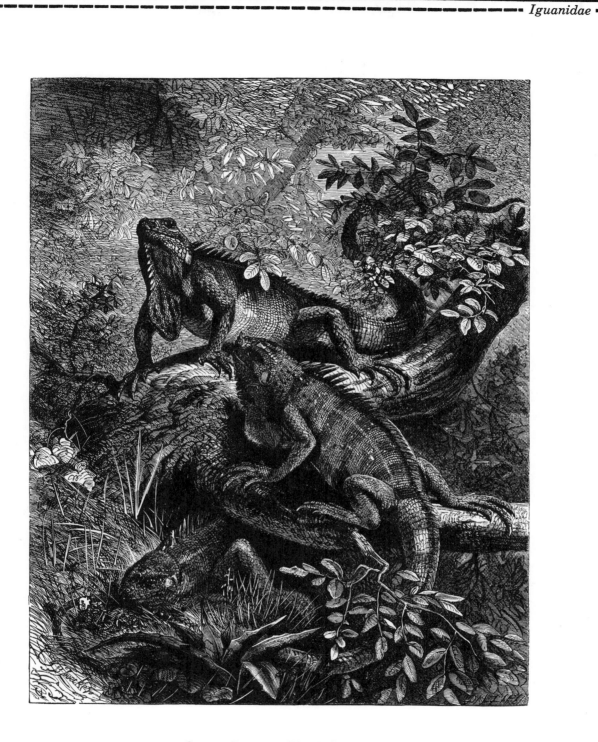

Common Iguana West Indian Iguana

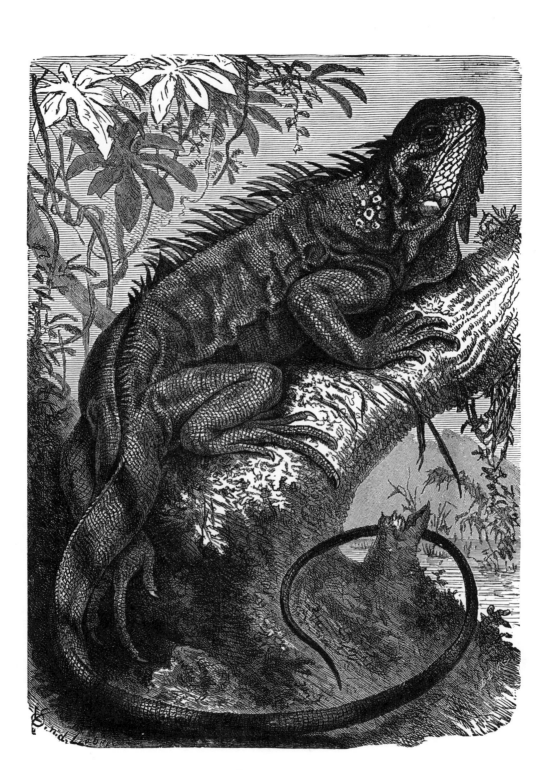

Common Iguana

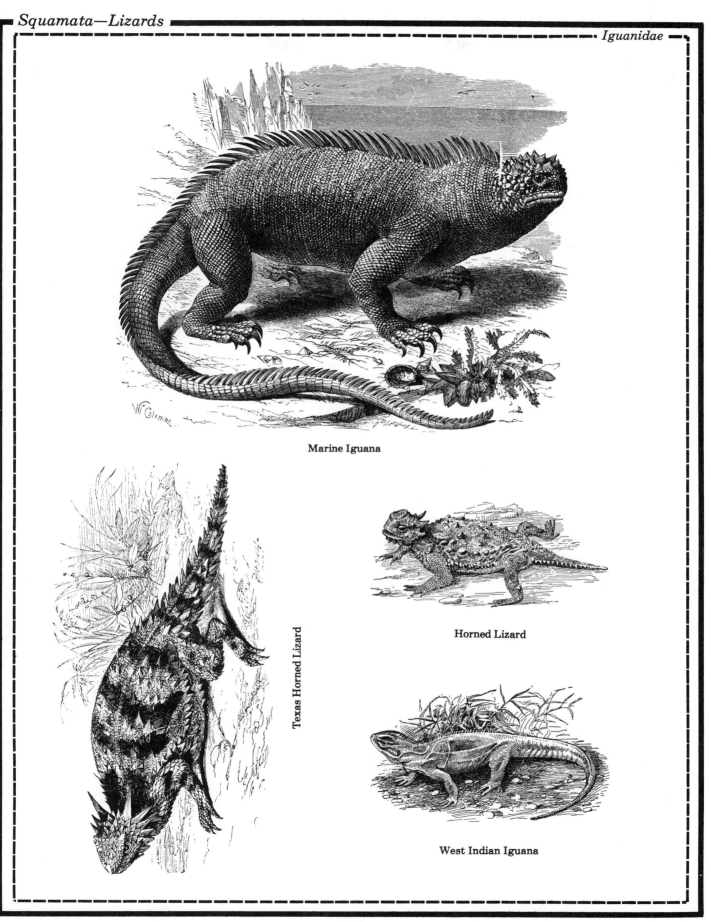

Marine Iguana

Texas Horned Lizard

Horned Lizard

West Indian Iguana

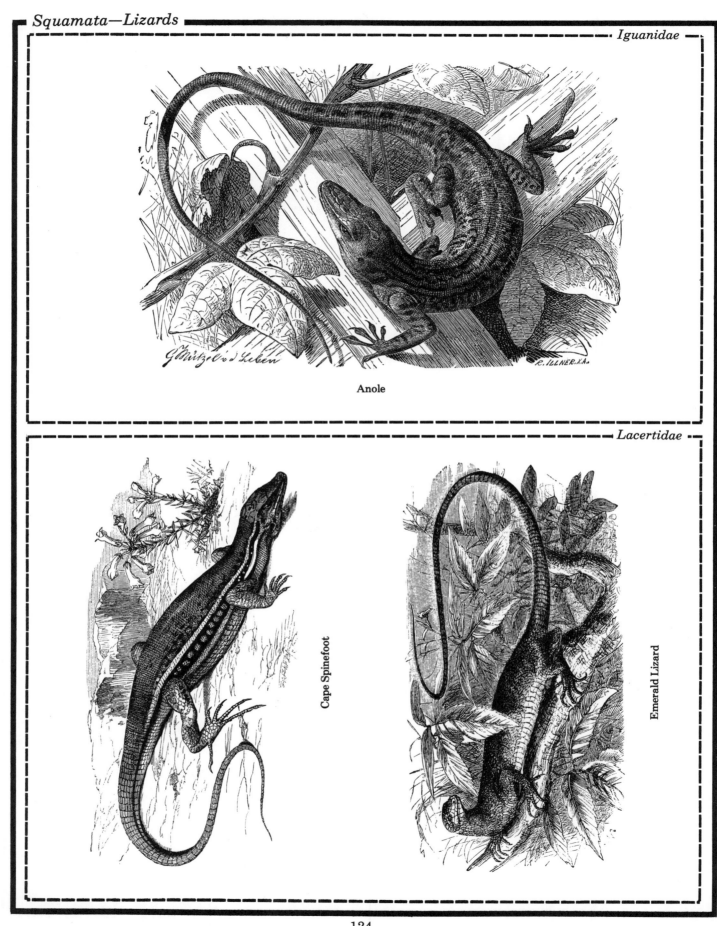

Anole

Cape Spinefoot

Emerald Lizard

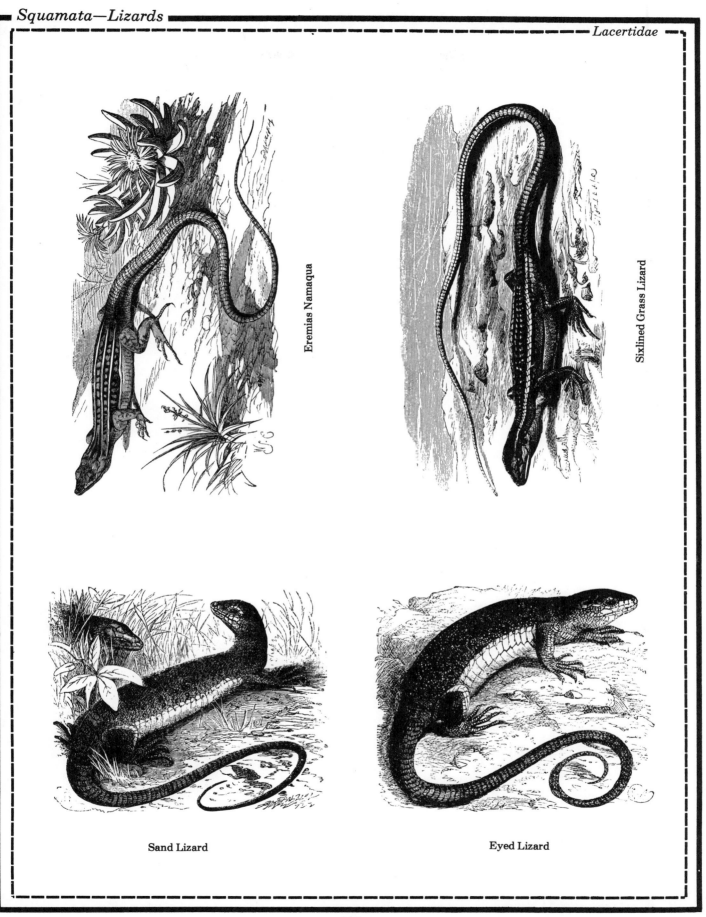

Eremias Namaqua

Sixlined Grass Lizard

Sand Lizard

Eyed Lizard

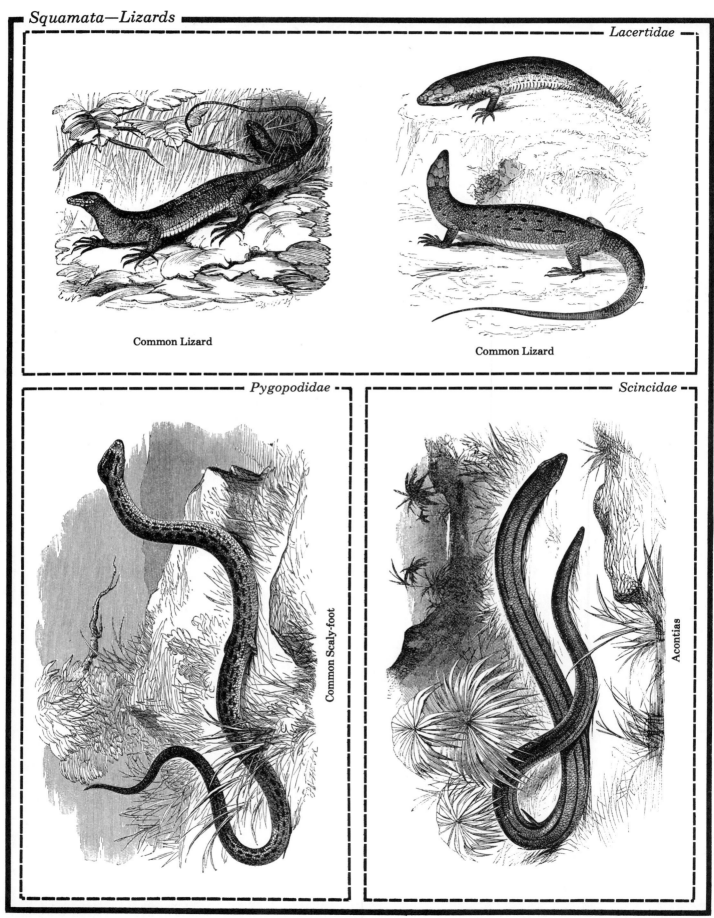

Common Lizard

Common Lizard

Pygopodidae

Common Scaly-foot

Scincidae

Acontias

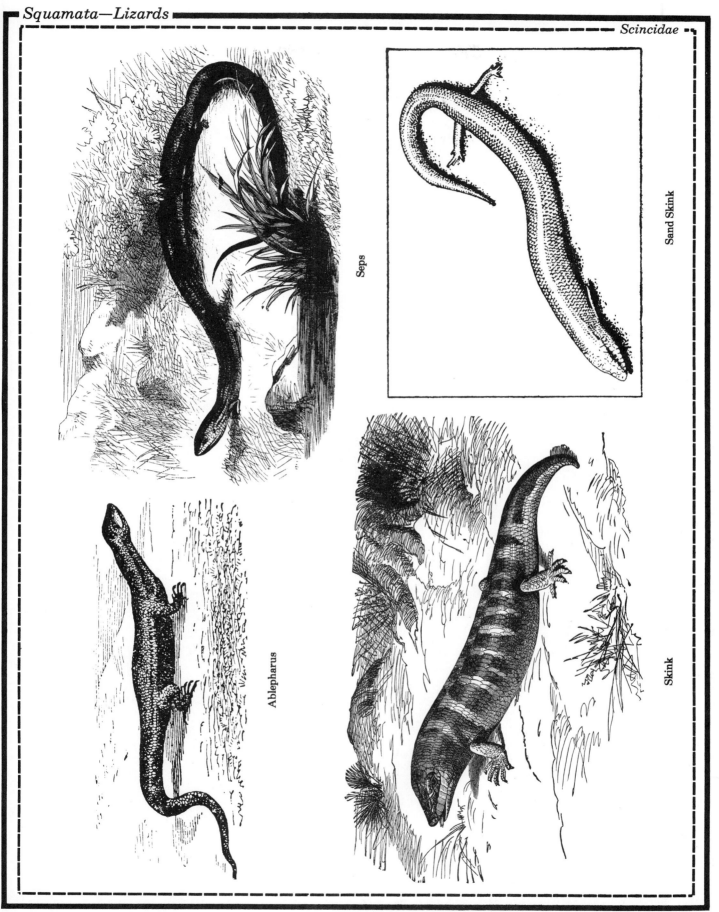

Seps

Sand Skink

Ablepharus

Skink

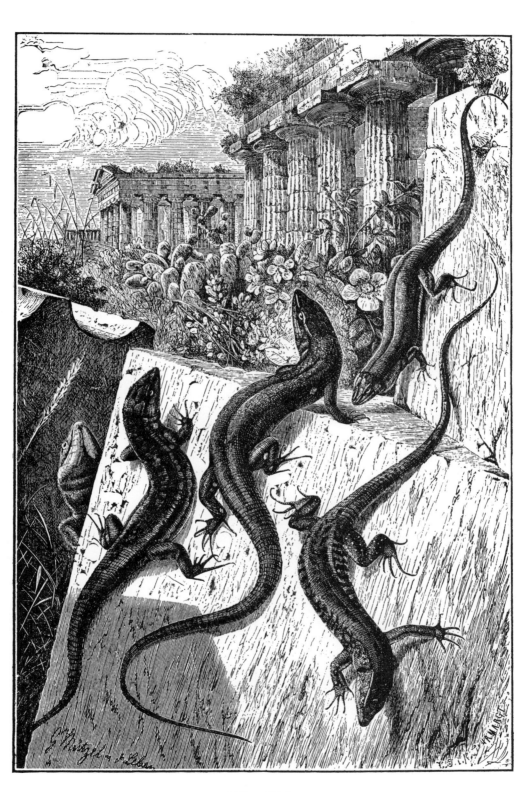

Lidless Skink

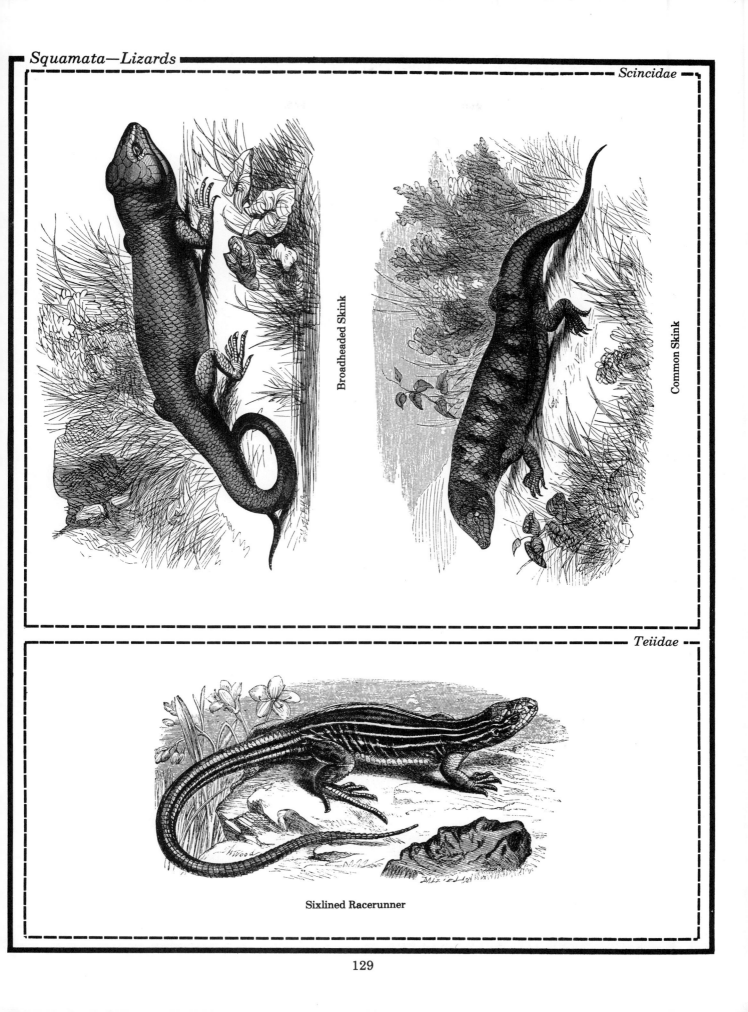

Broadheaded Skink

Common Skink

Sixlined Racerunner

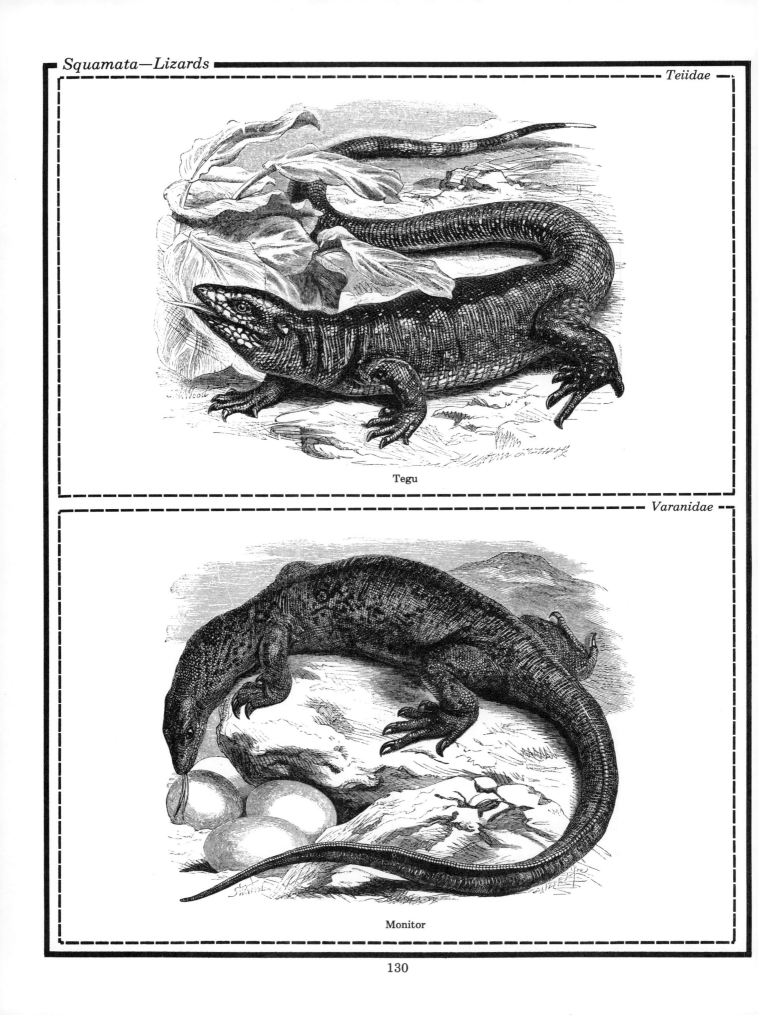

Tegu

Varanidae

Monitor

Indian Monitor

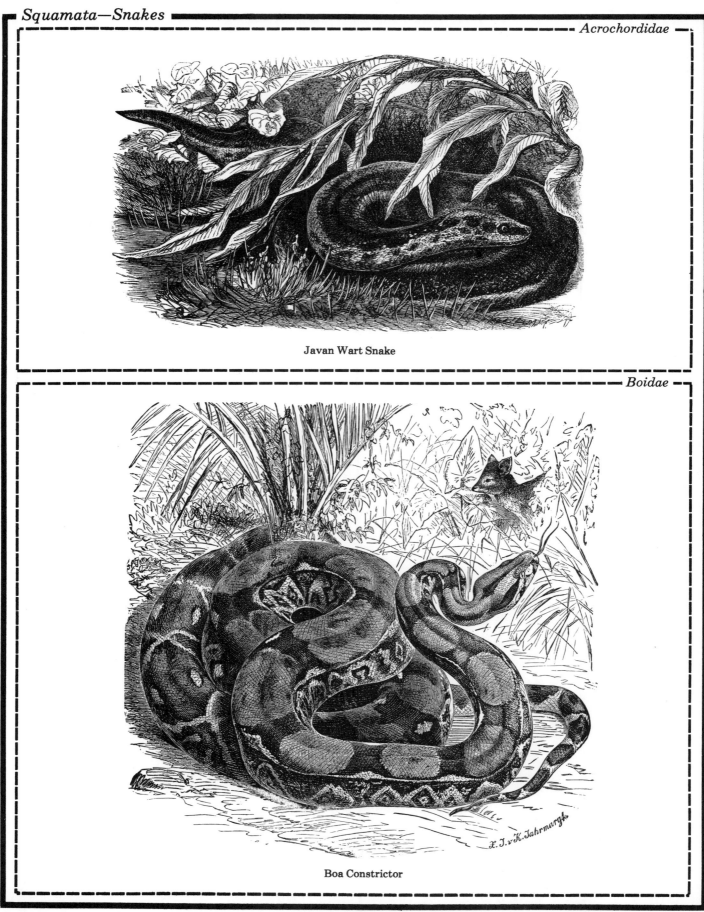

Javan Wart Snake

Boa Constrictor

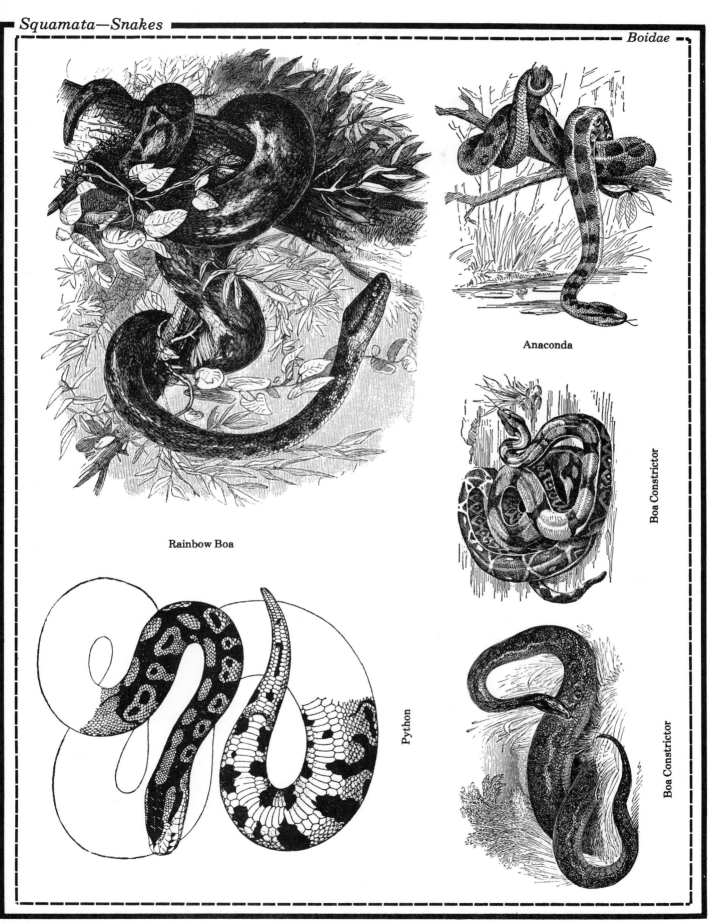

Anaconda

Rainbow Boa

Boa Constrictor

Python

Boa Constrictor

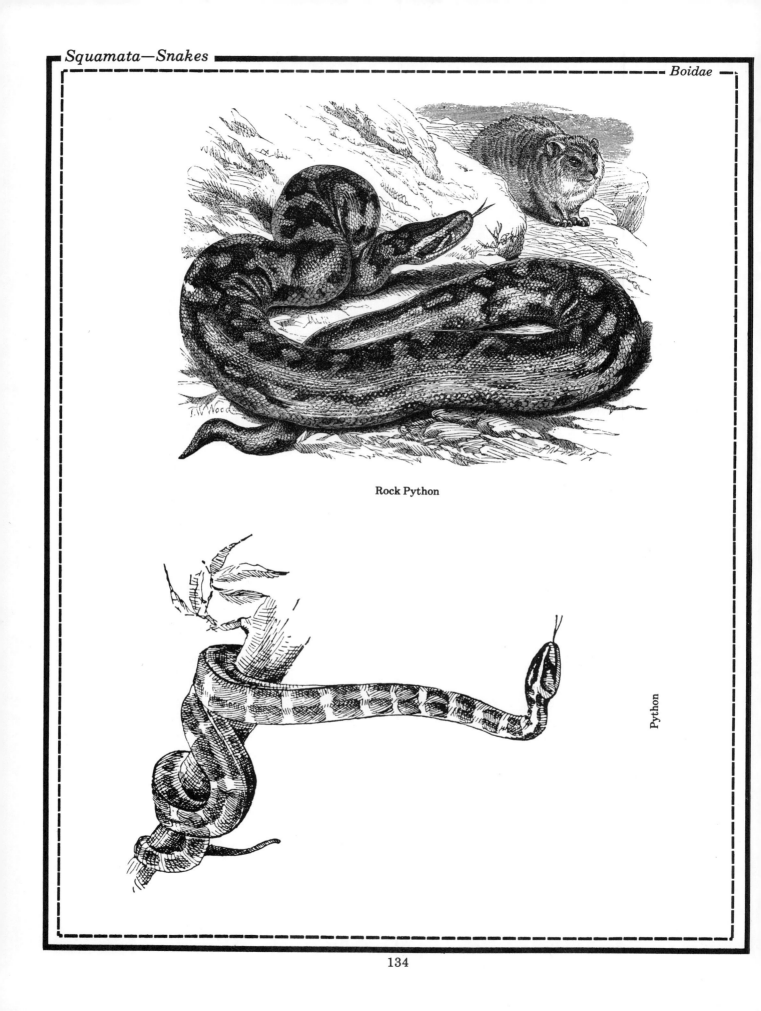

Rock Python

Python

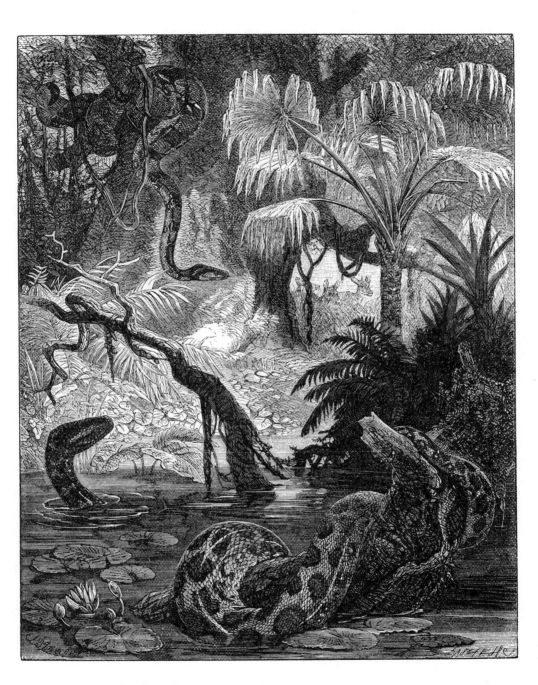

Boa Constrictor

Anaconda

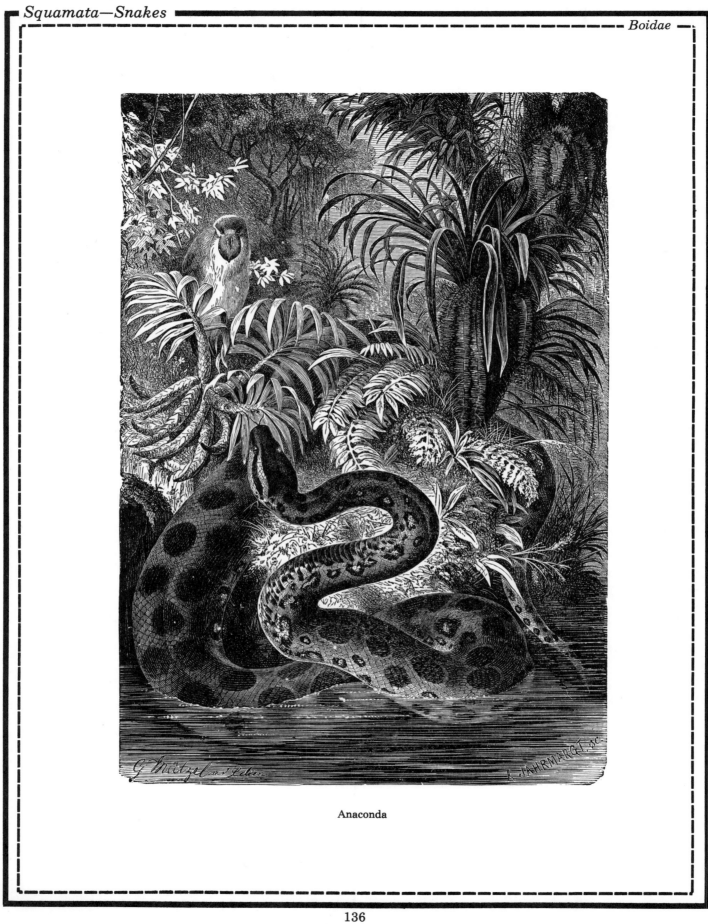

Anaconda

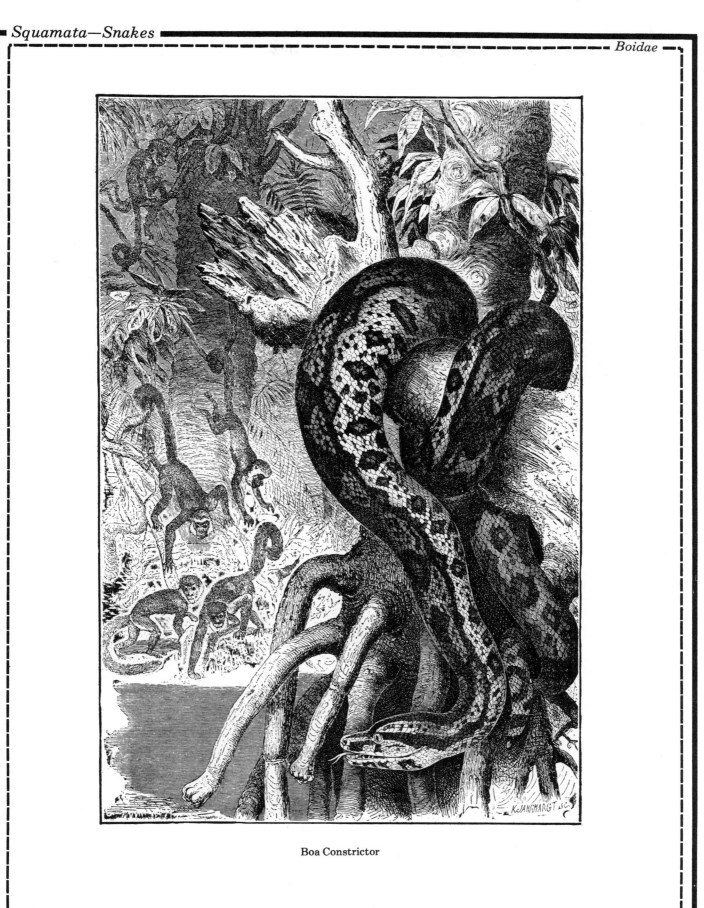

Boa Constrictor

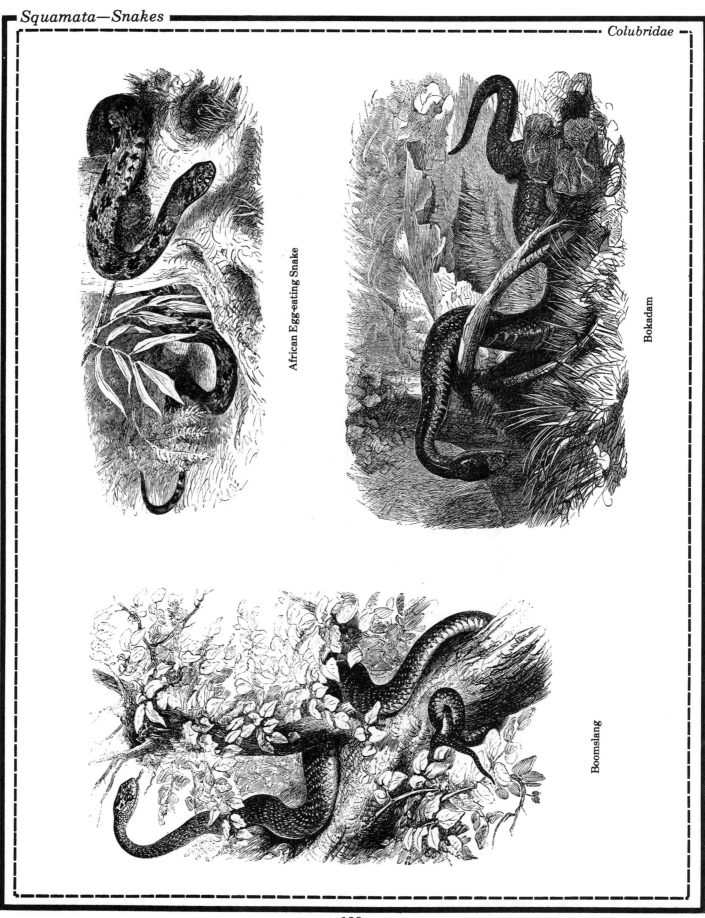

African Egg-eating Snake

Bokadam

Boomslang

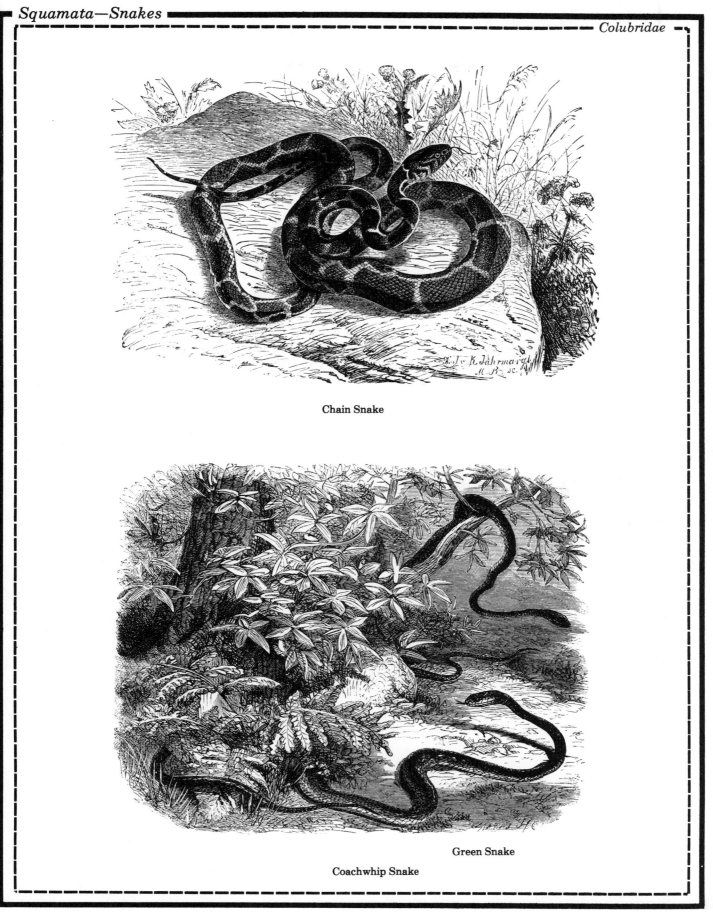

Chain Snake

Green Snake

Coachwhip Snake

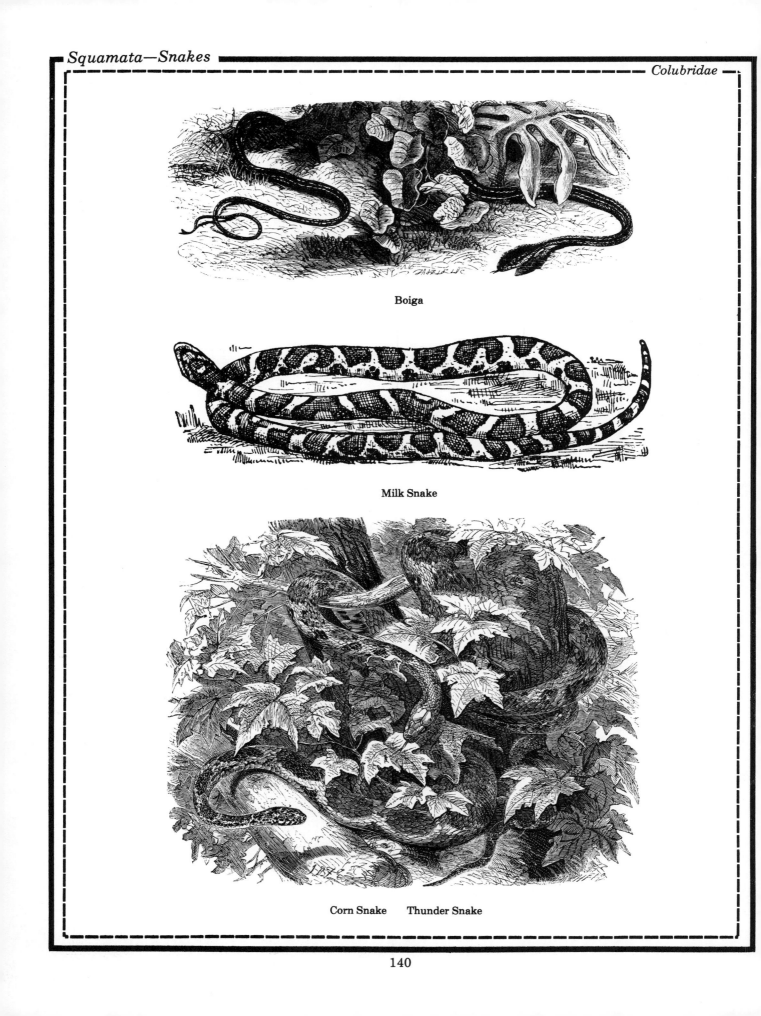

Boiga

Milk Snake

Corn Snake Thunder Snake

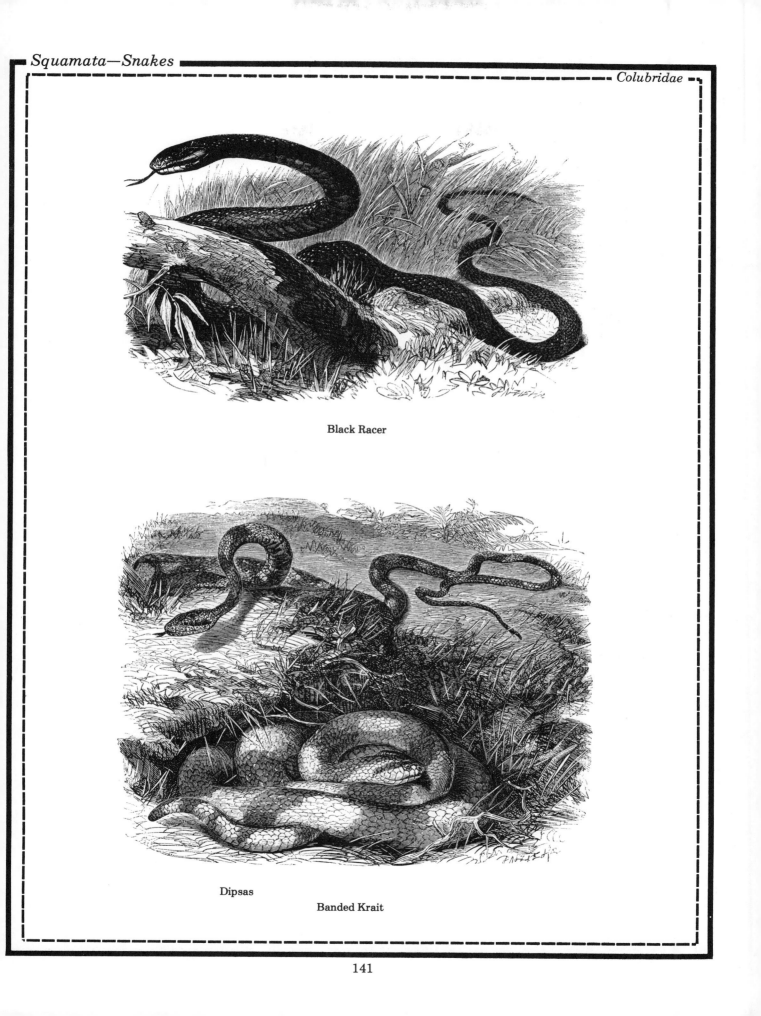

Black Racer

Dipsas

Banded Krait

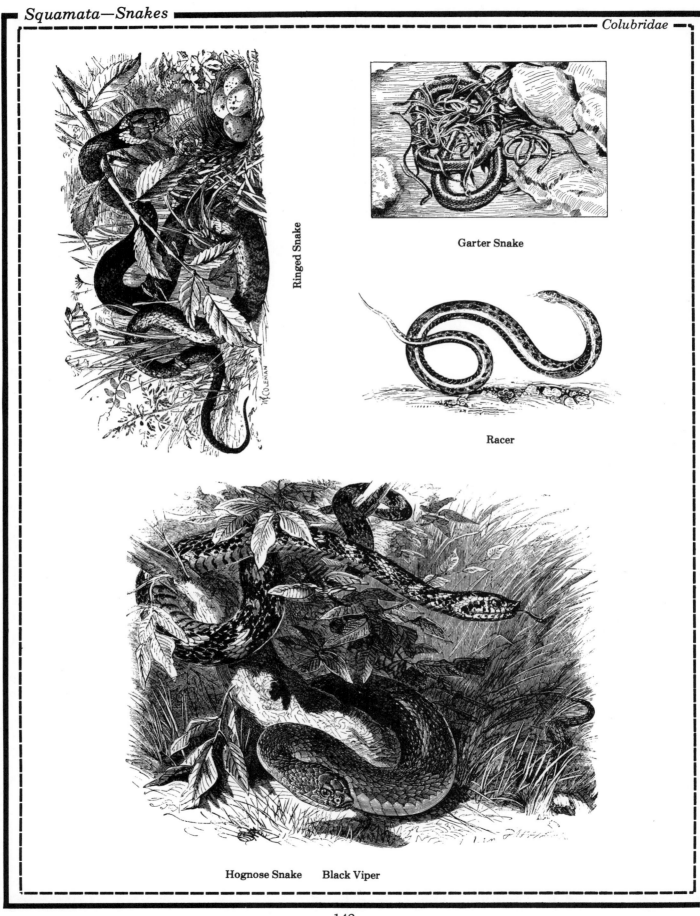

Ringed Snake

Garter Snake

Racer

Hognose Snake Black Viper

Schaapsticker

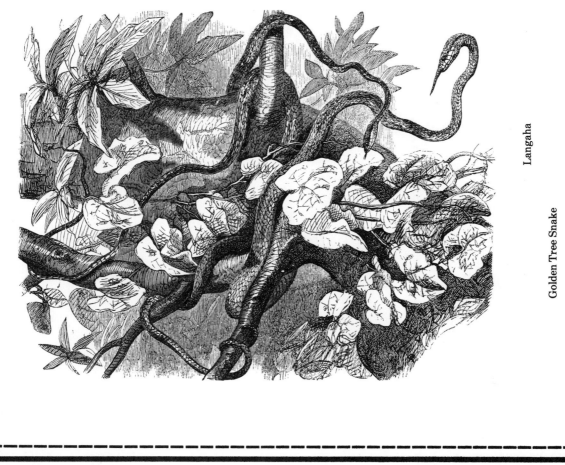

Langaha

Golden Tree Snake

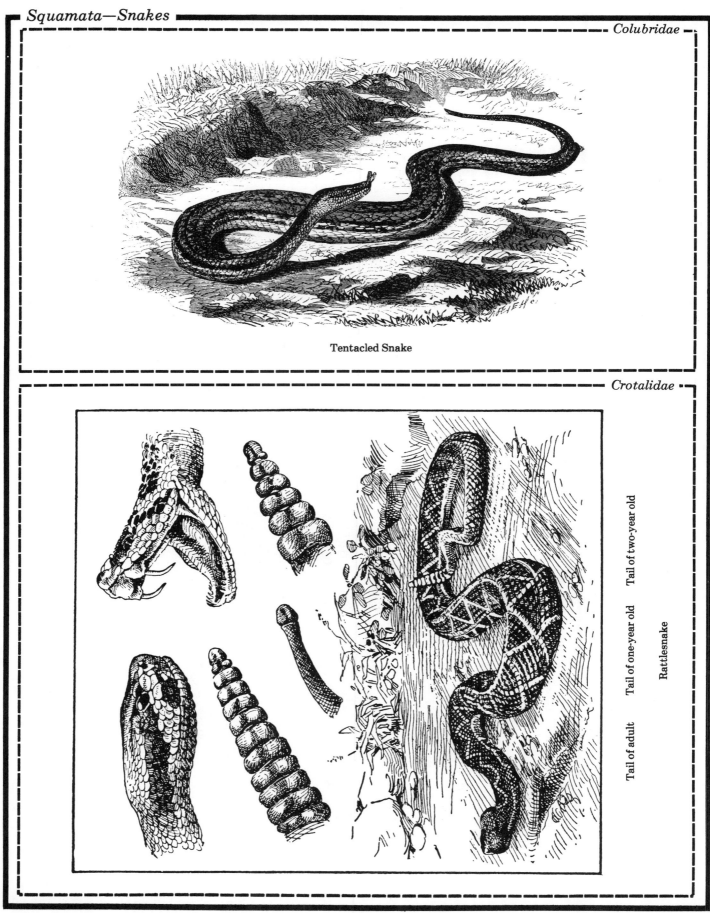

Tentacled Snake

Tail of two-year old

Tail of one-year old

Tail of adult

Rattlesnake

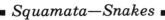

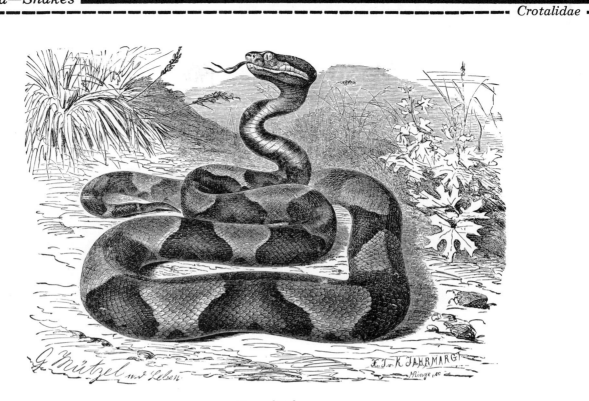

Copperhead

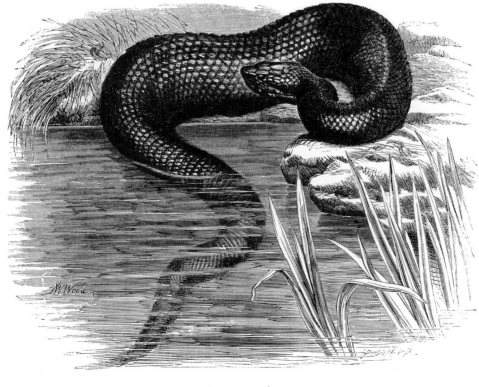

Cottonmouth

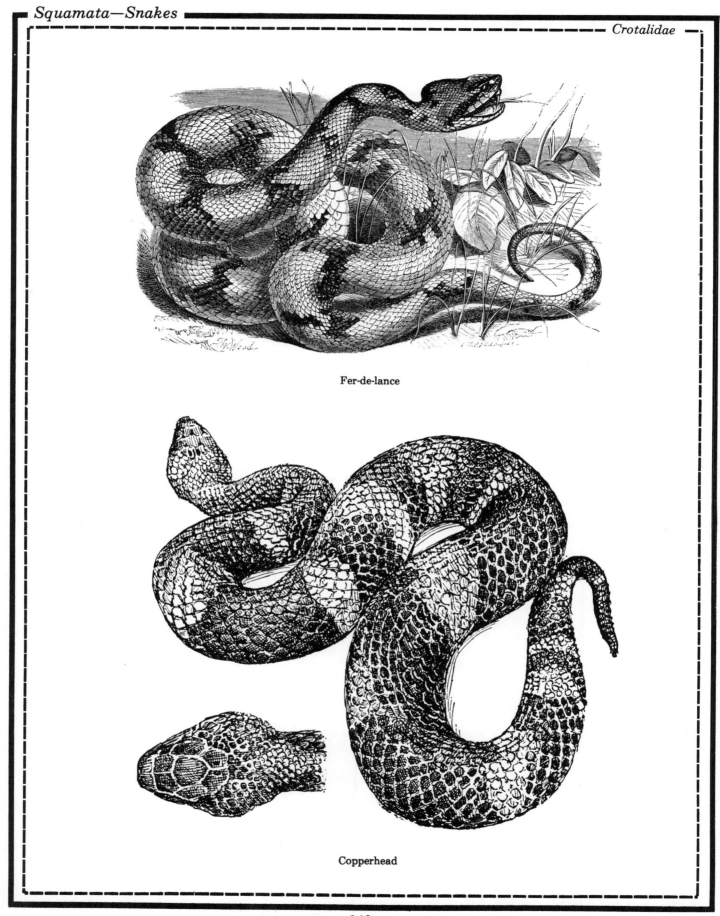

Fer-de-lance

Copperhead

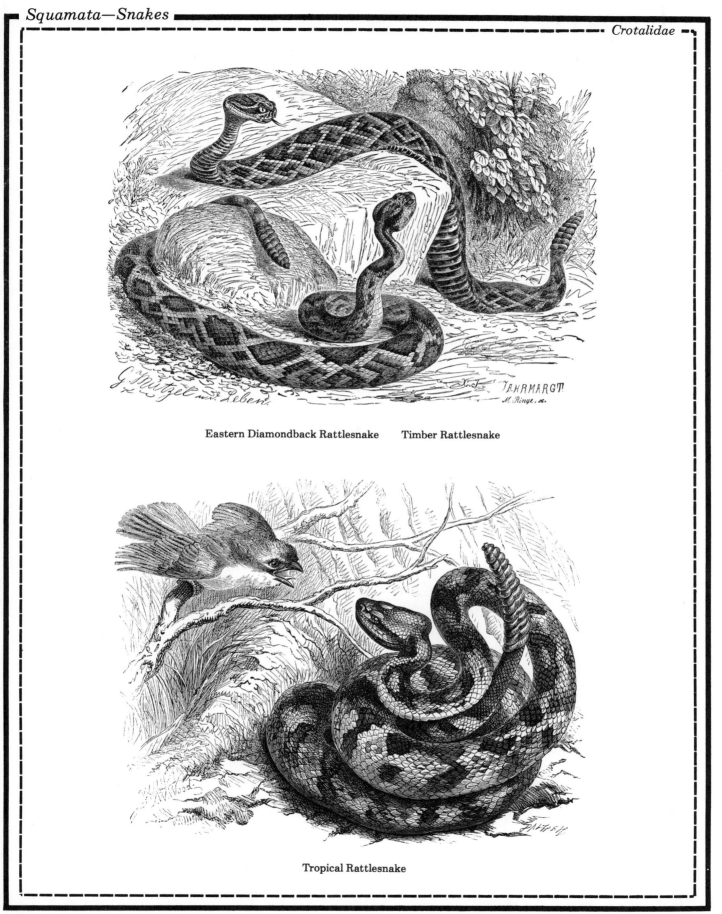

Eastern Diamondback Rattlesnake Timber Rattlesnake

Tropical Rattlesnake

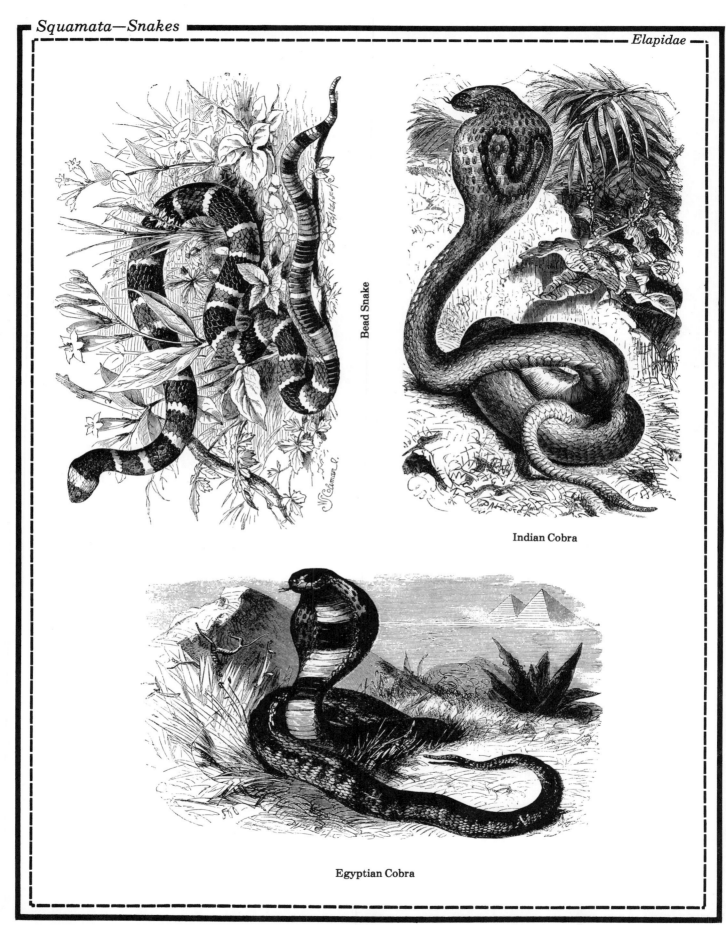

Bead Snake

Indian Cobra

Egyptian Cobra

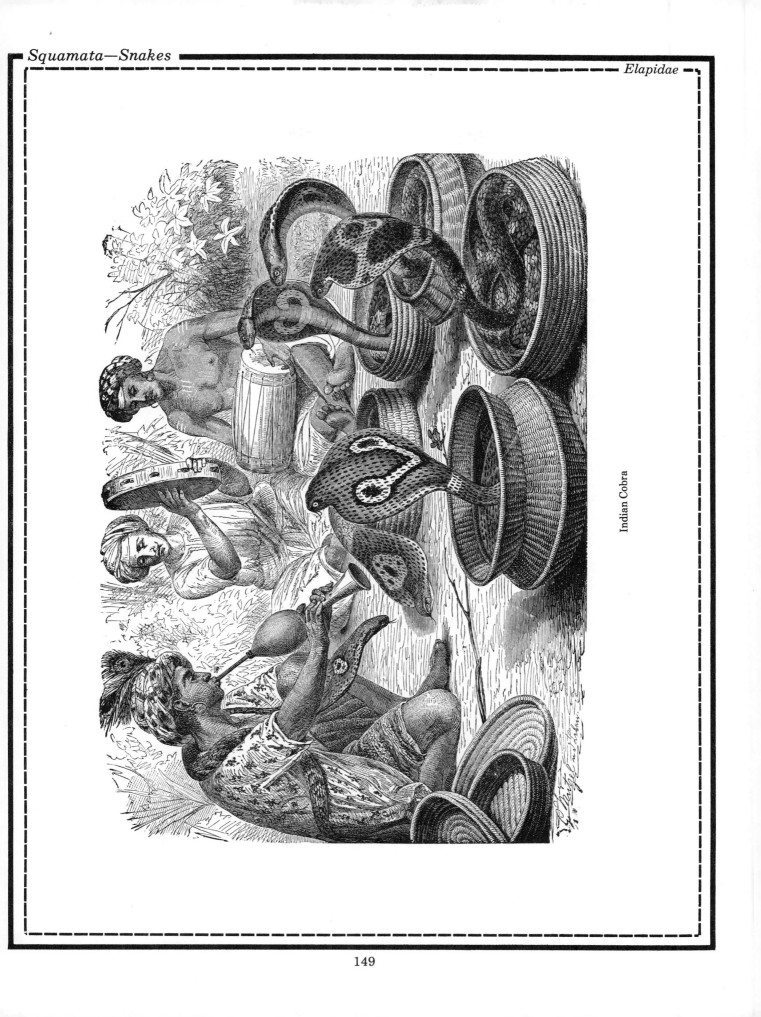

Indian Cobra

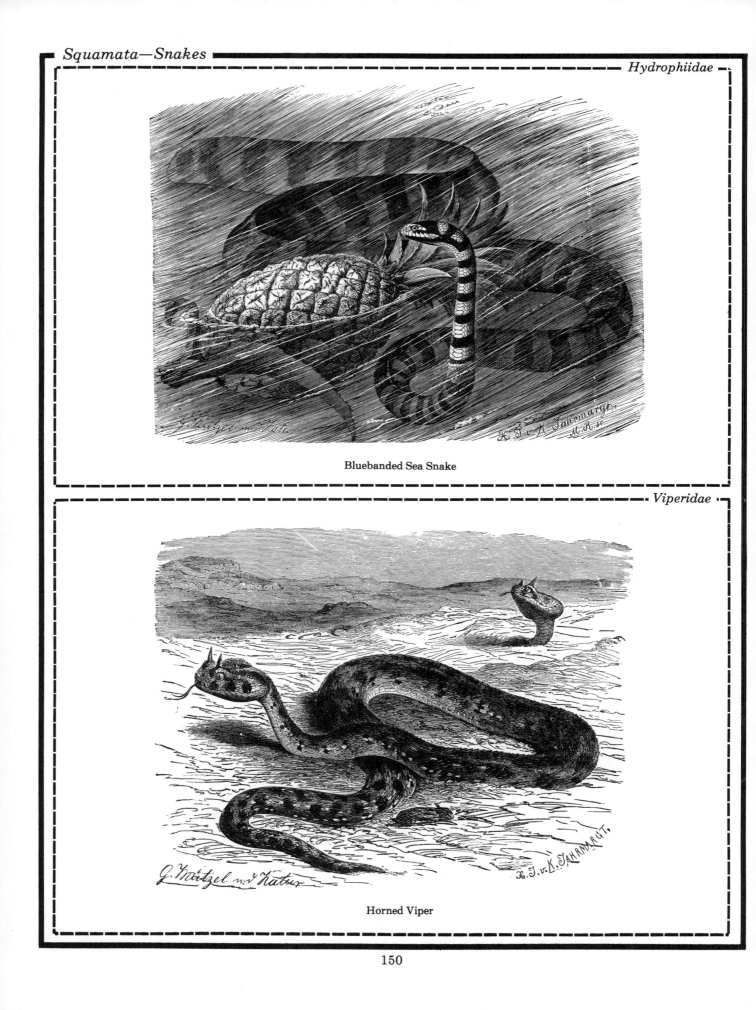

Bluebanded Sea Snake

Horned Viper

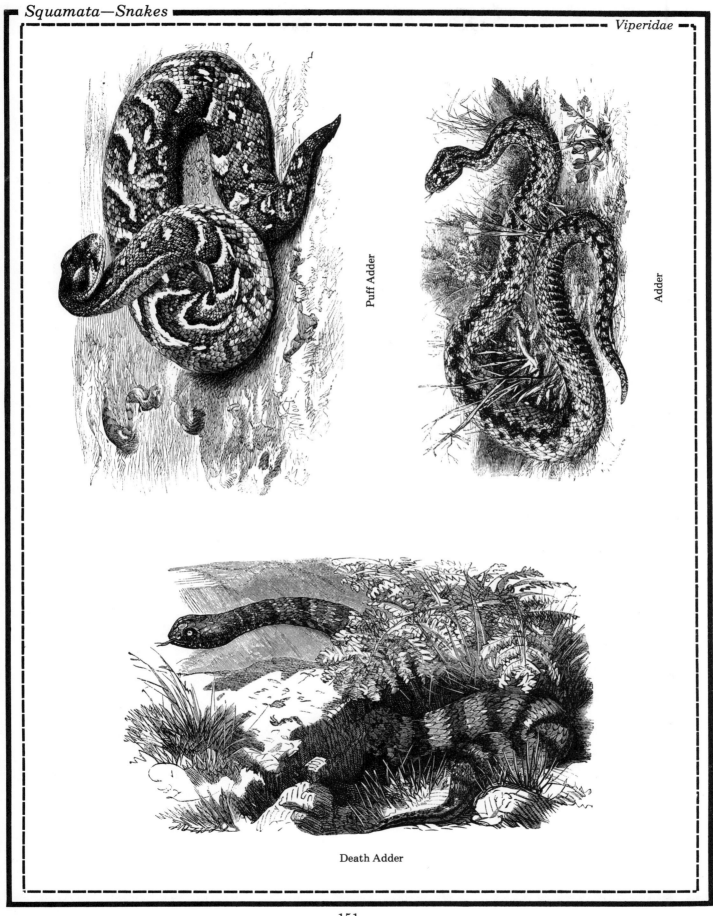

Puff Adder

Adder

Death Adder

At different times and in different places an individual species may be known by various names. As an aid to the reader, over 300 alternative names of some of the creatures pictured in this book have been cross-indexed here.